May 8, 1993

Congratulations, Mom!

Love Drew

May 8, 1993

Congratulations, Mom!

MASTER PHOTOGRAPHS FROM PFA EXHIBITIONS, 1959–67

INTERNATIONAL CENTER OF PHOTOGRAPHY, NEW YORK CITY

MASTER PHOTOGRAPHS FROM PFA EXHIBITIONS, 1959—67

Master

INTRODUCTION BY

Cornell Capa

ESSAYS BY

Norman Cousins

Evan H. Turner

Miles Barth

Nathan Lyons

Naomi N. Rosenblum

Photographs

This book is published in conjunction with the exhibition, "Master Photographs from 'Photography in the Fine Arts' Exhibitions, 1959-67," organized by the International Center of Photography. The exhibition, its U.S. tour, and this publication are sponsored by the Professional Photography Division of Eastman Kodak Company.

Distributed by Cameron and Company, 543 Howard Street, San Francisco, CA 94105, 415 777-5582.

Library of Congress Catalog Card Number: 88–81617

ISBN: 0-933642-12-1

Photographs edited and publication supervised by Miles Barth.

Texts edited by Anne H. Hoy.

Designed by Karen Salsgiver.

Printed and bound in Japan by Dai Nippon Printing Co., Ltd.

The International Center of Photography was established in 1974 to present exhibitions of photography; offer photographic education at all levels; preserve and study important 20th century images; and provide a forum for the establishment of standards, exchange of ideas and dissemination of information. ICP is chartered by the Board of Regents of the State of New York and accredited by the American Association of Museums.

6

ACKNOWLEDGEMENTS

With any project that has the size and scope of the one presented here, there are many people and organizations to thank. The first person to be acknowledged is Ken Lieberman, who introduced ICP to E. Nobles Lowe. Mr. Lowe kept the spirit of the PFA alive and was entirely responsible for bringing the collection of prints and correspondence from the Photography in the Fine Arts Foundation to ICP. When the collection was first given to the Archives of American Art in the early 1970's, Garnett McCoy and his staff made sure that the material they received was well documented and kept in good order. Over the years, Mr. McCoy, Judy Throm, and Cynthia Ott of the Archives have given ICP access to pertinent research papers and documents, and we gratefully recognize their assistance.

Shortly after the PFA collection arrived at ICP in 1981, the New York State Council on the Arts gave us a grant to do preliminary research and preparation for an exhibition, and funding for conservation of the prints. We again thank NYSCA for its early encouragement.

Reconstructing the records of the PFA was necessary in order to determine the sources from which the original photographs were obtained, the correct titles and dates of the prints, and additional technical and legal issues. I would like to thank Mary Donlon for her assistance at various times over the last six years, for research into the records of the PFA, and for coordinating other aspects of this publication.

Valuable assistance in clarifying information regarding the life of Ivan Dmitri was given to us by his son, Peter West; his secretary and the assistant to the PFA organization, Emily Suesskind; Robert K. Brown, formerly of Eastman Kodak Company; and Margaret R. Weiss, former photo editor of the *Saturday Review.*

I am grateful to Frank De Luca and Ernest Scarfone for developing the initial concept of this publication and to Beth Schiffer at the Quality Color Lab in New York City for making the large-format transparencies that are reproduced here from the original photographs. Karen Salsgiver has produced a handsome design that allows the quality and diversity of the images to be fully appreciated.

Most of all, the many photographers, their agents, and estates must be thanked for their cooperation and enthusiasm in contributing their photographs and allowing us to publish them in this book. The Professional Photography Division of Eastman Kodak Company deserves our sincere appreciation for the funding that made this publication and exhibition possible.

Miles Barth
Curator
Archives and Collections, ICP
Project Director

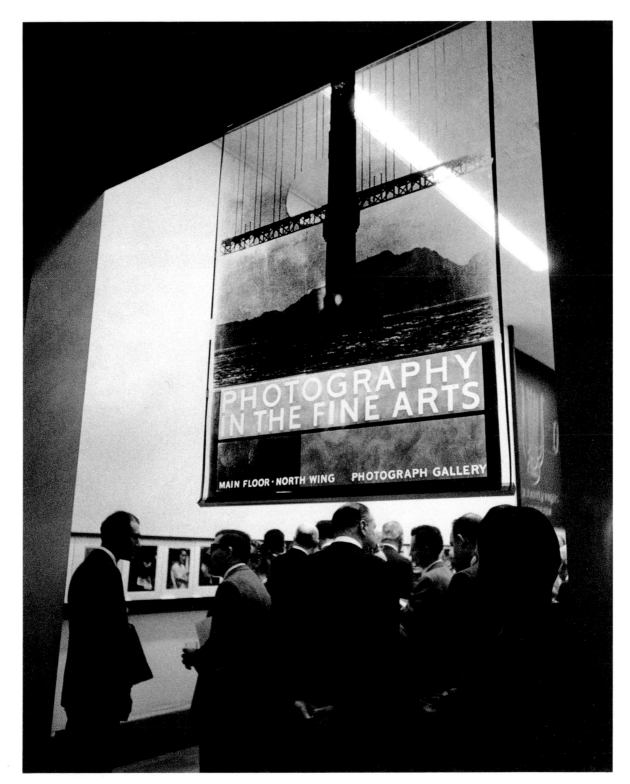

Opening of the first PFA exhibition,
Metropolitan Museum of Art, May 8, 1959.
Photograph by Yale Joel, LIFE

Cornell Capa

"Is photography an art?" Today the question is a chestnut. Today photographs are exhibited worldwide in museums, sold in art galleries, collected by curators and private connoisseurs, studied by scholars, and reproduced in the highest-quality art books—like etchings, lithographs, or other kinds of prints. We established the International Center of Photography on Fifth Avenue, on New York's Museum Mile, to proclaim our view of photography's equality with the other arts. But photography did not always enjoy such standing.

New York's Museum of Modern Art was remarkable in establishing a separate department of photography in 1940, directed first by Beaumont Newhall and then by Edward Steichen. Here photography was on an equal footing with the other modern arts. In 1955 Steichen's "Family of Man" exhibition broke all attendance records at the museum and was seen by millions on its later international tour. ICP was founded in 1974, a significant date for photography's acceptance in art circles. That year saw a special issue of *Newsweek* devoted to photography, and about the same time Sotheby's started promoting specialized photography sales. What had happened to the perception of photography during the twenty years between "The Family of Man" and the birth of ICP?

Of course there were many things. But one project—which was highly controversial during the sixties and subsequently slipped into obscurity—may have played an important role in raising popular consciousness of camera art.

In 1959 the photographer Ivan Dmitri, supported most significantly by the *Saturday Review*, began what would become a series of six large-scale group exhibitions of photography by contemporary practitioners. The prints were selected by juries of American museum curators and exhibited in museums of national standing: the project was called, suitably enough, "Photography in the Fine Arts." The "best" of the first four PFA exhibits became the display in the Eastman Kodak Pavilion at the New York World's Fair of 1965; the last PFA show took place in 1967. All told, PFA's six traveling exhibitions gave photography unprecedented national exposure. The project might have continued if Dmitri had not died in 1968. He could not be replaced.

In 1981 Dmitri's papers and over 700 photographs from the PFA exhibitions were donated to the Archives and Permanent Collection of ICP. ICP's Fourteenth Gala Exhibition and this book—both generously supported by the Professional Photography Division of Eastman Kodak Company—present the choicest prints from this remarkable gift. They were selected by Miles Barth, Curator of the Permanent Collection: from the vantage point of the eighties, they are works that we think have stood the test of time.

This unique gathering of fine black-and-white and Dye Transfer prints lets us appraise PFA, its effects, and the taste of its participating museum curators for the first time. The essays we have commissioned for this book offer additional perspectives on the project and the still-lively issues it raised.

The Pulitzer Prize-winning author Norman Cousins recalls his role in the inception of PFA, when he was editor of the *Saturday Review.* Dr. Evan Turner, Director of the Cleveland Museum, writes of his experience as a juror and reflects on the selection process for PFA exhibitions. Miles Barth, curator of the exhibition, details Dmitri's colorful life and the history of PFA. The noted educator Nathan Lyons evaluates the controversy roused by PFA among certain museum professionals and photographers. The photography historian Dr. Naomi Rosenblum traces the history of critical acceptance of photography as a fine art, in order to situate PFA in its time and place. The photographs are organized into three sections—"Illustrative," "Documentary," and "Expressive"—reflecting how they were generally perceived during the sixties and their sources for PFA. Dmitri solicited the photographs from organizations such as the American Society of Magazine Photographers (ASMP), photo and advertising agencies, magazines such as *Look*, LIFE, *Harper's, Vogue*, etc., and leading practitioners and educators. The section introductions are by Anne Hoy, who served as text editor of the book.

It is hard to say what contributed most to photography's high popular evaluation today. There is continuing government support, from Roy Stryker's FSA project of 1935-43 to current funding for photography by the National Endowment for the Arts and State Councils on the Arts. In the last fifteen years corporations have come forward to underwrite photography exhibitions and institutional activities. There are mass-market magazines and high-quality books, from LIFE, *National Geographic* and *American Photographer* to the growing photography lists of Aperture, New York Graphic Society, Abrams, Abbeville, and other art publishers. There are technical advances—as in color film, printing paper, and instant technology—that have opened new professional avenues while bringing more amateurs to photography. There is avid collecting, with galleries and auctions devoted solely to photography; and energetic growth in photography education, in numbers of MFA's and Ph.D.'s granted, in university art departments offering courses, in nationally known workshops and festivals.

Certainly, Dmitri and PFA deserve to be included in all this. We salute them for their contribution to the public appreciation of photography. We offer this book and exhibition as opportunities to appraise their stimulating role in photography's history.

Cornell Capa
Director
International Center of Photography

Norman Cousins

THE SATURDAY REVIEW AND 'PHOTOGRAPHY IN THE FINE ARTS'

It is commonplace today to regard photography as one of the fine arts. Almost all the leading art museums now find a significant place for the works of outstanding photographers. Yet only thirty years ago, the attempt to give photographs the status accorded to paintings ran into considerable opposition. The obvious arguments were heard: anyone could activate the shutter of a camera. The camera itself performed whatever artistry was represented in a picture, providing instant capture of whatever striking scene presented itself. The film supplied the color combinations, and what the film failed to do in this respect, the printing shop was able to offer. All sorts of mechanical leeway were available to camera operators.

Such, at least, were the arguments used to block the inclusion of great photographs in some of the nation's art centers.

It was in 1959 that Ivan Dmitri, then regarded as an important portrait and color photographer, approached the *Saturday Review* with a proposal to advance the cause of fine photography. The *Saturday Review* would publish photographs chosen by a committee of distinguished judges. A number of museums would exhibit them as an integral part of the project, which would be an annual affair. Dmitri's proposal was enthusiastically accepted.

PHOTOGRAPHY
IN THE FINE ARTS

*An Exhibition of
Great Contemporary Photographs*

THE METROPOLITAN MUSEUM OF ART
May 8th ... September 7th, 1959

Cover of first PFA catalogue, a reprint of the *Saturday Review* issue of May 16, 1959.

The prime mover of the project at the *Saturday Review* was J.R. Cominsky, publisher of the magazine. Jack had a keen editorial eye and recognized the value to the *Saturday Review* of a feature that would have a great deal of visual appeal. Jack had been approached by Dmitri, an old-time friend, who wanted the *Saturday Review* to be the point of contact with the public for what Dmitri called "Photography in the Fine Arts." I was then Editor-in-Chief. Jack brought Ivan into my office. I have a very vivid recollection of Ivan opening his large portfolio of photographs by various contemporaries and describing his belief that the time had come for photography to take its place on the walls of the world's great art galleries.

My own interest in photography went back some years earlier. I had been fascinated by the way the camera could be an extension of the photographer's imagination. The way one looks at an object can be as individual as one's fingerprints. The way we observe the bark of a tree, for instance, can determine whether the bark will reveal its secrets, spreading before us exotic designs, or whether it will be merely part of a heavy, solid, round object. No artist with multiple colors or dozens of paint brushes with varied thicknesses has as much to work with as a photographer with a camera in which lighting and depth of field can be controlled.

My awareness of these possibilities was profoundly nourished by the photographs that Ivan presented to us then and later. As an editor, I could also recognize the appeal for the reader of photography as a fine art. Thus it was that fourteen men and women who were prominent in the fine arts came together in Dmitri's New York studio to examine several hundred photographs from which the selection was to be made. I was especially pleased that Ivan had initially been able to engage the interest of Edward Steichen of the Museum of Modern Art, who had encouraged me in my own photography. Among others he had enlisted as jurors were James Rorimer, Director of the

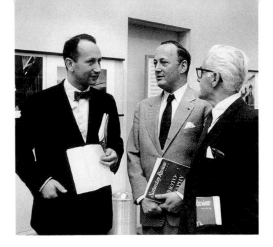

(left to right) Norman Cousins, Editor, *Saturday Review*; James Rorimer, Director, Metropolitan Museum of Art; and Bruce Downes, Editor and Publisher, *Popular Photography*, at the press preview of the first PFA exhibition. Photograph by Lew Merrim

Metropolitan Museum of Art; Beaumont Newhall, Director of the International Museum of Photography at the George Eastman House; and Aline Saarinen of the *New York Times*. Jack Cominsky stretched our printing budget to the extent necessary to provide for the cost of extra-fine paper stock and color plates, a special feature.

The *Saturday Review* of May 16, 1959 was a special issue intended "to serve the cause of photography as a fine art," in the words of the editorial. It explained:

> In the past twenty years, the editors have become increasingly aware of the place earned by photography in national culture. This is manifested not only by the millions of Americans who have taken a strong participative interest in photography but by the increasing number of books dealing with creative photography.
>
> The central feature of this issue is a special selection of photographs in color and in black-and-white, chosen by a panel of distinguished art authorities. The editors and judges emphasize that they do not offer these photographs as the "greatest" taken in this country or elsewhere. It is obviously impossible to set up any selection machinery procedures that could competently serve that purpose. What the judges have done is to choose a number of outstanding photographs from among a wide range of nominations as examples of fine art.
>
> The filtering process was elaborate but not cumbersome. Magazines like LIFE, *Look, The Saturday Evening Post,* and *Holiday* went through hundreds of thousands of photographs for the preliminary selections. New York's Museum of Modern Art, the picture library at Columbia University, advertising agencies, industrial picture libraries, and comparable sources also submitted photographs from their own wide collections. . . .

Twenty-one of the eighty-five photographs selected by the judges were reproduced in that issue of the *Saturday Review*. All eighty-five were exhibited at the Metropolitan Museum of Art in the first showing of PFA. It ran for four months and attracted widespread public attention. Its success led to showings throughout the country, from Long Island to San Diego and back.

When PFA came to Richmond, Virginia, the Virginia Museum of Fine Arts juxtaposed the photographs with paintings and drawings in order to demonstrate the similarity of values in both. Rembrandt's *Bearded Old Man* was shown next to Richard Avedon's *Ezra Pound.* John Singer Sargent's *The Sketchers* was hung alongside Irving Penn's *Two in a Canoe.* At this exhibition, the public was asked for its views as to whether photography deserved to be recognized as a fine art. Of the 599 museum-goers who responded, 549 ballots were in the affirmative.

The editor of the *Saturday Review* for thirty-five years, Norman Cousins is the author of twenty books, including *Anatomy of an Illness, The Healing Heart, Human Options,* and, most recently, *Pathology of Power* and *The Human Adventure*, a book of his photography. He teaches in the School of Medicine at the University of California, Los Angeles, and has received many humanitarian and literary awards and honorary degrees.

Other museums involved in the nationwide tour of PFA reported similar public interest. It was apparent that Ivan Dmitri's conviction that photography was an important art form was being justified by the response, both critical and public, to the project. To be sure, some early criticism persisted. It was said that the general idea was pretentious and presumptuous; that selections were arbitrary; that even a distinguished jury was not enough to ensure a proper selection, etc. But the extraordinary quality of the photographs carried the day, and PFA became a regular event. Between 1959 and 1967 it launched a total of six major exhibitions of photography that circulated throughout the United States, and were seen by an estimated eight million viewers.

Evan H. Turner

IVAN DMITRI'S DREAM: A JUROR'S VIEW OF PFA

In 1958 a survey of museums made by the *Saturday Review* reached the curious conclusion: "Most museum acquisitions are made through specialized dealers, which constitutes a first screening of works of art for quality, rarity, condition, and the other factors that make for desirability." Building on this, the photographer Ivan Dmitri observed: ". . . With photography, a relatively new medium of the arts, such a screening process suitable to museums had not yet been developed."

Indeed, the resources for museums acquiring fine photographs were all too few at the end of the 1950's. That this should be true was proof of Dmitri's contention: aside from very few institutions—most notably the Museum of Modern Art in New York and the International Museum of Photography at the George Eastman House in Rochester—the American museum world had little interest in, much less commitment to, photography. There was, therefore, a need for challenge and Dmitri recognized that need. Thus he decided to launch "Photography in the Fine Arts" (PFA).

The first PFA exhibition opened on May 8, 1959, at the Metropolitan Museum of Art in New York. From the beginning, Dmitri never swerved in his pursuit of two compelling goals. As he put it: "Photography in the Fine Arts is . . . designed to advance the acceptance of photography as a fine art and of its practitioners as artists."

As part of his great idea, Dmitri shrewdly recognized that his primary vehicle for success must be not only the well-established art museums on the East Coast but also the many others scattered throughout the United States. The pursuit of these goals would draw upon every ounce of the energy, amiability, and persuasive force that typified Ivan Dmitri.

Partial view of installation of PFA at Eastman Kodak Pavilion at New York World's Fair, 1965.

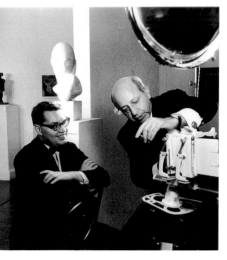

Evan Turner sitting for his portrait by Karsh, Philadelphia Museum of Art, 1964–65. The portrait was eventually used in the Museum Directors' Selections for the New York World's Fair. Photograph by Ivan Dmitri

Between 1959 and 1967, six Photography in the Fine Arts exhibitions toured throughout the United States, circulating simultaneously in two or three editions. Possibly the most interesting PFA exhibition became the major attraction of the Kodak Pavilion at the New York World's Fair of 1965. Focal to the achievement of PFA's goal, each exhibition was juried by a group of museum directors, curators, and other art authorities. They made their selection, however, from a much larger group of photographs that had been, as Dmitri put it, "first qualified by photographic authorities." That preliminary screening group was never as clearly defined as the jurors were, but its makeup can probably be deduced from the list of PFA's National Consultants of 1961: it included the board chairman of the National Press Photographers Association, the president of the American Society of Magazine Photographers, the president of the Photographic Society of America, the executive manager of the Professional Photographers of America, and the president of the George Eastman House.

PFA's exhibitions toured widely and had an impressive exposure. At the end of the first three years—the most energetic and the most successful ones in PFA's history—Dmitri justly bragged that some three and a half million people had seen the exhibitions in more than forty museums and that an equal number of viewers were anticipated in another forty-eight bookings. As is discussed in another essay in this book, the *Saturday Review* became his staunch ally in introducing the greater American public to the concept of photography as an important form of esthetic expression. That magazine broke with its long-standing austere format and published glossy reproductions of many of the images exhibited. Thus hundreds of thousands of people who might never visit one of the museum shows enjoyed the choices made by the museum professionals.

By the time the final edition of the Photography in the Fine Arts exhibitions opened in 1967, 794 photographs by 413 photographers had been chosen, circulated, and published (see Appendix B). Some of them had been acquired by the exhibiting museums, most notably by the Metropolitan Museum of Art. The PFA series had responded to a genuine lack. But was it the best possible answer?

First it needs to be said that the undertaking had two fundamental weaknesses: each exhibition could be no more distinguished than the material submitted for selection, and the selection could be no more perceptive than its jurors.

Since I was living out of the country, I became a juror only at the time of the World's Fair display, and thus I know all too little about the functioning of the screening committee, which chose the material to be judged by the museum professionals. Clearly, much commercial and journalistic material was included—hardly a surprise given the makeup of the clearing committee. Many distinguished photographers working at that time were only passingly included; some, not at all. That Edward Weston died the year before the first exhibition may be one reason that explains his omission from PFA I of 1959, but a great photographer such as Paul Strand was never represented. There were very few foreigners; the most notable one included was Henri Cartier-Bresson. In contrast, great numbers of names were included that are scarcely remembered today, unless possibly by one image that has caught the public fancy, but certainly by no significant body of work.

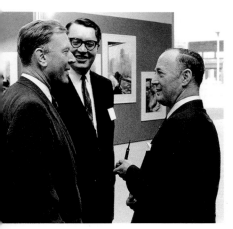

Bartlett H. Hayes, Jr., Director, Addison Gallery of American Art, Andover; Evan Turner, Director, Philadelphia Museum of Art (center); and James Rorimer, Director of the Metropolitan Museum of Art, at the opening of the Museum Directors' Selections for the 1965 New York World's Fair Exhibition, May 20, 1965.

In studying each exhibition as a whole, one would have all too little sense of the great issues and concerns confronting the then major masters of photography. Rather than the timeless image, most of the material was highly editorial and frequently quite subjective, with a strong leaning toward portraiture and souvenirs of travel. The charming and the picturesque—even, alas, the cute—crept in rather too often. And yet, when one thinks of the many popular photographic magazines of the 1960's—glossy in format, presenting what might commonly be called "art photography" as opposed to the journalistic material of LIFE and *Look*—one realizes what a significant forward step that "Photography in the Fine Arts" represented.

And then the jurors: Ivan Dmitri chose his museum professionals well. Most notably in the World's Fair exhibition, but for each exhibition he successfully persuaded the nation's leading museum directors and other authorities to participate in selecting exhibitions from PFA's medley of images. The actual judging was a lively affair, each person choosing his favorite images from prints with no identification as to artist. And given the jurors' lack of in-depth knowledge in this area, I would suspect that most of the images were truly unknown. In five of the exhibitions, there was no sense of an individual's taste; a group chose the material to be shown. In the World's Fair show, ultimately the most ambitious one, each director made his own selection of twelve to sixteen prints from the 533 images that had been in the previous four exhibitions; each group was then exhibited with Yousuf Karsh's photograph of the director who had chosen it. Those portraits showing each director surrounded by favorite art works hanging in his own museum subtly made the point that the selected photographs were fit company for such material.

In the World's Fair exhibition of 1965, there is no question that the directors chosen as jurors were indeed responsible in the aggregate for the choice of the greater part of the artworks then acquired each year by American museums. And on their own turf, working with their curatorial colleagues, they were immensely successful in carrying out their responsibility. Nonetheless, I am not sure that Dmitri was correct in observing in the Fair's press release: "A study of the photographs each man has selected reveals a common denominator to his philosophy of art." Certainly, each selection may have told one much about the individual's personal delights and interests. But speaking broadly, as a group, in the area of photography, the jurors lacked a considerable degree of sophistication, that is, informed perceptions of the issues facing the photographer and of the various possible methods of solution, which are expected of a trained curator today. Naïvely, perhaps, in the same release Dmitri went on to say, "Here are the ideas and the credos that guide the museum director who acquires, presents, protects for us art of and for the ages. . . ."

It is no wonder then that the photography establishment quickly came to view "Photography in the Fine Arts" with sentiments ranging from condescension to absolute dismissal, expressing its feelings in no uncertain terms. Dmitri's venture may have been virtually worthless from their viewpoint, given their own eager—and not dissimilar—efforts to achieve for photography the attention that this original art form deserved. Yet curiously, when it came to furthering their declared goals, the contribution of PFA cannot be lightly dismissed, as we have seen since then.

Assuming that, in the aggregate, the museum professionals did choose as intelligently as possible from the material offered for judgment, then the number of examples of each photographer's work shown in the six exhibitions tells one much about the material gathered for their consideration.

No one was chosen more often than Yousuf Karsh, twelve times in all, in addition to the eleven commissioned portraits of the directors. Without question, some of his most famous images were exhibited; they were often-repeated well-known faces. With eleven prints, Hans Landshoff came next; his photographs of Manhattan drew upon everyone's experience. Next in number was Irving Penn, with nine images, including two of the portraits for which he is best known today. Right away, one discovers an obvious truth about these exhibitions: the juries particularly favored portraits. But the work assembled for their consideration consistently represented impressive portrait photographers. In the six PFA exhibitions, there were eight works each by Richard Avedon, Cartier-Bresson, and Ernst Haas, and seven each by Dmitri Kessel and John Vachon. In addition, four more photographers who are greatly respected today were represented by six works each: namely Wynn Bullock, Andreas Feininger, George Silk, and Brett Weston.

Then, at the other end of the spectrum, the work of 335 photographers was illustrated by one or two prints only, which is ample proof of the wide-ranging inclusiveness of the camera work chosen. As has been observed, most of these photographers are scarcely known today, although among them are some well-known names: for example, Margaret Bourke-White, Harry Callahan, Imogen Cunningham, Robert Frank, Dorothea Lange, Inge Morath, John Szarkowski, and Minor White. That such artists are found primarily in the first or second exhibitions—and not later—is telling proof that the commitment to PFA of the avowed leaders in the field quickly waned.

Considering such statistics, one realizes more firmly that the great weakness of the whole venture was the relatively permissive attitude in assembling the material for the jurors. One senses the influence of agents, for example, and one suspects that Ivan Dmitri must have played some politics at times. His enthusiasm—or that of his advisors—may have nurtured too great a tolerance. Understanding the selection process becomes the key to assessing the whole venture. It is, therefore, important that finally the PFA archives enter the public domain. Now at last the politics and energies of the venture as a whole can be analyzed. And such information is desirable because there is no question that PFA was an admirable dream, one that deserves just consideration.

Director of the Cleveland Museum of Art since 1983, Dr. Evan Turner was director of the Philadelphia Museum of Art from 1964 to 1977; director of the Montreal Museum of Fine Arts from 1959 to 1964; and curator and assistant director of the Wadsworth Atheneum from 1955 to 1959. He is vice-president of the American Federation of Arts, and was president of the Association of Art Museum Directors.

Dmitri ended his report of 1961 with the hope "that eventually every museum in the country will include photography in its program of exhibiting, collecting, and preserving great art." I suspect that no one—least of all Ivan—had any idea then what extraordinary strides would in fact be made toward achieving that goal in the next quarter-century. There is no museum of any stature in this country today that does not have a firm commitment to photography's just place among humanity's achievements in the visual arts. Simultaneously, there is equally no doubt that photography has an enthusiastic and widespread audience. Without question, the activities of "Photography in the Fine Arts" played a very real role in nurturing that audience.

Miles Barth

IVAN DMITRI AND THE HISTORY OF PFA

The first of six exhibitions organized by the "Photography in the Fine Arts" (PFA) project opened to the public on May 8, 1959 at the Metropolitan Museum of Art in New York City. It remained on view for three months, until September 7, and enjoyed a reported attendance of just over 500,000.[1]

The PFA project, like many organizations, had a history that was intertwined with its creator; PFA's was Ivan Dmitri. One year before the opening of the first PFA exhibition, the August 2, 1958 issue of the *Saturday Review* published several of his observations on photography, including his conviction that it should be collected and exhibited by the leading museums in the same manner that they collected and exhibited fine paintings, prints, and sculpture.

Within a week of the article's publication, William Patterson, Associate Publisher of the *Saturday Review*, sent copies of it along with a cover letter to twenty museum directors and other leading authorities on art, soliciting their opinions of Dmitri's thesis. Who was Ivan Dmitri? Why would the *Saturday Review* have published his ideas and gone further in inviting the responses of art experts to them?

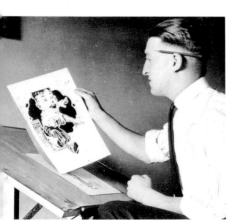

Levon West, illustrator and cartoonist, Minneapolis, 1923.

Ivan Dmitri was born Levon Fairchild West on February 3, 1900, in Centerville, South Dakota. His father was a Congregational minister, and in his early years Levon West moved often, as his father was transferred to various parishes in South Dakota. His mother was a descendant of the early American painter, Benjamin West.

After graduating from high school, Levon West took a job as a teacher in a one-room school. A year later he entered the Navy and served in the Great Lakes region until the Armistice. He held various jobs in his early life, mostly as a sign painter and draftsman. In 1919 he received a four-year scholarship to the University of Minnesota to study economics. The choice of specialty was made by his father, but West was determined to continue his studies of art.

To help cover his expenses, he took various jobs as an illustrator. He received several commissions from *True Confessions*, the Fawcett publication, and from the *Minneapolis Tribune*.[2] While still at the university, he contributed numerous drawings to the school paper, the *Minnesota Daily*, and was eventually made art director of the publication. After graduation, he took a small studio in Minneapolis where he continued illustrating for various advertising agencies and publications.[3] Around 1923 West bought a series of books entitled *Modern Masters of Etching*.[4] They were a revelation to him.

In 1924, while en route to Boston where he was to enroll in the Harvard Business School, he made a detour to New York. Inspired by the works presented in the series of etching books, he remained in New York where he enrolled in the Art Students' League. West's ideal was the work of Joseph Pennell who was one of the featured artists in the *Modern Masters of Etching* series and was teaching at the Art Students' League. West enrolled and soon became one of Pennell's best students; he was urged to continue his etching.

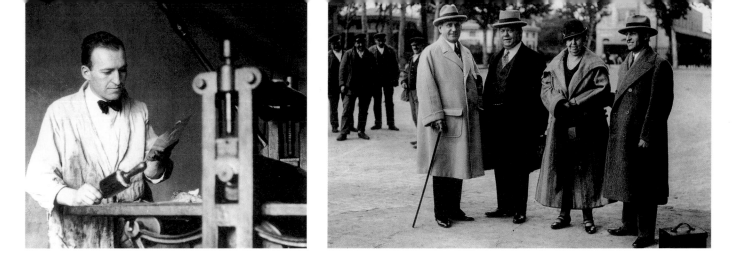

Levon West at his etching press, New York, 1925–27. Photograph courtesy of the Archives of American Art, Washington, D.C.

Levon West (far right) in Madrid, 1925.

Encouraged by Pennell, West traveled to Spain in 1925 to study with the painter and printmaker Ignacio Zuloaga. During his six months in Europe, he produced about fifty etchings.[5] Short of funds, he had to return to New York, where he took a job as art director for a land development company about to build a large complex in San Sebastian, Florida. In Florida, West worked with the architects in finishing drawings, and documented the progress of construction by taking photographs, becoming familiar with the camera's capabilities. After the company went bankrupt, West again returned to New York to continue his career as an etcher. By this time some of his etchings had been exhibited in various galleries and small museums. In 1929 Kennedy & Co. (now The Kennedy Galleries) gave him a one-man exhibition and began representing his etchings and watercolors. He continued to photograph, but primarily to document his artwork and to make travel pictures as souvenirs.

By 1934, in the midst of the Depression, West found his etchings and other works not selling well enough to make an adequate living, so he began to take assignments as a commercial photographer. He began calling himself a photographer in the hope that this change of profession might bring a new source of income in what he believed was a creative field.

Sometime in 1934, the transmogrification of West into Dmitri took place. There are several stories told regarding how and why this change of names occurred; one version by Dmitri appears in the May 29, 1937, issue of *The Saturday Evening Post*:[6]

> So I went into photography. It was tough, I must admit, for I thought at that time that art must be useless and that commercial photography was outside the pale. I took a strange-sounding Russian name, pledged my friends to secrecy, gritted my teeth and went to work. Strangely enough, in spite of my dislike for my new work, other people seemed to like it. At first I thought this was due to their bad taste. And then gradually I started to enjoy it myself—that is, I enjoyed the strangeness of it.

In the spring of 1935, a friend of Dmitri's at the Eastman Kodak Company introduced him to Leopold Godowsky, who was at work with Leopold Mannes on the development of Kodachrome film.[7] Dmitri persuaded Godowsky to allow him to field-test the 35mm format of this early color film. By the late fall of that same year, Dmitri had established himself as a leading "color" photographer, publishing many

Dmitri was one of the first to use oversized black-and-white enlargements for advertising displays. Shown here at left and center are two of his photographs in DuPont's display in a trade exposition at Atlantic City, 1936.

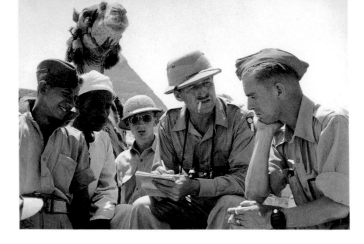

Ivan Dmitri, war correspondent for US
Army Air Force Transport Command,
Northern Africa, 1943–44.

articles and books on how to use color film, how to compose, and how to operate the 35mm or "candid" camera.[8] As a result of working with color film almost exclusively, he received an increasing number of assignments from both magazines and advertising agencies. His association with *The Saturday Evening Post* began in 1937, and would last for the next twenty-four years while he operated his own commercial studio. Besides producing an enormous amount of work during this period, he became a regular contributor of photographs to many exhibitions and publications dealing with photography as an art.[9]

During World War II Dmitri was assigned to the Army Air Force Transport Command in North Africa and worked as a war correspondent for *The Saturday Evening Post*.[10] At the end of the War, he returned to New York, resuming commercial photography.

For several years, during the late 1940's and early 1950's, Dmitri enjoyed a successful career, receiving assignments from the leading publications and advertising agencies. He was a regular contributor of photographs and text to *The Saturday Evening Post* series, "Face of America." His commercial clients included General Electric, Trans World Airways, and many other corporations involved in industry and transportation.

By the mid-1950's, however, Dmitri's fortunes began to wane. The Kennedy Galleries informed him that owing to slow sales, they wished to return their inventory of his etchings and watercolors. There was a decreasing market for his subject matter, they explained, and it would be better for him to find a different venue.

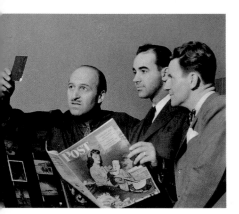

Ivan Dmitri reviewing transparencies for
The Saturday Evening Post, ca. 1951.

During this same period, Dmitri was receiving fewer assignments from the publications and advertising agencies with which he had been associated. He submitted numerous ideas to *The Saturday Evening Post*, but the magazine was interested in using younger photographers and began to reject Dmitri's submissions with more frequency. Although Dmitri was still sought out as a lecturer on photography, his career as an active photographer was beginning to decline.

Over the years, Dmitri had made many friends in the photographic, advertising, and publishing fields. One of his closest at the *Saturday Review* (originally called the *Saturday Review of Literature*) was J.R. Cominsky, publisher of the magazine and a member of its editorial board since 1942. During the period of the late 1940's and early fifties, Dmitri was occasionally hired by the *Saturday Review* to produce portraits of writers featured in the magazine and to write reviews of newly published books on the technical and artistic sides of photography.

In 1952 the *Saturday Review* began its first annual World Travel Photo Contest, and Dmitri was asked to be one of its jurors.[11] When he learned that 16,281 photographs had been submitted, he was startled. Although he had been both a contributor to competitions and a judge of just as many, several problems became clear to him: the extraordinary number of camera enthusiasts and how few outlets there were for their creative work other than contests or occasional showings at camera clubs; how few public institutions were regularly exhibiting photographs and how fewer of these were acquiring photographs for their collections.

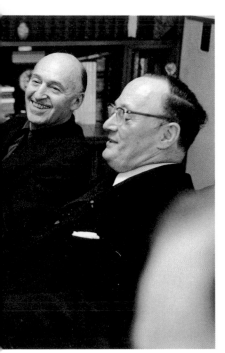

Ivan Dmitri and James Rorimer, Director of the Metropolitan Museum of Art, ca. 1958

Although Dmitri had written several essays expressing his views on art, creativity, and photography before, in 1954 he authored "The Creative Urge and Photography." The essay was never published in its original form but was incorporated into Dmitri's book review of the *U.S. Camera 1954* annual published in the *Saturday Review.* In its original form, the article was filled with comparisons between the established fine arts and photography. Dmitri suggested that Van Gogh's *Bedroom* could have been made with wide-angle vision, and portraits by Rembrandt could have been painted with a "telephoto" eye. Dmitri went further to offer his theory on what makes a "good" photograph, applying criteria from other fine arts. He wrote that, "a good picture is nothing more than good taste. It is good taste in the use of color or values, good taste in composition and design, arrangement of form, spontaneity, and so on ad infinitum. The aim of picturemakers should be to establish the sort of emotional experience that one enjoys when reading a good book or watching a great play—which is a sense of participation by reason of detachment and is not the experience of being 'sent.'" Apparently Dmitri was beginning to detach his own commercial photography from his ideas of what photography could and should be. His critical writings on photography became more copious.

In the summer of 1957 while Dmitri was spending time in East Hampton on Long Island, he was introduced to James Rorimer, Director of the Metropolitan Museum of Art. The two met several times and discussed Dmitri's ideas on art, but, more specifically, what American museums could do to elevate photography to a higher stature. Although Rorimer agreed with Dmitri and his ideas about expanding the museum's role in the acquisition and exhibition of photographs, he made it clear that there were many directors of museums and curators of print collections who did not share his enthusiasm. Dmitri's evolving ideas became more articulate as a result of his meetings with Rorimer. He concluded that if the prevailing popular attitude were going to change, there needed to be a new approach to photography and that he would be the one to initiate it.

Dmitri was certainly not the first person to take up this mission for photography, and he acknowledged the pioneering efforts made by Alfred Stieglitz, the importance of the Department of Photography at the Museum of Modern Art, and Edward Steichen's landmark exhibition of 1955, "The Family of Man." However, it was Dmitri's belief that there was still little being done to encourage photographers to consider their work as art and not simply illustration. If photography were indeed art, then who better to proclaim it so than art authorities and where better to show it than in museums?

Dmitri began to investigate how museum collections and exhibition programs were designed. Did the museums rely on their own staff to decide what photographs entered the few active collections of the late 1950's? Did they borrow photographs from other institutions or commercial sources or only show their own holdings? How many collections of photographs were there in this country and where were they located? Where and how was photography taught and did these programs lead to anything other than commercial careers? Without answers, he could not successfully further his case that this was the time for the elevation of photography

By the spring of 1958, Dmitri had obtained many of the responses he needed. They reaffirmed his sense of purpose. He approached his friend Jack Cominsky, the publisher of the *Saturday Review*, as well as William Patterson, the associate publisher, and Norman Cousins, the editor, with his findings and his conviction—that photography should be broadly accepted as a fine art. He explained that "the decisions pertinent to and methods of furthering photography as an art were in the hands of one small, tightly knit group determined to maintain their hold and standards at all costs, interested only in furthering the reputation of a few, rather than giving encouragement to the young and vital adherents of the new art."[12]

Patterson mentioned Dmitri's comments in the "Trade Winds" column of the August 2 issue of the *Saturday Review* and subsequently sent copies to a list of art authorities for their response. What Patterson sought was not only their comments but their support in a nationwide search for photographs that could be considered "true works of art" to be reproduced in a supplement of the *Saturday Review.*

Patterson did not have to wait long for responses to his query. Almost immediately, letters from the authorities began to be received, most with great optimism that the *Saturday Review's* objective could be met.[13]

Ivan Dmitri was named director of the project, "Photography in the Fine Arts." As it was originally conceived, the *Saturday Review* would publish a selection of photographs, assembled by Dmitri from as many sources as possible and chosen by a panel of recognized art authorities. Dmitri had always kept meticulous records and in a preliminary report to the editorial board of the *Review*, he listed the following as sources for his gathering of photographs: national magazines such as LIFE, *Look, The Saturday Evening Post, Holiday, Vogue,* and *National Geographic*; photo agencies such as Magnum, Black Star, Pix, and Rapho-Guillumette; The Pulitzer Prize Collection of Photographs at Columbia University, and industrial photo libraries. He also consulted the art directors of the advertising agencies J. Walter Thompson, McCann-Erickson, and N.W. Ayer.

Additionally, he conferred with the publishers of photography books, the heads of photography departments at many American schools, and the photo organizations, the Professional Photographers of America, the American Society of Magazine Photographers, the National Press Photographers Association, and the Photographic Society of America. He also requested submissions from many of the larger camera clubs across the country. Each source was asked for pictures that "communicated or evoked an idea, a mood, or emotion; pictures that were created with artistic integrity and with esthetic appeal." Some of the sources were more cooperative and generous than others.[14] Dmitri devised a system whereby many of the sources would screen the photographs representing their organization prior to sending the material to New York for final evaluation.

Initially Dmitri had planned only to reproduce the best works in the *Saturday Review*, but he soon saw their potential for exhibition. Believing that the final group of photographs selected would constitute an important collection, he described his ideas to his friends at the Eastman Kodak Company. He suggested that if the right location could be found under the right circumstances, and appropriate funding obtained, the *Saturday Review* photographs would make an exceptional exhibition. Kodak officials agreed, but added that they would not commit any support without further examination of his progress.

By mid-January of 1959, the call for submissions had produced 438 photographs (197 in color, 241 in black-and-white) for final selection. Now, as the *Saturday Review* and Dmitri had agreed, it was time to select their judges, a panel of recognized authorities in the field of art. Through the connections of the editorial board of the *Saturday Review* and Dmitri's acquaintance with James Rorimer of the Metropolitan, an advisory committee of fourteen men and women was convened (see Appendix A) with Dmitri acting as Executive Director (not a voting member of the group).

The committee met on the afternoon of January 23, 1959, to decide which photographs merited the status of inclusion in the forthcoming portfolio of the *Saturday Review*. It was decided that only those photographs receiving six or more votes would be selected. From the 438 nominations, 85 photographs were chosen (see Appendix B).

As was his habit, Dmitri was thorough about documenting events and situations. The session was photographed and tape-recorded. On the day after the judging, he issued "A Report of the Advisory Committee Meeting." On the first page of this report, he set forth the doctrine of PFA: "The chief aim of our project Photography in the Fine Arts is to further the interest of museums in forming and exhibiting permanent collections of fine pictures created through the medium of photography and thus raise the standards of creative photography." The report went on to describe how the project came about and the sponsorship of the *Saturday Review*. Citations of the sources of the photographs, the number of votes cast, and how the final decision was reached were included in this document. Dmitri mailed copies to each member of the jury, the editorial board at the *Saturday Review*, and the staff of the advertising department at the Eastman Kodak Company.

A. Hyatt Mayor, Curator of Prints, Metropolitan Museum of Art (left) and Joyce C. Hall, founder of Hallmark Cards, at the first meeting of the PFA Advisory Committee, January 23, 1959 (list of Advisory Committee on wall behind Mayor).

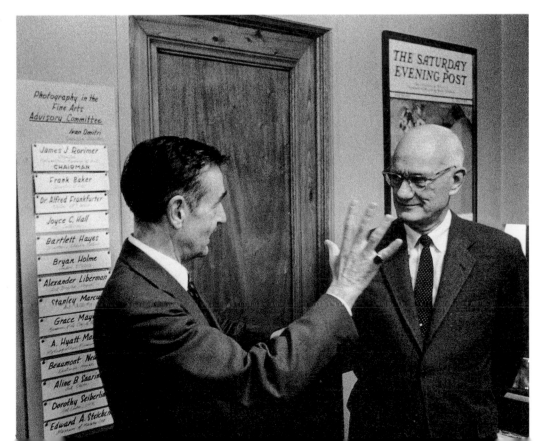

Shortly after the report was issued, Dmitri approached James Rorimer and A. Hyatt Mayor, curator of prints at the Metropolitan Museum, and explained that an exhibition of the jury-selected photographs would be one of the most important ever to take place. Dmitri observed that the Metropolitan had photographs as part of its print collection and that there was no better institution to give public exposure to this work. After lengthy discussions with the trustees of the museum, the Metropolitan agreed to host the first exhibition. Opening on May 8, it would take place in the reception area outside the auditorium, a space that the Metropolitan renamed "The Photograph Gallery."

Dmitri immediately began to prepare the photographs for the exhibition. He asked each of the photographers selected to send him exhibition-quality prints, and he obtained permission to have Dye Transfer prints made from all of the color entries. Eastman Kodak offered to make the separations and plates to print the pages for the *Saturday Review's* special issue, scheduled for May 16.

The exhibition opened as planned and was immediately hailed and condemned by the public, press, and photographic community. The small but vocal opposition assailed Dmitri, the exhibition, and the project on three major points. It claimed that other than Edward Steichen of the Museum of Modern Art and Beaumont Newhall, Director of George Eastman House, none of the jurors was qualified to pass judgment on photography. They also noted that many photographers who had established reputations and had shown previously in museums and galleries were never contacted because they were not members of any of the groups invited to submit photographs to the original jury or because they had never published in any of the magazines that contributed to the judging. Finally, their most serious charge, they asked how amateurs could be shown alongside many of the established photographers who were included.

Dmitri answered all of his detractors one by one. He was insistent, and in fact stubborn, in his belief that the exhibition was organized in the fairest and most appropriate method.

Edward Steichen, Director of the Photography Department, Museum of Modern Art, judging submissions for PFA I, January 23, 1959.

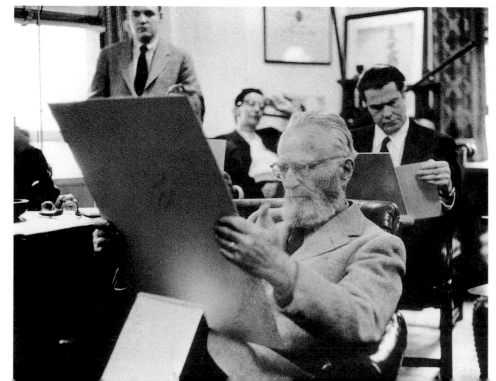

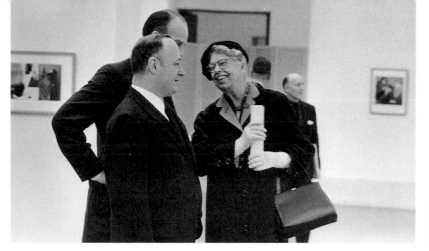

James Rorimer with Eleanor Roosevelt at the opening of PFA II, Metropolitan Museum of Art, May 20, 1960. Photograph by Lew Merrim

The popular success of the exhibition and the responses received by the *Saturday Review* were encouragement enough for the magazine to announce that "Photography in the Fine Arts" would become an annual event. In its first two years of touring the United States, the exhibition was viewed by more than two million visitors at twenty-six different museums and art galleries.[15] Dmitri believed that his efforts had begun to pay off and that photography was well on its way to becoming respected as a fine art.

Not missing a beat, Dmitri began to assemble photographs and solicit jurors for PFA II. It was his conviction that the enormous success of the first exhibition dictated the enlargement of the second. Through the *Saturday Review*, he began a national campaign to obtain photographs from as many sources as possible. He believed that the ideals of PFA were not limited to the boundaries of America but should be universal. To this end, he asked the Royal Photographic Society in England, the Photographers Union of Russia, and the Photographic Society of Japan to send photographs by their members that would fit the criteria established by PFA I. The group of photographs submitted to the PFA II Advisory Committee for evaluation numbered 800, from which the committee made a final selection of 176 for the exhibition, more than double the number chosen for the first exhibit.

Three identical versions of PFA II were produced for travel throughout the U.S. and Europe. The exhibitions were circulated under the auspices of the American Federation of Arts, ca. 1961.

Dmitri continued to capitalize on the successes the PFA exhibitions were having at museums and art galleries throughout the country. Beginning in 1960, the exhibitions traveled under the auspices of the American Federation of the Arts, which placed them in some major institutions as well as many small regional museums and university art galleries (see Appendix C). To accomplish one of his original goals—to have these exhibitions seen by as many people as possible—Dmitri was one of the first photography organizers to make duplicate and triplicate sets of each show. In this way, any PFA exhibition could be seen in two or three cities simultaneously, and versions of it could travel abroad while an identical set toured the United States.

It had been one of Dmitri's early goals to stimulate sales of photographs through their exhibition and circulation in the PFA project. One of his many reports was a document of 1963 titled "The Policies and Program of Photography in the Fine Arts," which listed the six elaborated points of the PFA program. The last of these states that one purpose of PFA was:

> . . . to establish a Photography in the Fine Arts Sales Gallery, an exemplar which, it is hoped, will set a standard for others to follow; a gallery where great photographs covering a broad range of viewpoints and techniques, and selected without partisan prejudice, will be constantly on view in rotation; a place where the photographer may receive the concrete criticism and appreciation from his peers; where the public will be welcome to view and purchase photographs from a staff trained in aesthetics and able to explain and instruct.

Although PFA never established a gallery, many photographs were purchased from the exhibitions, and some of the photographers obtained commercial assignments as a result of the display of their work.

Dmitri continued to organize PFA exhibitions and promote its ideas. By 1963, four exhibitions had been prepared, and, with the exception of PFA III, all had their premiere at the Metropolitan Museum. When the announcement was made that Eastman Kodak was going to build a

pavilion at the New York World's Fair, Dmitri proposed that a special panel of museum directors should make a selection of their favorite photographs from the preceding four PFA exhibitions and have them exhibited as "The Museum Directors' Selection for the New York World's Fair" in the Kodak building. Kodak agreed to Dmitri's proposal, in light of its current support of the PFA program and its earlier decision to have rotating exhibitions throughout the length of the Fair. The PFA exhibition opened on May 20, 1965.

During 1966, work on the next installment of the PFA series began. PFA V opened at the Metropolitan Museum on March 14, 1967, but it would be the last in the series. By the time the fifth exhibition opened, estimated attendance for the previous showings of PFA exhibitions was 6,500,000 visitors at 150 different museums and university art galleries in the United States and abroad.

On April 25, 1968, Dmitri died, leaving no successor to the project. From the outset of PFA, he had handled every aspect of the exhibitions, including preparation, administration of the program, and production work for each catalogue. In the May 18, 1968, issue of the *Saturday Review*, Margaret R. Weiss wrote, "No facet of PFA escaped his keen sense of merchandising and sales promotion or his instinctive flair for showmanship." His staff was small—one full-time secretary and a full-time assistant. By today's standards, it is hard to comprehend how one man, with limited means, could maintain so ambitious a program.

For several months, Dmitri's wife, Louise West, searched for someone to continue the work initiated and directed by her late husband. After several months she reached the conclusion that there was no suitable candidate for the position. Without a replacement for Dmitri, PFA could not continue. There seemed to be little interest or encouragement from any other sources in pursuing the continuation of PFA.

The tour of PFA exhibitions concluded. Louise West died in 1970, and E. Nobles Lowe, a friend of Dmitri and legal counsel to PFA, began to search for an appropriate home for the materials contained in Dmitri's estate. Finally Joseph Noble, Director of the Museum of the City of New York, suggested that the entire collection be donated to the Archives of American Art, a bureau of the Smithsonian Institution with an active program of collecting the papers of American artists.

The Archives accepted the material and began to inventory it, but soon realized that the majority of the items acquired did not reflect the life and work of Levon West, the etcher and illustrator, but the history of Ivan Dmitri and PFA.

Early in 1981 the Archives determined that the collection would be more appropriately housed at another institution. E. Nobles Lowe contacted the International Center of Photography and in April of 1981 all of the correspondence of Ivan Dmitri, the papers of PFA, and the print collection were transferred.

This book and accompanying exhibition present only a selection of work originally exhibited by PFA. It is not the intention of ICP to revive the work or methodology of PFA, but to present it in historical retrospect.

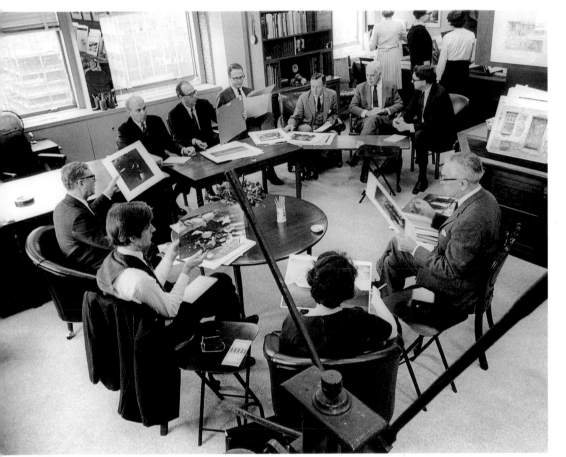

Final meeting of the PFA Advisory
Committee, November, 1966. Photograph
by Werner Wolfe

1. Figures for attendance are cited from
 the *Saturday Review*, May 28, 1960,
 40.

2. Dmitri (at this time still known as
 Levon West) did his first commercial
 assignment as a photographer in
 1934, but in June of 1925 he was
 commissioned to take photographs of
 a storm for the *Minneapolis Tribune*.

3. The subject matter of West's illustra-
 tions included scenic landscapes of
 the Midwest and Prairie states and
 portraits of life in rural America.

4. This series of books on masters of
 etching was published by The Studio,
 Ltd. London. Issue No. 24 of the
 series (1930) featured the work of
 Levon West with an introduction by
 Malcolm C. Salaman.

5. Several etchings he made while in
 Spain illustrated the book, *Vivid Spain*,
 by J.M. Chapple, Boston, Chapple
 Publishing Company, Limited, 1926.

6. The cover of this issue of *The Satur-
 day Evening Post* reproduced a photo-
 graph by Dmitri of a driver in a racing
 car, the first color photograph ever
 used on its cover.

7. Kodachrome film was first introduced
 in 1935, but only in formats for
 motion-picture cameras. Godowsky
 and Leopold Mannes continued to
 improve the Kodachrome chemistry,
 which became commercially available
 in the 35mm format during the fall of
 1936.

8. Books by Ivan Dmitri include: *How to
 Use Your Candid Camera*, New York:
 The Studio Publications, Inc., 1936;
 Composition in Photography, New
 York: Simon and Schuster, 1937; *Color
 In Photography* (Little Technical Library
 Series), Chicago, New York: Ziff-Davis,
 1939, and *Kodachrome and How to
 Use It*, New York: Simon and
 Schuster, 1940.

9. In 1934 Willard D. Morgan invited
 Dmitri to enter the Second Interna-
 tional Leica Exhibit. The latter submit-
 ted several boards showing how his
 photographs could be used to tell a
 story, and also entered what many
 called the largest black-and-white en-
 largement ever made from a 35mm
 negative, a print measuring 6'8" high
 by 10' long. The December 7, 1935
 issue of *Newsweek* called it "one of
 the most amazing feats of candid
 camera history." As a result Dmitri
 was asked to be a participant on the
 WNEW radio broadcast, "Camera In-
 terviews." His comments made during
 this broadcast were to be prophetic of
 the ideas he expounded on behalf of

PFA. "Being an artist I have many
times served on art juries for fine
painting and etching exhibits. Allow-
ing for certain limitations a good
photograph may be judged in the
manner similar with the fine arts. . . .
Just as the tight, detailed manner of
painting in the nineties has been
replaced with the free, spontaneous
style of our best modern painting . . .
so the movement in photography must
of a certainty break away from the
tight, stifled manner in which most
present-day photographers work."

10. A selection of his photographs, docu-
 menting the activities of the Army Air
 Force Transport Command, was pub-
 lished in *Flight to Everywhere, Photo-
 graphs by Ivan Dmitri*, New York,
 London: Wittlesey House, McGraw-
 Hill, 1944.

11. Dmitri continued to be a juror for this
 contest until 1968.

12. Quoted from a letter from Dmitri to
 J.R. "Jack" Cominsky, May 1, 1958.

13. Even prior to the opening of the first
 PFA exhibition, some objections were
 beginning to be raised. In a letter to
 the editor of the *Saturday Review*,
 dated April 27, 1959, Minor White
 asked the question of Norman Cous-
 ins, "does our [*Saturday Review*] pho-
 tography project represent a 'sincere
 promotion and furthering of photogra-
 phy as communication and evocation'
 or is it the result of 'clever engineer-
 ing of assent?' " Part of Cousins'
 answer began, "Without attempting to
 claim any special virtue, I confess that
 I have been personally interested in
 photography for many years. I am an
 amateur photographer and I have been
 seeking for a long time to find some
 way for the magazine to develop an
 important interest in the field. Mean-
 while, Ivan Dmitri has been urging us
 in the same direction. Dmitri's special
 concern has been to gain for photog-
 raphy the same acceptance accorded
 painting as a fine art. The present
 project evolved from many discussions
 and meetings that considered this
 objective."

14. For example, the editors of LIFE asked
 Doris O'Neil, director of the picture
 collection, to review all of the photo-
 graphs ever published in the magazine
 (at that time approximately 175,000)
 and to submit a group of one hundred
 for evaluation.

15. Figures sited are from the "Director's
 Report," April 17, 1961.

Nathan Lyons

PFA AND ITS CONTROVERSY

Like the act of making a photograph, it is not simply what has been included in the frame, but also what has been excluded from it that makes the difference. What I have chosen to exclude from this discussion is the more generalized notion of applied photography in order to try to understand why, in the evolution of expressive practice, there was even a need, or presumed need to formulate the position that Ivan Dmitri did in launching the "Photography in the Fine Arts" project in 1959. Certainly there seem to have been enough historic precedents to suggest that his motivation and that of a number of leading museum directors was after the fact. For just this reason, Edward Steichen chose not to continue supporting the project after PFA I had taken place, even though he had been a juror of that first exhibition. He explained in a letter to Ivan Dmitri, on February 8, 1960:

> Your pretense that this venture would initiate the collecting of photographs by art museums, and persuade them to consider photography as an art, may, on the whole, have been due to ignorance. For instance, you may have been unaware that some European art museums acquired photographs during the latter part of the nineteenth century (as a matter of fact, I sold prints to art museums in Brussels and Hamburg over fifty years ago). You may know that the Boston Museum of Fine Arts has a small collection of photographs; that the Art Institute of Chicago has a department of photography and an excellent collection of prints; that the Metropolitan Museum of Art has an aggregation of early photographs second to none; that the Museum in Indianapolis has a department of photography and that—to name only a few—the Buffalo and San Francisco museums have small collections of prints.

To press the point, Steichen continued in the same letter:

> The Museum of Modern Art has exhibited, collected and purchased photographs almost from the time of its inception. Since 1932 it has organized and presented seventy photography exhibitions, mainly under the curatorship of Beaumont Newhall, until the end of World War II, and under my direction for the past twelve years. The works of over 800 have been included in these shows. We have also sent out forty circulating exhibitions to sister institutions throughout the country, as well as to museums in Europe and Asia. You may not know, of course, although many people do, that this museum has a collection of over 5,000 prints.

Dmitri's response was conciliatory, in an attempt to ". . . maintain a warm relationship between all of us . . . ," but he did state emphatically: "To presume me ignorant of knowing that a mere handful of museums in the U.S. and abroad have collections of photography is not only patronizing but incorrect. Also, it implies that any improvement in the relationship between photographer and museum is impossible—perfection having been already achieved. I think that you somewhat exaggerated this relationship."

I do not think that most critics or photographers objected to the possibilities of expanding an audience for photography, or that Ivan Dmitri's observation that more could be done was inaccurate. Rather, the objections voiced by Steichen and others to the PFA project center around the question of method as well as the revival of judging procedures that the field thought highly questionable. In addition, Peter Stackpole, writing in *U.S. Camera* in September of 1959, was astonished by the posturing in launching the PFA project. "I can't recall as much fanfare for such a small show before over which so many profound words were said by so many prominent people, most of whom know relatively little about photography." He saw the exhibition as a gathering of "safe choices." In August of that same year, the editors of *Modern Photography* emphatically denounced the project in an article entitled "The Day Photography was Kicked in the Head." "The peculiarities of the venture should have been evident from the beginning. An assumption seemed to exist that museums had not previously held photo

exhibitions, that the Metropolitan Museum of Art, in labeling photography a 'fine art,' would be breaking ground in this direction." The editors also objected to the method of selecting the original work for review by soliciting them from commercial sources: "A most important omission: apparently no photographers were asked to submit their work. It was simply assumed that most pictures worth looking at had been published commercially."

Subsequently, in an undated letter written sometime after the opening of the first PFA exhibition and sent to the Metropolitan Museum of Art, a group of photographers stated the following:

> As working, practising photographers we take exception to your claim to represent photography as a fine art.
>
> Perhaps we should be flattered in your interest in us, and we would be, if it weren't for the fact that the men you have invited to judge us are strangers to our world of photographic imagery. You have formed a jury of men expert in assessing paintings, sculpture and work in graphic media, but novices when it comes to evaluating photography.
>
> We also notice that your jury sent no invitations to photographers; they have made no public announcements in the photographic press. Instead, the invitations have been extended to organizations to select from their membership or their files. No person close to photography would accept such a second-hand relationship with the photographs he must choose from. No person close to photography would attempt to choose from work submitted by as unlikely a combination as amateur camera clubs, professional organizations, advertising agencies, picture magazines, and the picture agencies and salesmen that service these same commercial houses, and think that it represented anything at all. The diversity of views combined with the number of photographs and photographers represented makes us believe that it should be called a "bazaar" rather than an exhibition.
>
> Let us add that we take a dim view of those heavily-promoted photography extravaganzas that show a hundred photographs by as many photographers. At best this is a symposium that has value to those already informed about contemporary photography. It serves as a reminder of the extent and scope of photography. To the lay public, however, this is photography deprived of the subtleties and meanings because it is deprived of its context and motivation.
>
> Exhibitions such as these encourage the photographer to choose his submission in terms of the flashy and sensational in order to gain the jury's attention and votes. The fact is that what is most meaningful about the photographer's work may be something very different from what he submits. The significance of a photographer's work comes from his strivings and not from any single "great" photograph.
>
> For the reasons given we have not submitted our work for consideration in the current "PFA" show.
>
> | Robert Frank | Simpson Kalisher | Walt Silver |
> | Lee Friedlander | Saul Leiter | David Vestal |
> | Ray Jacobs | Jay Maisel | Garry Winogrand |

These men spoke for a significant segment of the photographic community, that segment concerned with photography's expressive possibilities. They lacked the series of support systems enjoyed by those concerned with commercial or amateur photography, and were relatively anonymous as practicing artists, struggling to survive outside the world of applied camerawork. That world was represented by the National Press Photographers Association, the American Society of Magazine Photographers, the Photographic Society of America, and the Professional Photographers of America, which all served as national consultants to the PFA project. There had been a long history of attempts to distinguish between commercial and expressive concerns within the medium, but for many and especially for camera artists, "Photography in the Fine Arts" continued to confuse the issue.

In addition, despite Steichen's assumption that photography in the 1950's was accepted as a fine art, a broader, more informed audience did not exist for the field. Beaumont Newhall's *History of Photography*, for example, produced in 1949 in 3,000 copies, took almost ten years to go out of print. But in 1964, when a subsequent edition was published, that same number was sold within the first few months of publication. Audience development was to become a key factor, and it was the emergence of more informed viewers that would be central to the rapid growth of the medium that took place in the 1960's. While the "Photography in the Fine Arts" project was a product of the late 1950's and continued well into the 1960's, it is important to view it in the context of other developments to understand what contribution it may ultimately have made.

One of the most important precedents for Dmitri's project was the activity of the Museum of Modern Art and its photography program, its commitment to one-person exhibitions, as well as its presentation of a number of important thematic exhibitions. It was not only one of the primary producers of photography exhibitions, but also the source of a series of monographs on individual photographers.

Additional support for the photographic community came from the Photo League. This organization, led by a group of socially concerned photographers, emerged from the Film and Photo League in the early 1930's. At first it proceeded primarily with documentary interests, but later many members shifted their emphasis to more personalized investigations, to what was often discussed as "creative photography." The League served as one of the most active forums for the discussion of photographic concerns. It provided lectures and exhibitions, a publication and an educational program. Its membership included most of the prominent people working in the field. It did not, however, escape the wave of hysteria generated by McCarthyism and the Internal Security Act of 1950, as well as the House Un-American Activities Committee. The Photo League wound up on the Attorney General's list of hundreds of organizations considered to be totalitarian, Fascist, Communist, or subversive; and, as a result, it was forced to disband in 1951. It is hard to determine in retrospect what effect the continuation of the Photo League might have had on developments within photography or what real justification there was in the Attorney General's action, which had a chilling effect on the field. What does seem evident was that during its later period, it developed a model of activity that focused the energies of the field and provided some alternative to the interests of existing professional societies. Not until the formation of the Society for Photographic Education in 1963 did an alternative exist once again.

In 1959, the same year that Dmitri launched "Photography in the Fine Arts," the George Eastman House celebrated its tenth anniversary by mounting an international exhibition curated by Walter Chappell. In contrast to the selection process used by PFA, the Eastman House exhibition had an invitational as well as an open section. The only rule was that the photographs had to have been made during the previous ten years. Two hundred and fifty-three photographers participated in the exhibition, most represented by two photographs each. In the introduction to the catalogue, Beaumont Newhall stated that the exhibition clarified ". . . photography's standing today both as an art and as a powerful and convincing means of communication." Newhall assessed the work in the exhibition essentially by identifying four stylistic trends, which appeared to be rooted in tradition. He wrote in the catalogue:

1 | The "straight approach," first explored by Alfred Stieglitz, Paul Strand, Edward Weston, Ansel Adams and others, in which the ability of the camera to record exact images with rich texture and great detail is used to interpret nature and man, never losing contact with reality. The approach is classical, and the fine print is presented as an experience in itself.

2 | The "experimental," a heritage of the restless experimentation of the 1920s, characterized especially by Man Ray and the teachings of L. Moholy-Nagy, in which certain phenomena of the photographic process are exploited, such as the deliberate narrowing of tonal scale, solarization of the image, the negative as an end, exaggeration of perspective.

3 | The photo-journalistic, essentially a desire to communicate, to tell about people, to record without intrusion the moment that has been called by Henri Cartier-Bresson "decisive," typified by the use of the miniature camera, wide aperture lenses and high speed film.

4 | The development of the theory of the "equivalent" as first explored by Alfred Stieglitz, in which the photograph becomes, not only the interpretation of a given place, not only an image to be appreciated for its own challenging beauty, not only a journalistic report of a given moment of time, but also an evocative release, a symbol—even, at times, a trigger to a stream of consciousness.

These approaches generously overlap each other and defy oversimplification which, in the interest of clarification, we have suggested. One characteristic they have in common, which marks photography at mid-century apart from photography during the four preceding decades: emulation of the painter has ceased to be an overwhelming preoccupation for the majority of photographers. Today photography is almost unanimously accepted as a medium in its own right, with its own characteristics, limitations and potentials. A short time ago this attitude was limited to a handful of pioneers. By common consent, the effects which the painter alone can obtain with his own special art are no longer imitated. The field which the painter has neglected— the representation of man and nature—has become the special province of the photographer.

By establishing an invitational section, Chappell sought to acknowledge the work of the individual photographer and to de-emphasize the "picture contest" mentality that had plagued the exhibition of photography since the turn of the century.

While PFA's continued effort to sanctify individual photographs by declaring them "works of art" had a disquieting effect on the field, the public, however, responded with great enthusiasm. In this regard, Dmitri was right: "more needed to be done," and it was. By the mid-1960's, expanded traveling exhibitions programs were established by the Museum of Modern Art and the George Eastman House. Publishing began to flourish, supplementing technical literature by calling attention to the work of individual photographers. Collectors and institutional collections began to emerge; commercial photographic galleries began to show signs of stability, and a phenomenal number of educational programs were established at colleges and universities throughout the country.

Nathan Lyons is the founder and director of the Visual Studies Workshop in Rochester, New York; the director of the Program in Visual Studies at the State University of New York at Buffalo and the State College of New York at Brockport; and an active photographer. He was the founder and first director of the Society for Photographic Education (SPE).

The climate changed rapidly; interest in the expressive potential of photography intensified, and dramatic shifts took place in how photographers responded to the challenges of the 1960's through their use of the medium. Possibly not since the period between the two World Wars was photography to experience such freedom of exploration and redefinition.

To suggest that the PFA project affected the practice of photography would be questionable, however. Its contribution rests in the fact that it helped to develop within the general public a broader interest in the medium and an appreciation of its expressive potential.

Naomi N. Rosenblum

A RETROSPECTIVE LOOK AT THE ACCEPTANCE OF PHOTOGRAPHY AS FINE ART

"Of all the delusions that possess the human breast, few are so intractable as those about art."[1] From the middle years of the 19th century until well into the 20th, the question of whether photographs expressed matters of the spirit and therefore should be considered "art," or only mirrored visible reality as perceived by the eye, was extensively debated. Artists, art critics, museum personnel, literary figures, scientists, and, of course, the photographers themselves, all had opinions on the matter, which were reflected as late as the "Photography in the Fine Arts" project of 1959-67.

Because camera images seemed to capture the real world of landscape, objects, and people with accuracy, they were thought to be concerned with "Reality" and "Truth." On the other hand, "Beauty," which involved refinement, taste, genius, intellect, and spirituality, was regarded as a necessary component of a work of art; it required idealized themes and treatments distinct from the minutely detailed views of mundanity so effectively achieved by the camera lens. Furthermore, photographs were considered incapable of "compensation, compromise or contrast"—elements found even in the least competent paintings of nature.[2] In the second half of the 19th century, the most persuasive advocates of artistic photography accepted the division between the mechanical and the spiritual in their medium. Henry Peach Robinson and Peter Henry Emerson, opposed in all other respects, nevertheless agreed that photographers should be cultivated individuals concerned with more than just optical and technical matters. Alfred Stieglitz, who described himself as struggling against "mechanicalization," held that artistic photographs required more than accurate depiction and good technique.

The struggle for the photograph's status as art was complicated by its nature as a commodity. As mechanically produced artifacts, camera images were less costly than those made by hand. They could be acquired by middle-class people from street-level displays mounted by photographers and optical shops, from dealers in graphic art, and through catalogues. Both their accessibility and the fact that they were not unique made them seem less valuable in the eyes of the art establishment, which maintained that they appealed to uneducated taste. This perception grew firmer after the early 1850's, when the technology was being transformed by the use of glass-plate collodion negatives and prints on paper coated with albumen to produce an even more "faithful transcript" of nature than had been possible with earlier processes. Both those who made these realistic images and those to whom they appealed were considered "crude, ignorant, and lower-class."[3]

In contrast, photographic reproductions of works of art were accepted by critics because such images were believed to improve the level of mass taste. In addition, these photographs were also intended to improve the design of products that depended for their value on tasteful composition and decoration. On occasion, portrait and landscape photographs might also be considered uplifting—providing the camera and the process were held "subservient" to the individual photographer's taste and skill.

Photographers themselves—many of them originally graphic artists of diverse talent—disagreed on whether they might be able to "think with their cameras as well as painters with their brushes."[4] Sir William Newton, a former miniature painter at the English court and founding member of the Photographic Society, declared it "finally to be settled that photography was not Art," while Roger Fenton, a painter-turned-photographer, maintained that photographs bore the same relationship to light and chemicals as drawings and paintings did

to pencils, paints, and canvas.[5] Some in the intellectual community held that just as scientific inventions in other spheres of activity had enhanced ordinary life, so photography would add to the means available to the artist; that "in addition to the brush, the pencil, and the gravers' burin, the artist now had the photographic lens."[6]

Writings on the artistic status of photography were not only theoretical but practical. One important question concerned the suitable exhibition of photographs, since during the early period, portraits and architectural and scientific documents were hung side by side with landscapes and genre pieces. Should articles of commerce, such as commissioned portraits and landscapes, be exhibited as camera art? How should the critic deal with the fact that photographic prints were not unique—that exact replicas existed, yet, unlike suites of etchings and lithographs, they were not numbered to indicate the position of the image in a finite set or edition? Given their small size, would it not be better to display photographs in albums rather than on walls? Should they be shown in the scientific or mechanical sections or with works of graphic art at the universal expositions held every few years? Showing photographs to enhance their status as art eventually became a motivating factor in many exhibitions, including the "Photography in the Fine Arts" projects.

Throughout the 19th and early 20th centuries, these issues were handled in a number of ways. At the Salon of 1850 in Paris, large photographic landscapes submitted by Gustave LeGray were hung among the lithographs but then removed by a later committee, which decreed that products of the lens could not be hung among works of graphic art. At the Great Exposition in London in 1851 and the New York Crystal Palace Exposition in 1854, camera images were displayed along with photographic apparatus in the scientific sections, and at the Paris *Exposition Universelle* of 1855 photographs reposed between engravings and typography in the section labeled Industrial Design. Pressure both from photographers to judge their work as artistic expression and from graphic artists who dissented led to the creation of a special exhibition gallery at the Paris Exposition of 1859. Its physical location, adjacent to the fine arts section but not part of it, straddled the question of whether or not photography was an art. As late as 1904, Alfred Stieglitz refused to allow the group of American photographers for whom he spoke to exhibit at the St. Louis Exposition because officials declined to designate photographs as art.

Up until the 1890's, the other main venues for showing camera images were the exhibitions arranged by the leading photographic societies of the United States and Europe. Within this context, photographs usually were regarded as partly artistic, partly scientific expression, rather than as industrial products, and were hung like Salon paintings above and below eye-level to accord with a notion of comparable quality. The first organizations to foster this outlook—notably the Photographic Society in London and the *Société Française de Photographie* in Paris—had appeared on the scene early in the 1850's as centers for the exchange of information, ideas, and prints among both amateur and professional photographers.

Societies exclusively devoted to the work of amateurs emerged during the 1850's and sixties and continued as viable entities for the next twenty-five or so years. They sponsored exhibitions—on their own or in cooperation with other societies—in which works in specific categories, such as landscapes, portraits, and genre, were selected for their artistry and awarded special commendations and grand prizes. In theory, the images were the best of artistic photography, although all along there were disagreements about the standards used to

exclude some works and to award prizes to others—just as there were to be disagreements about the quality of the work shown in the "Photography in the Fine Arts" exhibitions.

Efforts to assure photography's acceptance as art also influenced photographers' interest in traditional rules of artistic composition and in soft-focus techniques. Any number of mid-century manuals and books, in particular Henry Peach Robinson's publications, contained material on the proper placement of the center of interest, the vertical, horizontal, and diagonal elements, and light and shade. Such books, which overtly imitated painting manuals by Joshua Reynolds, John Burnet, and the like, were extremely popular in the industrialized countries from the middle of the 19th century on. Even after the unique esthetic character of the camera image was recognized, painterly concepts continued to influence photographers.

Themes were also chosen for their esthetic associations. A still-life, for example, had to be considered artistic because it was deliberately arranged by the photographer who, for the most part, emulated painted models. Literature appealed especially to English artistic photographers; both amateurs and professionals were inspired by Burns, Gray, Longfellow, Tennyson, and Scott, and landscape views meant to serve as illustrations for editions of these authors began to appear from the 1850's on. Allegories of moral instruction and depictions of Bible stories and other legends empowered photographers to control composition and meaning closely while elevating the image to a level that demonstrated, according to a contemporary critic, "great artistic feeling, and great taste. . . ."[7]

In England, France, the German-speaking countries, and the United States, photographers were also drawn to less exalted themes based on everyday life. Genre compositions, which took their cue from the Salon paintings popular with the bourgeoisie, might depict an event that the photographer actually witnessed or a staged imaginary scene. French photographers especially were influenced by the writings of the well-known portrait photographer Disdéri, who held that peasant culture, occupations (*petites metiers*), and domestic interiors would provide suitable material for the camera. Unlike commercial products showing similar scenes, artistically oriented genre compositions were carefully composed and lighted to emphasize their higher intentions. In their time, they were often associated in the public mind with traditional painted scenes, in particular 17th-century Dutch painting, but photographers also addressed contemporary realities. Scenes of peasant life by the French photographer Humbert de Molard, for example, can be regarded as deriving from the same impulse, though not the same talent, as the peasant images of Gustave Courbet. In England, on the other hand, photographers (with the exception of Peter Henry Emerson) were less apt to deal with contemporary reality than to deploy costumed and posed models in settings made to appear rural, and to accompany their images with descriptive titles that made a moral point.

Perhaps the most controversial strategy called upon to circumvent the documentary aspect of the medium and proclaim the individual photographer's artistic intention was composite photography. With this technique, photographers used more than one negative to produce a print. Many landscape photographers (LeGray, for example) employed it in order to eliminate the empty white areas of the sky caused by the uneven sensitivity of the collodion silver emulsion to the various wave lengths of spectral light. However, it was most disputed when used in figure compositions for which models were posed, a number of exposures were made, and portions of each print were combined in

a predetermined composition. In general, the French photographic community frowned on such manipulations (except in landscape), denying them exhibitions, while the British were of two minds. Some critics felt that photographs could be pardoned all faults provided that their "redeeming merit, truth" was respected; "the *true* artist," it was claimed, "will never attempt to build up pictures by photography."[8] Others found these pastiched works acceptable because of their elevated sentiments. Still others, comparing them with popular paintings, applauded the makers of composite imagery for raising the level of photography to art.

The two British photographers most closely associated with this approach during the 1860's were Robinson and Oscar Rejlander, both initially trained as painters. Rejlander produced his best known composite work, *The Two Ways of Life*, in part to compete with historical paintings that he expected to be exhibited at the Manchester Art Fair of 1857, and in part as a catalogue of poses that he believed might be useful to graphic artists. He thus attempted to bridge the highest and lowest aspirations of the medium in a single work.

Robinson credited the acclaim garnered by his composite image of 1858, the sentimental *Fading Away*, with keeping him in the photographic business, and he continued to make composites up to 1890.[9] As a result of numerous articles and translations of his *Pictorial Effect in Photography* (1859), his work and ideas were known and emulated far beyond the British Isles. They especially encouraged the proliferation of staged genre subjects in photography, but few photographers actually followed his method of montaging images, preferring to re-enact scenes in a studio, in the manner of the highly regarded Canadian photographer, William Notman.

In the late 1860's and seventies, interest in the intrinsic expressive possibilities of the medium leveled off. The photographers maturing then seemed to have concentrated on achieving success in the commercial sector. The attitude of the period was symbolized by the critic John Ruskin's change of heart; initially enthusiastic, he now dismissed photography as "a mere transcript, having nothing to do with art."[10]

Toward the end of the 1880's, a new movement emerged to claim for photography the status of art. This second flowering, which roiled both the art and photographic communities for the next twenty years, re-introduced many of the same questions but now with a larger field of practitioners. The expansion that took place between the 1880's and 1910 occurred because the availability of simplified equipment and processing prompted greater numbers to take up the medium as a recreational activity. In Europe and America, hobbyists banded together to found photographic societies whose primary goal was publicizing the role of the camera image as art. They tackled the familiar issues of suitable exhibition treatment, subject matter, style, and technique—for example, the propriety of manipulated versus straight images—but this time as central to the new artistic movement known generally as Pictorialism. This movement incorporated esthetic concepts derived from Symbolism, with its components of tonalism and pictorial ideas recently imported from Japan.

Initially, the central idea of the new Pictorialism originated with Emerson. A man of scientific background, this English photographer nevertheless believed that a scientific approach to photography yielded up too much truth and not enough form, which to his mind was the sole means of evoking feeling in visual art. He urged photographers to avoid the kind of evenly sharp, highly detailed image that he associated with conveying scientific information, and so advocated differential focusing for the making of the negative (to insure a more "natural-looking" representation) and platinotype or photographic etching (gravure) for the making of the prints.

These ideas were unveiled in *Naturalistic Photography* (1888), in which Emerson used the term "naturalism" in opposition to "realism," and to the kind of composites advocated by Robinson. In effect, this formulation was Emerson's means to promote an "impressionistic" treatment of nature, and it prepared the ground for the precepts enunciated a few years later by Stieglitz, who decreed that originality, simplicity, and tone, rather than data, were the key elements in artistic photographs. To achieve these ends, Pictorialists eventually condoned all manner of hand manipulations of the photographic process, and invented several new techniques, among them gum-bichromate and bromoil printing. The proper exhibition of photographs to enhance their perception as artistic entities became a highly charged issue among the new Pictorialists. They deplored displays in which all kinds of photographs—portraits, landscapes, scientific and medical images, works by professionals and by amateurs—were hung together. Because large exhibitions of snapshot photographs also were materializing as a result of the popularity of the Kodak camera, Pictorialists sought separate and more prestigious spaces for showing artistic photography.

The Pictorialists' stringent standards were realized by a new development—the international exhibition of photography, which originated in Europe and provided a showcase for the most artistic camera work, leaving the rest to be shown in events organized by the older photographic societies. The first such international show took place in Vienna in 1891, under the auspices of the *Club der Amateur-Photographien*, while similar events were held in Hamburg in 1893 and in Paris in 1894 under the auspices of the newly formed Photo-Club of Paris. In Hamburg, five hundred photographers exhibited six thousand prints, and the jury consisted solely of painters and graphic artists, while in Paris it included photographers as well. In 1892, the London-based society, The Linked Ring, inaugurated a similar kind of exhibition, now called a Salon, but unlike the Continental groups, only photographers—of both "purist" and "manipulative" persuasion—were judges of exhibitable work by both members and outsiders.

In no time at all, the issue of jury membership aroused controversy, as it continued to do through the exhibitions of the 1960's with which this publication is concerned. Simply put, photographers objected to being judged by those outside their field. In the polemics over the matter, those in favor of mixed juries claimed that since few photographers had undergone the kinds of esthetic training given painters, they were in no position to judge esthetic quality—whether a work was produced by hand or by camera. Those in opposition held that training in the graphic arts did not guarantee understanding or appreciation of photographic esthetics, and they asked "on what grounds do [painters] claim to be experts?"[11] Furthermore, they maintained that because in most minds greater prestige was attached to painting and sculpture, photographer members of juries tended to defer to those from the other arts. Thus, even when photographer jurors considered a work inferior, they might pass it if the fine arts members of the jury favored it. In consequence, prestigious groups like The Linked Ring did not include painters as judges and did not offer prizes, relying instead on a committee of peers.

Developments in artistic photography in the United States around the turn of the century are of special interest to the topic of this book. Following the popularization of hand cameras and dry film, increasing numbers of amateurs (among them numbers of women) brought a revitalizing energy to photography. This democratization of the medium and the growing acquaintance in the United States with elitist photo-societies of Europe improved the originality and inventiveness of artistic photographs so greatly that by 1900 critics claimed that the "new American photography" had outstripped the European product.

The Salon idea was introduced here in 1886 through the joint exhibitions sponsored by amateur photographic societies in New York and Boston, but the first event actually to call itself a Salon occurred in Washington, D.C. in 1896. To avoid offending its large numbers of hobbyist members, the exhibit, under the auspices of the local camera club, presented two categories of work—artistic and less-than-artistic—and offered prizes. For this reason and because it had a poor representation of art photography from Europe, the exhibition was not supported by some of the most prominent artistic photographers in the United States, the most notable being Alfred Stieglitz.

Stieglitz, a key figure in this unfolding scenario, was involved with the next Salon, which took place in Philadelphia in 1898, where the event became annual through 1900. The Photographic Society of that city ruled that only photographs of "decided artistic merit" would be admitted to this exhibition, even if that limited the number of works on view. The Philadelphia Salon offered no prizes or honors, implying that in such a rigorously organized show acceptance was its own reward.

Besides establishing exacting standards of selection, artistic photographers of this era proclaimed their affinity with others involved in the fine arts by giving greater attention to methods of presentation. The new look was immediately recognized as an "essential difference," separating exhibits held under the auspices of older associations (such as the Royal Photographic Society) from those determined to elevate photography's status.[12] In sharp contrast to the jumbled effect of earlier exhibits in which works were usually abutted and encased in a variety of unmatched frames and mats, Pictorialist mats and frames were tastefully selected, more wall space was available for the photographs, and the arrangements were artistically conceived by "enthusiasts gifted with artistic temperament . . . [and] anxious to raise the craft to an art."[13] F. Holland Day and Stieglitz even refused to send unmounted prints to exhibitions where they had no control over their presentation. (The Salons also provided for sales of photographs, but artistic photography still was in a state where market value was of little significance.[14])

Another strategy to enhance the standing of artistic photography involved museum sponsorship of photographic exhibitions, and eventually museum purchase of such works. During the latter part of the 19th century, museums devoted to technology and local history were repositories of photographs of a historical and documentary nature; and works originally intended as art sometimes found their way into such agglomerations. However, the advanced wing of the Pictorialist movement hoped to breach the redoubtable classification systems of the fine arts museums and to introduce artistic photography into their collections.

Persuading museums to accept photographs as art and to collect them was probably the least immediately successful aspect of the Pictorialist effort; certainly the major fine arts institutions in England and France were unbending in their attitude toward photography. German and American museums appear to have been somewhat more flexible; for example, the Albright Art Gallery in Buffalo not only sponsored exhibitions of artistic photography, but purchased a body of work from the last significant Photo-Secessionist exhibition, held there in 1910. From 1900 to 1938, the Art Institute of Chicago held annual exhibitions of artistic photography, while the Corcoran Gallery in Washington and the Mark Hopkins College of Art in San Francisco undertook similar sponsorship. According to Stieglitz, the Metropolitan Museum of Art had been prepared to accept and hang a collection of American art photographs sent to Turin in 1903, but following the

Installation of Clarence H. White
photographs at second Philadelphia
Photographic Salon, 1899.
Photo courtesy William Innes Homer

death of the Metropolitan's director, General Cesnola, the promise was not honored.[15] Eventually, during the 1920's, Stieglitz arranged gifts of his own work to both the Metropolitan and the Museum of Fine Arts in Boston, in an effort to force the issue. In 1933, the Metropolitan received his collection, which at the time he estimated to be worth $15,000. As he and others had prophesied, these institutions followed such moves by accepting other gifts, purchasing individual works, and eventually mounting serious exhibitions, but devoted commitment to collecting photographs had to wait until after the end of the Second World War.

The prestigious Philadelphia Salon of 1898, held under the aegis of the Pennsylvania Academy of Fine Arts, was well received by the public and by both photography and art critics, making its repetition a foregone conclusion. At the same time, it strengthened the antagonism of Stieglitz and his associates toward mixed juries.[16] For the Salon of 1899, *all* the jurors were photographers: F. Holland Day, Frances Benjamin Johnston, Gertrude Kasebier, Henry Troth, and Clarence H. White. This show included a section of European images and one in which the work of the jurors was presented. Joseph Keiley, semi-official historian and publicist of the Philadelphia Salons, reported that there was "a pleasing variety of style, color, and form in the individual exhibitions," and went on to remark that the pictures were "exceptionally well-hung."[17] By this, he meant that they were framed in the manner appropriate to works of high art and that their placement on the wall evinced a feeling for the harmonious arrangement usually accorded the older visual media. However, although this second Salon presented works now regarded as among the most accomplished in the Pictorialist style, the critics were less kind than formerly, possibly because the photographs so obviously reflected Symbolist influence.

Under Stieglitz's tutelage, the Philadelphia Salons were intended to establish rigorous standards as to what constituted artistic photography, but in this objective the Salon organizers were only partially successful. By 1900, the year of the final Salon, the jury seemed to be in complete agreement that artistic photography should avoid all "coarse or vulgar" subjects (scenes of lower-class urban life) as well as sharply defined genre and landscape images, but a split had developed between what were then called the Old and New Schools of photography. Ostensibly this conflict concerned whether photographic art could be produced by using handwork if needed to create an image of beauty (the New School's position) or whether agreeable subject matter should be selected and rendered by purely photographic means (that of the Old or Rational School). In actuality, the division reflected an entirely different matter—the struggle for leadership of the artistic photography movement in the United States on the part of several ambitious individuals.

Two of these individuals were Day and Stieglitz. Maneuvering himself into the position of leadership in this struggle, Stieglitz shortly afterward founded and promoted the Photo-Secession (modeled on the Austrian Secession of painters), with members who adhered to more sublimated artistic concepts than those held by camera clubs and other amateur societies. Initially welcoming a variety of themes and a diversity of methods of producing prints (as long as he was convinced of a work's artistic intention), Stieglitz opposed juries composed of artists in other media, and indeed was eager to be the sole arbiter in selecting and hanging works of photographic art. He insisted on strict standards for presentation, and showed well-framed photographs in the harmonious setting of 291—The Little Galleries of the Photo-Secession—which the younger painter-photographer Edward Steichen had helped conceive and design. This concern for the stature of camera art was behind the elegant printing and fine design visible in *Camera Work*, the periodical of the Photo-Secession.

Despite Stieglitz's influence, however, and the generally favorable response by the photographic establishment and art press, the majority of the entries first to the annual Salons and then to the Photo-Secession exhibitions are by individuals whose names are now almost entirely forgotten.

European and American efforts to promote the artistic stature of photography through refined estheticism weakened after 1912, challenged first by changing sensibilities and then by the impact of World War I. In the United States, a Pictorialist movement continued to exist; indeed in 1916 it was restructured under the leadership of the former Photo-Secessionist Clarence H. White into the Pictorial Photographers of America. However, the search for beautiful subject matter and refined ways of treating such material remained of interest mainly to hobbyists. Serious photographers who came to maturity during the second decade took notice instead of fresh ideas in the arts emanating from Europe. For example, in 1923, Paul Strand, whose work had aroused Stieglitz's enthusiasm in the mid-teens, expressed the view that soft-focus oil and gum images in Pictorialist style were "unoriginal" and "an evasion of everything photographic."[18]

Opening exhibition at the Little Galleries of the Photo-Secession, 1905, from *Camera Work*, no. 14, 1906.

Furthermore, both in Europe and the United States, the period was one of increased commercial opportunities in photography. Advertising firms and periodicals began to use greater numbers of camera illustrations, opening up opportunities for photographers interested in visual design to market such images commercially. Changing notions about the hierarchical nature of the arts also influenced attitudes toward artistic photography. Both Constructivists and adherents of the Bauhaus in Europe held that visual expression in all media should reflect the technology of the time and be geared toward a functional objective; when the Bauhaus reproduced itself in Chicago in 1937, these concepts found ready acceptance in the United States.[19] In this climate, photography was perceived as singularly appropriate for expressing the temper of the machine age. With its utilitarian aspect in ascendancy, its stature as art was considered less significant than formerly. A few individuals in the United States, notably Stieglitz and Strand and the gallery owner Julien Levy, continued their efforts to enhance the camera image in the eyes of collectors and museums, but interest in photography had in fact shifted away from questions of artistic status to other arenas during the interwar period. In the thirties, economic depression, political turmoil, and finally global military conflict made the issue of photography's role as art seem even less relevant.

In view of these economic and social vectors, it may seem ironic that in 1940 an irreversible step took place toward according the medium the artistic status its advocates had so long urged. In that year, the Museum of Modern Art, founded in 1929, established a department devoted solely to collecting and exhibiting photographs and installed Beaumont Newhall as curator. Stating that the department was formed to provide a venue for "those artists who have chosen photography as their medium," MOMA adroitly sidestepped the tiresome arguments about whether photographs should be considered art.[20]

MOMA's inspired move also greatly expanded ideas of what kind of camera images constituted photographic art. While it paid homage to Stieglitz for forcing museum acceptance of the medium, its own understanding of artistic photography could not have been more at odds with the rarefied esthetic vocabulary he had promoted. Its first exhibition, entitled "Sixty Photographs," included topographical

photographs, news and war reportage, advertising shots, and scientific documentation as well as images made for reasons of personal satisfaction. In this and subsequent exhibitions, camera documentation of social phenomena hung beside expressions of a deeply personal nature, scientific images adjoined symbolic evocations. The first MOMA exhibition laid to rest the notions that photography's aspiration to high art was the key to its affective force and that those involved in commerce or the documentation of social and political phenomena were incapable of producing camera art.

During the mid-1940's, five exhibitions geared to winning the war reinforced the new attitude to photographs;[21] this direction was definitively sanctioned in 1947, when Edward Steichen, former Symbolist painter, Pictorialist photographer, sometime documentarian, and acknowledged master of advertising and publicity work, assumed the directorship of the Photography Department. His first major exhibition, "In and Out of Focus," which opened in 1948, presented 250 works culled from the spectrum of utilitarian and artistic images. Included were photographs conceived in purely esthetic terms, fashion and advertising illustration, scientific documentation, and photojournalism. As the title indicates, a gamut of stylistic approaches was visible, from sharply focused, pre-visualized works to intentionally blurred ones, from clearly understandable images to experimental prints with highly subjective messages.

"In and Out of Focus" was followed in 1949 by an exhibition of reportage entitled "The Exact Instant." Attempting to invalidate the distinctions erected by the various Pictorialist movements of the past, the Museum prepared the ground for a show that actually reflected in both theme and presentation the strategies of utilitarian magazine photojournalism, at the time one of the most vital phenomena in photography. Mounted in 1955 by Steichen and his assistant Wayne Miller under the title, "The Family of Man," this large, tendentious exhibition of some five hundred photographs consisted of works on a number of related uplifting themes. In sum, the show was meant to offer a benign view of humanity to post-war societies in which economic, political, and social conflicts already had become sharply visible.[22] Cropped, enlarged, and arranged in sequences and groupings that in essence mimicked the major picture journals of the period, the selection of images, the choice of hortatory quotations, and the all-encompassing installation combined to produce an effect somewhere between that of a giant three-dimensional magazine and a stop-motion version of a documentary film. With its message carried almost entirely by the visual materials rather than by an interrelation of word and picture, as was common even in magazines such as LIFE and *Look*, the exhibition validated pictorial reportage as a means of arousing emotion, rather than as a tool for informing and educating viewers. This transformation of photo-reportage completed the revolution that had begun when MOMA embraced images made for advertising, publicity, and social documentation as photographic art.

Author of *The World History of Photography* (Abbeville, 1984) and co-author of *American Art* (Abrams, 1979), Dr. Naomi Rosenblum has also published on individual 19th- and 20th-century photographers. She teaches the history of photography at Parsons School of Design and has taught at Brooklyn College and York College of the City University of New York.

Whatever the omissions and inconsistencies in MOMA's collecting and exhibiting policy, its recognition that artistic and utilitarian ends were not incompatible enlarged the field and brought a broader spectrum of photographic activity to the attention of other art institutions.[23] In a sense, photographic exhibitions had come full circle, from the early years when all kinds of images had been shown together in industrial expositions and displays of mechanical inventions, through periods when only images made for reasons of personal and esthetic satisfaction were considered appropriate for exhibition in institutions devoted to art, to the present inclusion of camera images of widely different nature and purpose in major art institutions. In consequence, the question, "is photography a fine art?" became largely irrelevant.

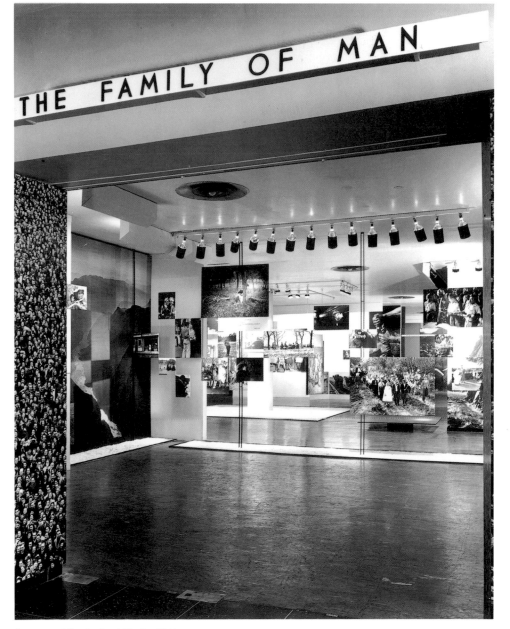

Entrance to "The Family of Man" exhibition,
Museum of Modern Art, New York, 1955.
Photograph by Ezra Stoller © ESTO

1. [Lady Elizabeth Eastlake], "Photography," *Quarterly Review* (London), 101 (April 1857), 461.

2. P.G. Hamerton, "The Relationship Between Photography and Painting," *Thoughts About Art*, Boston, 1874, 52; this essay was written in 1860.

3. [Unsigned], "Photographic Exhibition," *Art Journal*, V, 22 (Feb. 1, 1859), 46; R. Campbell, "Photography for Portraits," *Art Journal*, 1857, 273.

4. *Photographic Art Journal*, 5, 1859, 285.

5. Sir William Newton, "Correspondence," *Photographic Journal*, 1861, 332; John Hannavy, *Roger Fenton of Crimble Hall*, Boston, 1975, 83.

6. Louis Figuier, *La Photographie au Salon de 1859*, Paris, 1860, 14.

7. "Photographic Correspondence: Mr. Lake Price's Photographs," *Notes and Queries*, 1855, quoted in Grace Seiberling, *Amateurs, Photography, and the Mid-Victorian Imagination*, Chicago, 1986, 87.

8. [Thomas Sutton] Leader, *Photographic Notes*, CLIII, 8 (Jan. 15, 1863), 15.

9. Seiberling (see n. 7), 89.

10. R.N. Watson, "Art, Photography and John Ruskin," *British Journal of Photography*, XCI, 4375 (Mar. 10, 1944), 82.

11. Alfred Maskell, "Painters as Judges at Photographic Exhibits," *British Journal of Photography*, 43, 1896, reprinted in Peter C. Bunnell, ed., *A Photographic Vision*, Salt Lake City, 1980, 43.

12. Mark N. Aronson, "The Old Versus the New School and the 1901 Salon," in W.I. Homer, *Pictorial Photography in Philadelphia: The Pennsylvania Academy's Salons*, Pennsylvania Academy of the Fine Arts, 1984, 21.

13. Joseph T. Keiley, "The Salon: Its Place, Pictures, Critics and Prospects," *Camera Notes*, IV, 3 (Jan. 1901), 196.

14. Because selling photographs in opticians' shops and through book dealers was initially considered vulgar, artistic work was exchanged or sold through the various photographic societies. By the last decade of the 19th century, collectors of photographic art took advantage of the Salons and other group exhibits to acquire works. While purchases at the 1894 London Salon were considered respectable (see Margaret Harker, *The Linked Ring*, London, 1979, 108-09), considerable investigation into the extent and nature of the sale of artistic photographs needs to be done.

15. "Two Stories by Alfred Stieglitz: General Cesnola and the Metropolitan," *The Metropolitan Museum of Art Bulletin*, XXVII, 7, 1969, 334-35.

16. The jury for the first Salon consisted of the Philadelphia Pictorialist photographer Robert S. Redfield, Stieglitz, the illustrator and amateur photographer Alice Barber Stephens, and the painters William Merritt Chase and Robert W. Vonnoh, both of whom were too busy to participate in the judging.

17. Joseph T. Keiley, "The Salon: Its Purpose, Character and Lessons," *Camera Notes*, III, 3 (Jan. 1900), 138.

18. Paul Strand, "The Art Motive in Photography," 1923, reprinted in Vicki Goldberg, *Photography in Print*, New York, 1981, 277.

19. The school was called The New Bauhaus when it opened. After closing briefly in 1938, it reopened the following year as the Chicago School of Design. In 1944 it was renamed the Institute of Design and in 1956 it became part of the Illinois Institute of Technology.

20. Alfred H. Barr, Jr., "The New Department of Photography," *The Bulletin of the Museum of Modern Art*, VIII, 2 (Dec.-Jan. 1940-41), 3.

21. These exhibitions were: "War Comes to the People," 1940; "Britain at War," "Image of Freedom," 1941; "Road to Victory," 1942; and "Power in the Pacific," 1945.

22. Following its stay at MOMA from January 24 to May 8, 1955, "The Family of Man" exhibition traveled extensively. The images were published in 1955 in hard- and soft-cover book form by MOMA in conjunction with Simon and Schuster, New York.

23. The policy of collecting all the various manifestations of photographic expression did not extend equally to all images of social utility; in 1952, Steichen turned down a gift of negatives and prints by Lewis W. Hine offered to MOMA by a representative of the Photo League, to whom they had been left. While this is not the place to discuss this issue, serious analysis of MOMA's collecting policies has still to be done; nevertheless, in the context under discussion in this article, there is little doubt that their policy was broadening in effect.

The reproductions that follow appear in three groups—"Illustrative," "Documentary," and "Expressive." These categories reflect the conceptions of photographic genres generally operative in the late 1950's through the 1960's and, more concretely, the sources from which PFA solicited entries. Neither Ivan Dmitri nor any of the museums participating in the PFA tours used these categories. PFA juries selected photographs from entries identified only by number, and museums most often exhibited the prints alphabetically by photographer, as they were listed in the PFA catalogue that accompanied each show. The three-part organization of the photographs in this volume is intended to recontextualize the prints, to present this aspect of them visually, as effectively as possible within the format of a book.

Verification was sought of all the titles provided in the PFA catalogues. The titles given here were approved by the sources and either duplicate those printed in the catalogues or present more recent information. Similarly, dates were approved by the sources. The majority appearing here were researched by ICP, as most of the photographs in PFA exhibitions were presented without dates.

The measurements given are for the image area and are in inches, with height preceding width. All of the black-and-white reproductions were made from the original gelatin-silver prints. The color reproductions were made from large-format transparencies of the original Dye Transfer prints.

42

ARTHUR D'ARAZIEN Lightning Research undated 15⅜ x 19¾"

In the period spanned by PFA, "illustrative" photography appeared most often in the feature stories and advertising pages of the picture press. This was the heyday of the lavish, weekly, general-interest magazine, before television supplanted it as the American oracle of news and entertainment; and through their assignments, editors and advertising agencies exercised broad powers over the most lucrative areas of professional photography. In such magazines as LIFE, *Look*, and *The Saturday Evening Post*, illustrative photography was aimed at building readership and advertising revenue; the results were purposely eye-catching, whatever the subject. In the photographs gathered here, formal elements generally serve a story-telling line. Strong graphic design, sharp tonal contrasts, repeated surface patterns, dramatic lighting, drastic cropping, diving perspectives, surprising vantage points, and other devices lead the eye to the narrative climax. In this period, color appears in illustrative photography more frequently than in other genres, for editors and advertisers could ignore then relatively unstable materials—given reproduction in ephemeral magazines—and instead exploit the allure of rainbow hues.

Despite the mass audiences for illustrative photography, the field was surprisingly diversified, with subdivisions in sports, fashion, product advertising, travel, science, and other areas. Some of the subjects demanded technical specialization: micro-photography for medicine, for example. Other imagery began literally to blur with ersatz impressionism—in sports and travel photography, for instance—as if reflecting the increasingly hazy borders between information and amusement in the weekly press.

Of all the genres, portrait commissions inspired the most varied photographs. In head shots or bust-lengths, in the studio or personal environment, in careful poses or snapshot-style action, in color or black-and-white, the subjects here are public figures—when they are not individuals who personify sociological or national types.

ARNOLD NEWMAN Igor Stravinsky 1946 5⅛ x 9½"

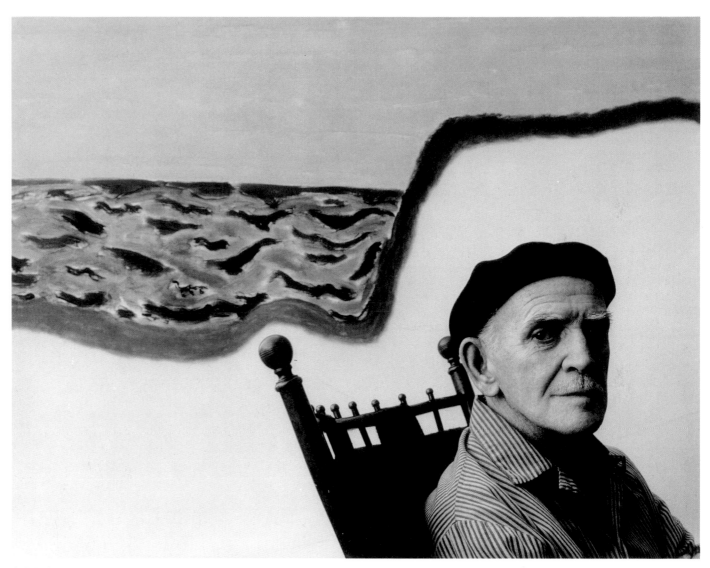

A R N O L D N E W M A N Milton Avery 1960 10⅝ x 13½"

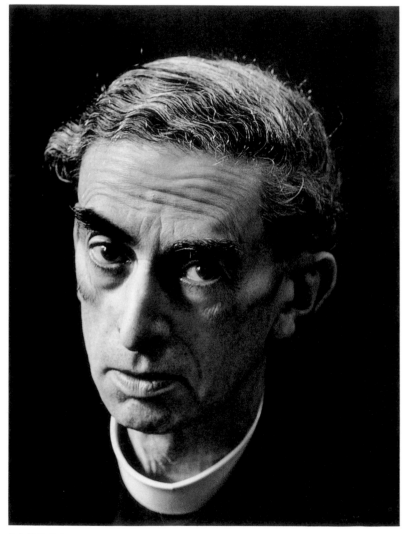

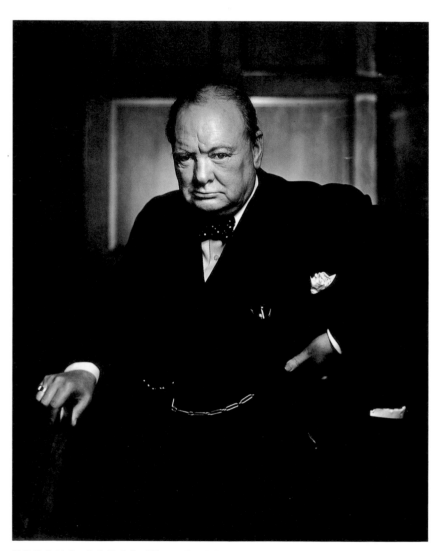

ALFRED EISENSTAEDT The Very Reverend Martin Cyril D'Arcy 1951
13½ x 10⅜"

YOUSUF KARSH Winston Churchill 1941 28 x 22"

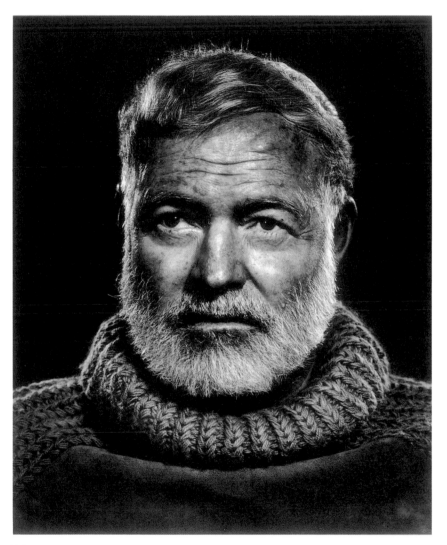

YOUSUF KARSH Ernest Hemingway 1957 16⅞ x 13⅞"

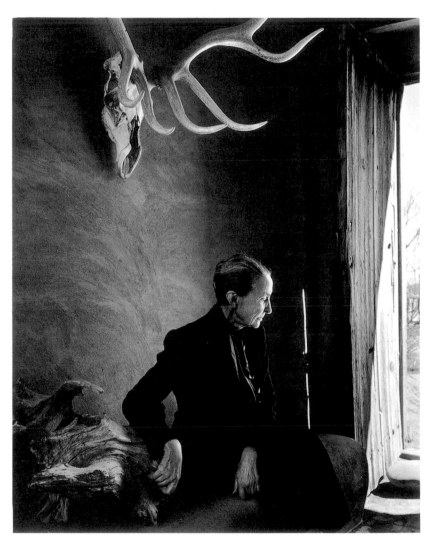

YOUSUF KARSH Georgia O'Keeffe 1956 19¾ x 16"

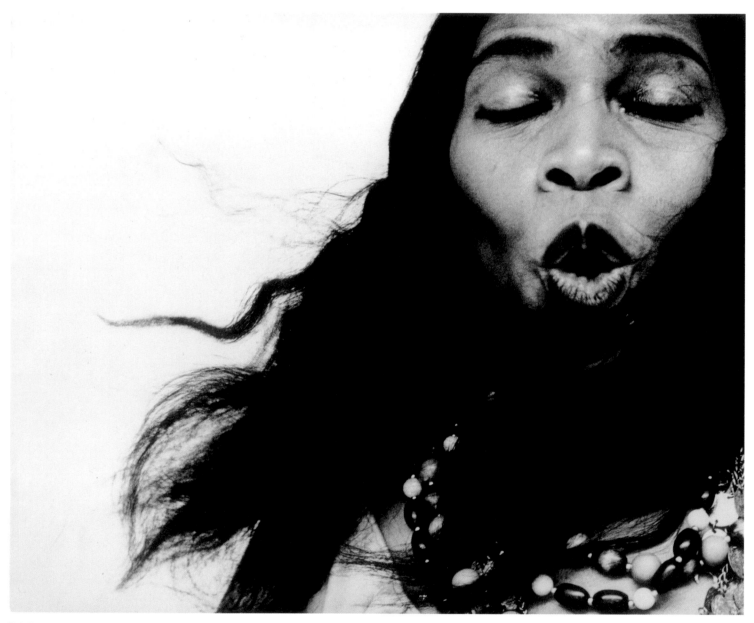

RICHARD AVEDON Marian Anderson, New York 1955 13½ x 16½"

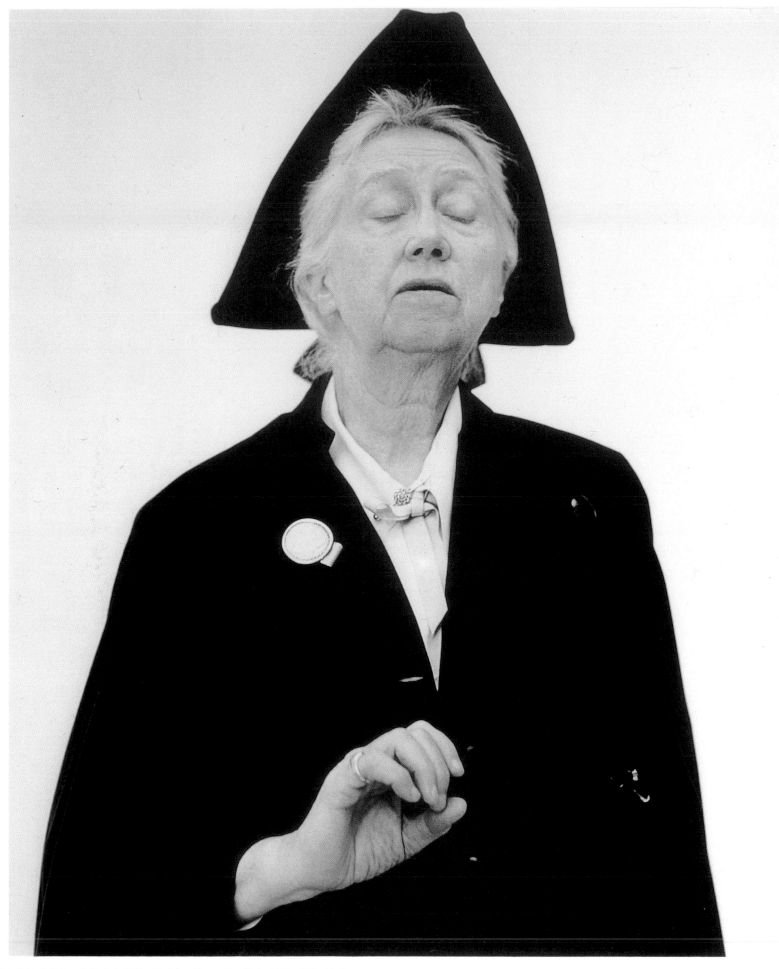

RICHARD AVEDON Marianne Moore, New York 1958 16½ x 13⅝″

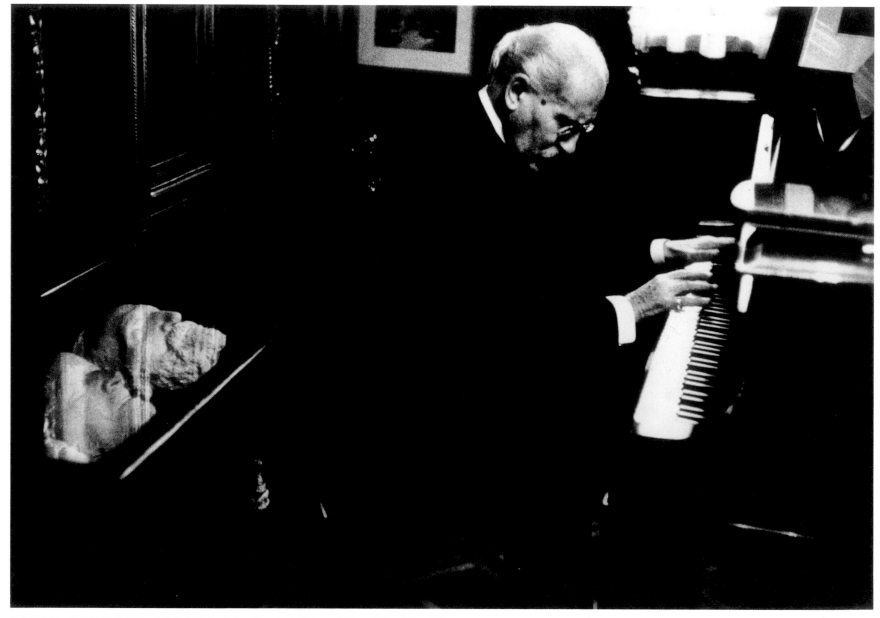

DAVID SEYMOUR "CHIM" Arturo Toscanini in his home, Milan 1954 13½ x 19½"

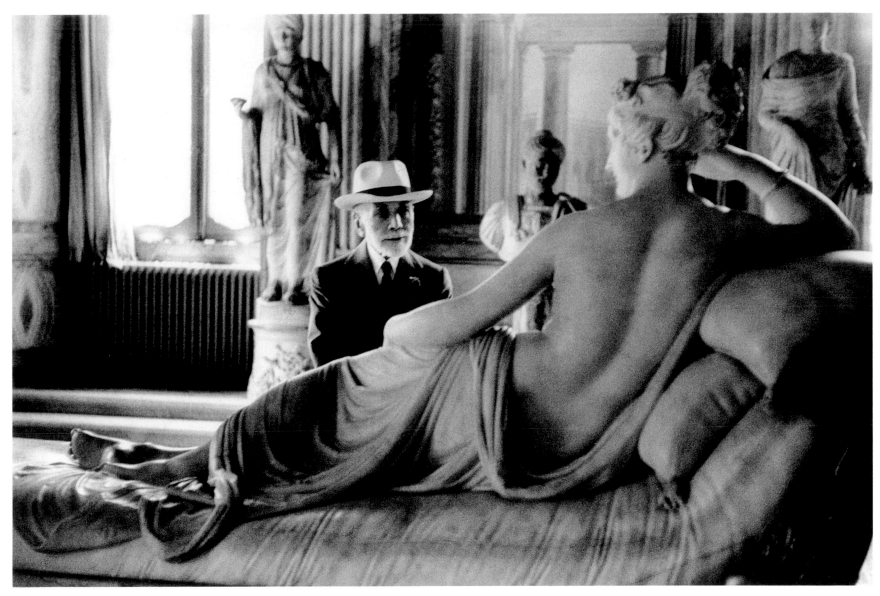

DAVID SEYMOUR "CHIM" Bernard Berenson at ninety, visiting the Borghese Gallery, Rome 1955 13 x 19¾"

H A N S N A M U T H Frederick Kiesler and Constantino Nivola 1964 13⅝ x 16½"

D E N A Willem de Kooning 1964 10½ x 13"

H . L A N D S H O F F Stieglitz at An American Place ca. 1945 13⅜ x 14⅞"

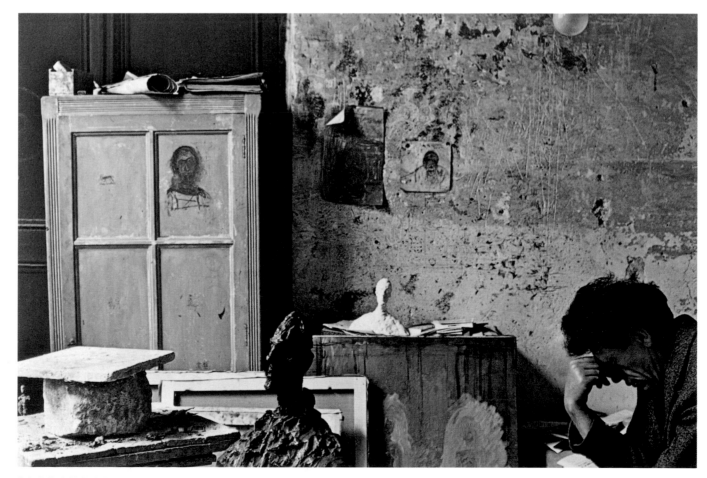

A L E X A N D E R L I B E R M A N Alberto Giacometti 1951–55 12¾ x 18⅞"

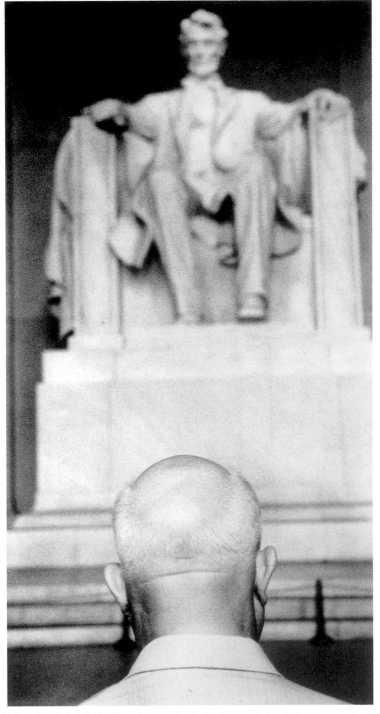

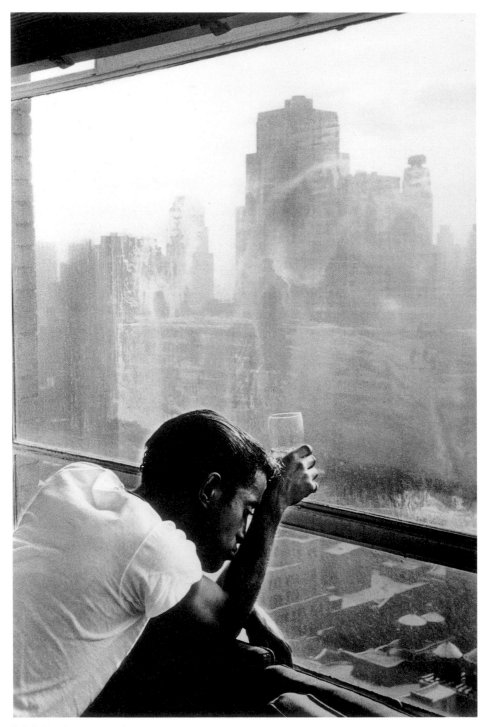

BURT GLINN Khruschev and Lincoln, Washington, D.C. 1959 19¾ x 10½"

BURT GLINN Sammy Davis, Jr. 1959 20 x 13½"

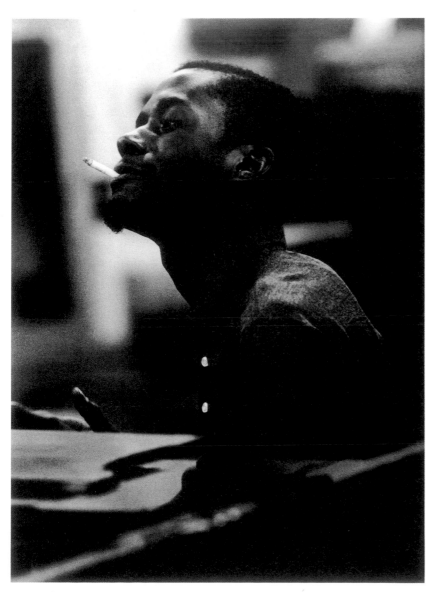

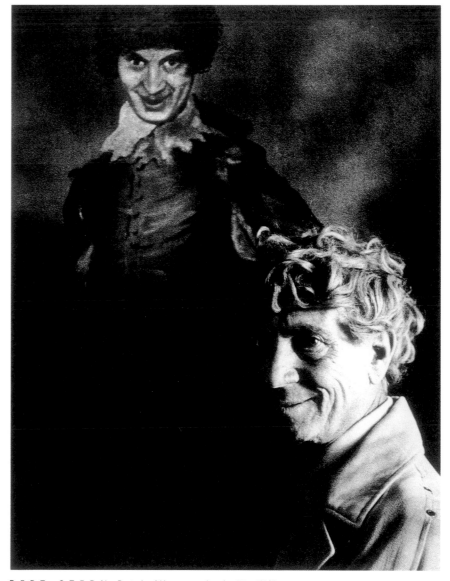

LAWRENCE SHUSTAK Jazz Composer Bobby Timmons undated 13¼ x 10"

BERT STERN Portrait of Harpo undated 14 x 10¾"

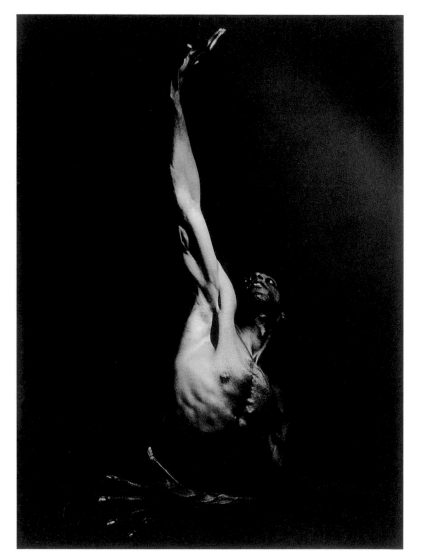

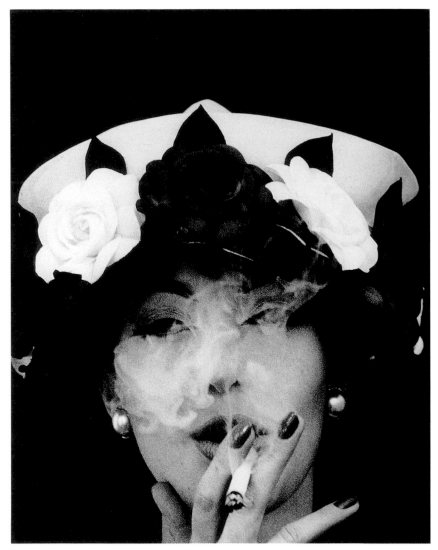

PETER FINK Charles Moore, Dancer undated 19½ x 14¼"

WILLIAM KLEIN Girl with Flowered Hat, Paris 1956 19⅜ x 15¼"

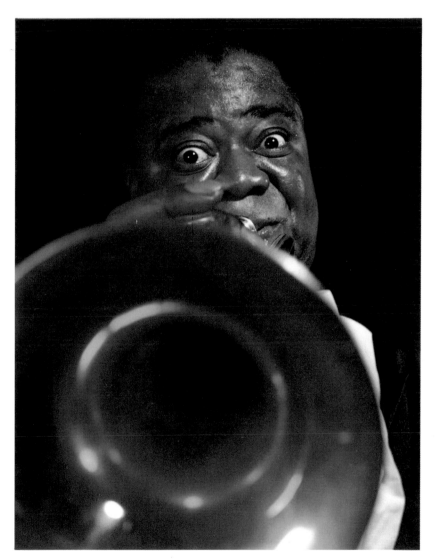

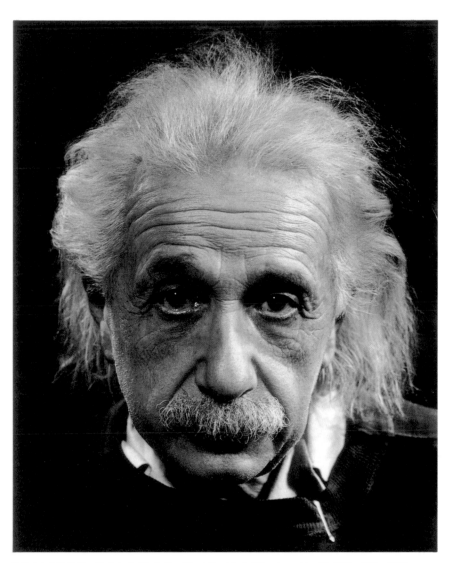

E L I O T E L I S O F O N Louis Armstrong 1954 16 x 13½"

P H I L I P P E H A L S M A N Albert Einstein in Princeton May 10, 1947 19½ x 15½"

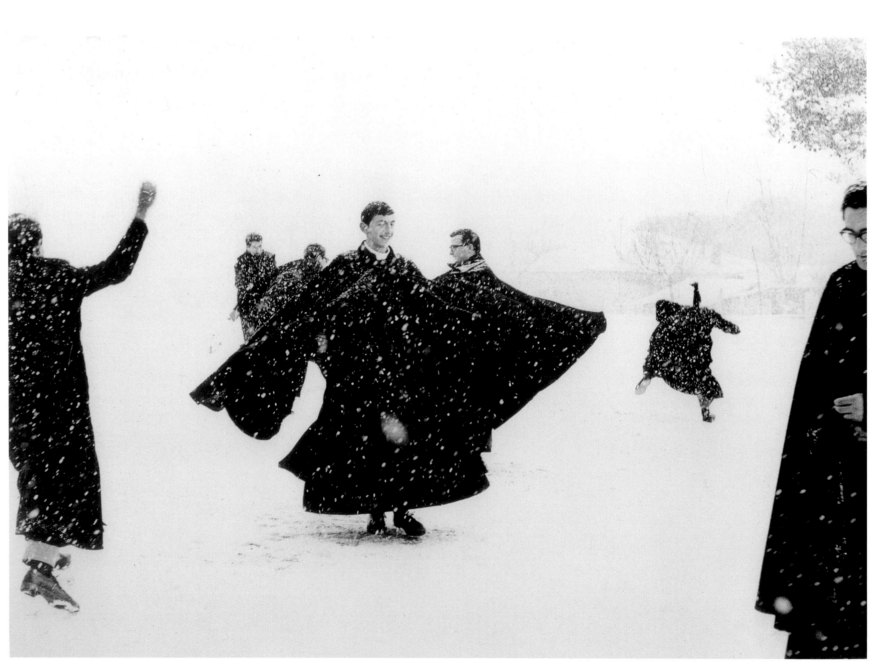

MARIO GIACOMELLI Pretini 1962–63 11¼ x 15½″

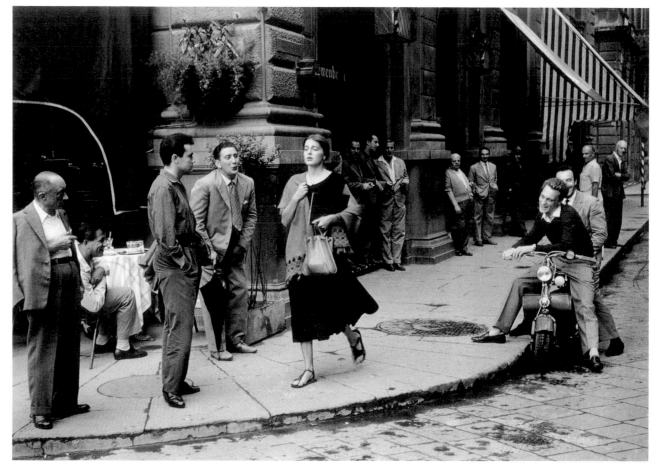

RUTH ORKIN American Girl in Italy 1951 9¾ x 13⅝"

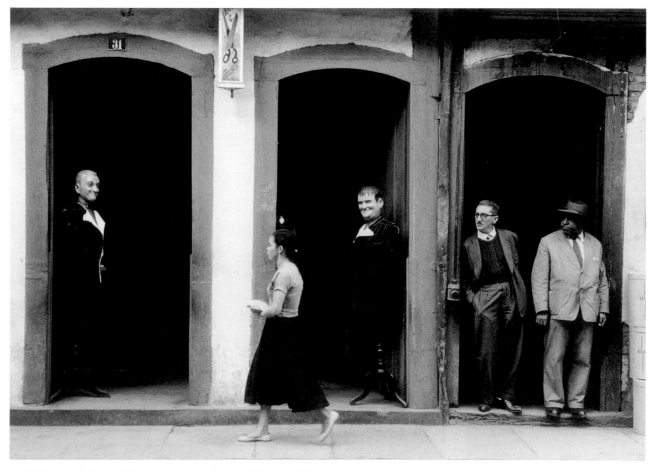

ESTHER BUBLEY Brazilian Street Scene 1956 14 x 19⅝"

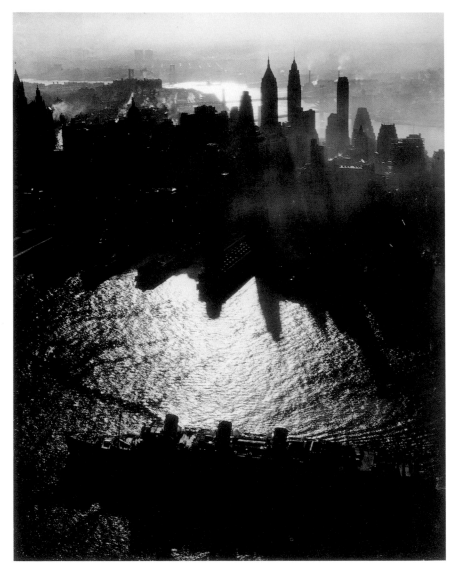

GEORGE SILK Nefertiti from the Mast 1962 20½ x 15⅞"

WILLIAM SAMENKO JR. Morning Arrival 1959 20 x 15¾"

GEORGE SILK Jet Fighters over Thule AFB 1953 15½ x 15½"

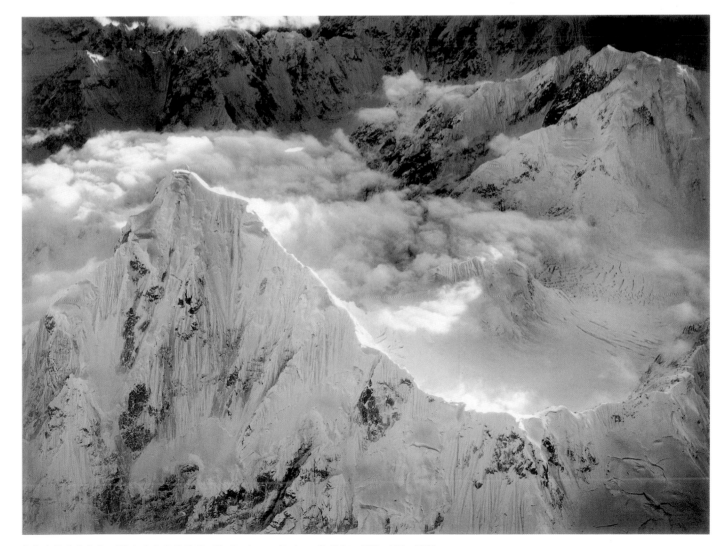

BRADFORD WASHBURN Mt. Huntington, Alaska, at Twilight 1964 14⅛ x 18¼"

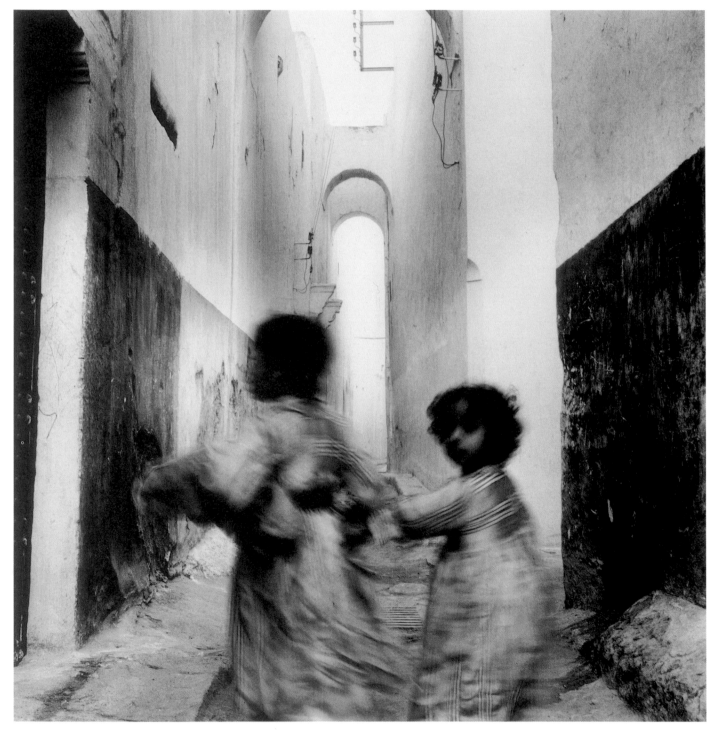

I R V I N G P E N N Running Children, Morocco 1951 18 x 17½"

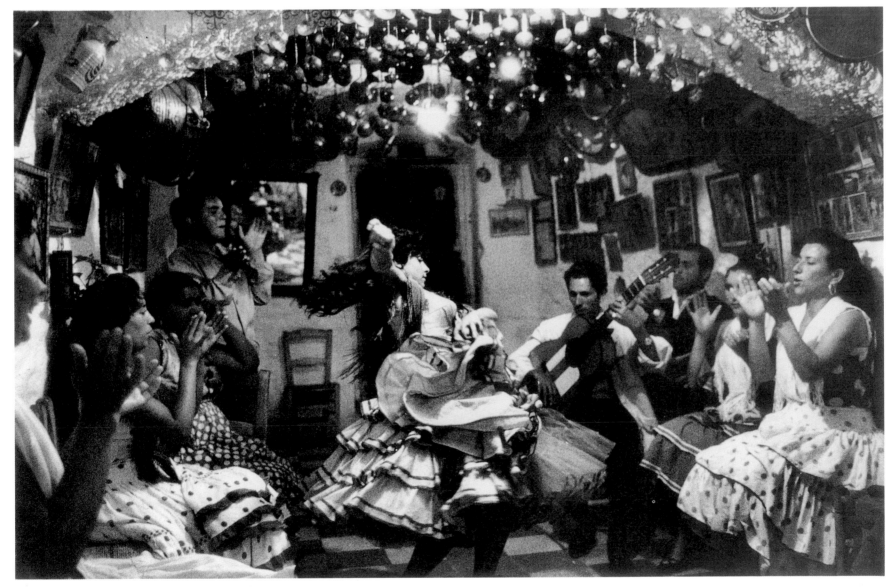

A L E X A N D E R L I B E R M A N Spanish Dancer 1963 10⅞ x 16½"

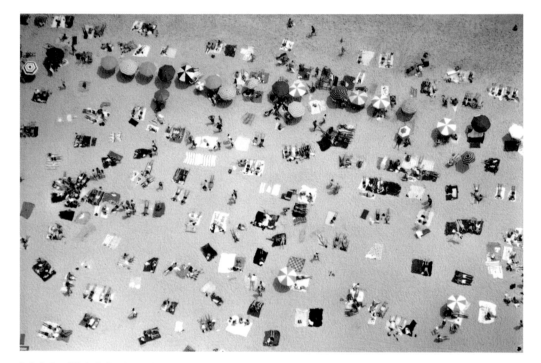

FRED WARD Aerial, Beach ca. 1966 11⅛ x 16¾"

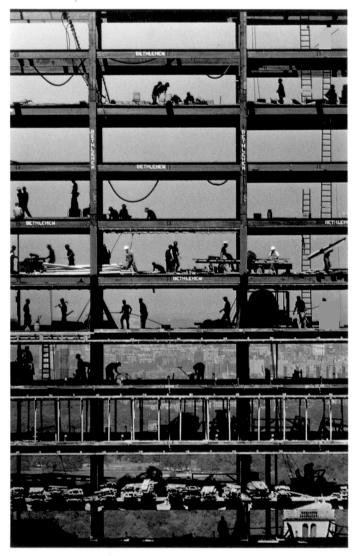

LEE LOCKWOOD New York Hilton Hotel under Construction 1962
18⅝ x 11¾"

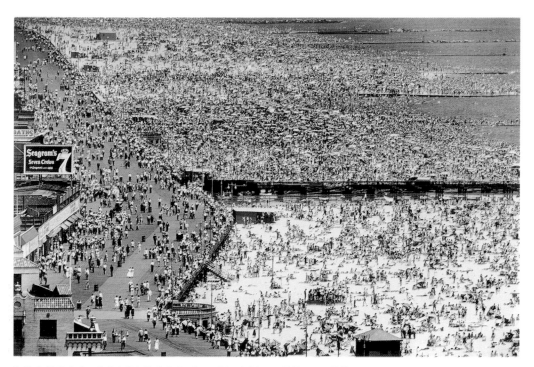

ANDREAS FEININGER Coney Island, July 4 1949 11 x 16⅜"

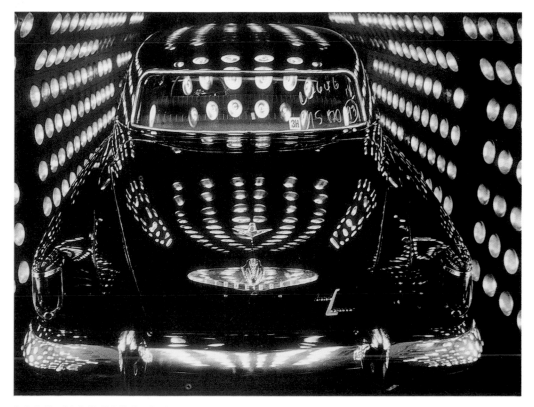

JACK MANNING Car Drying ca. 1953 14⅜ x 18⅞"

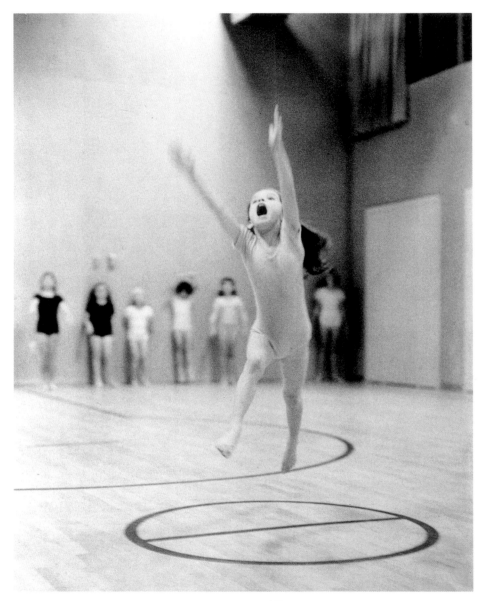

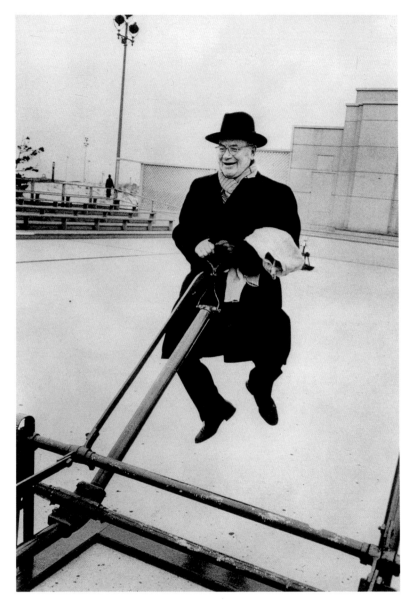

W A Y N E M I L L E R Dance Class 1956 16⅜ x 13⅛″

A R T H U R L E I P Z I G Grandpa at Jones Beach 1956 13⅛ x 8¾″

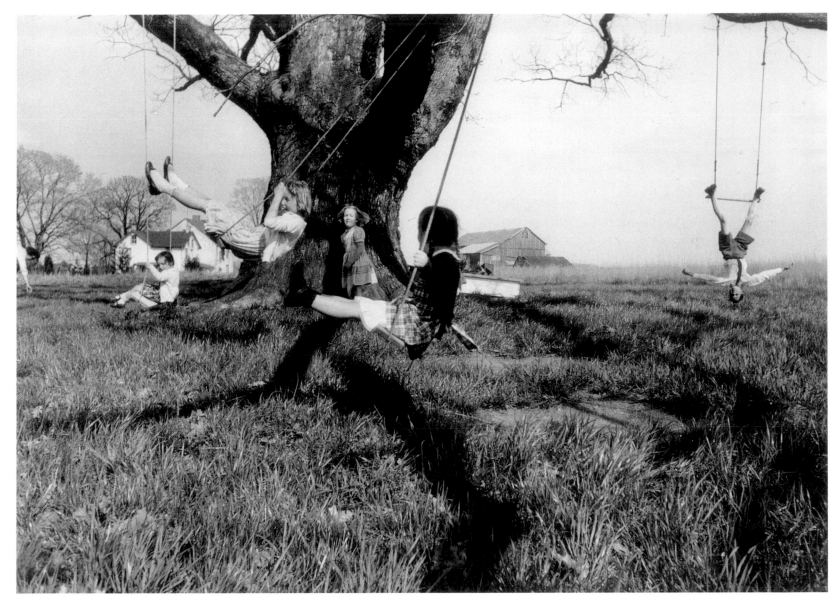

FRANCES McLAUGHLIN-GILL April Afternoon 1956 12 x 16⅝"

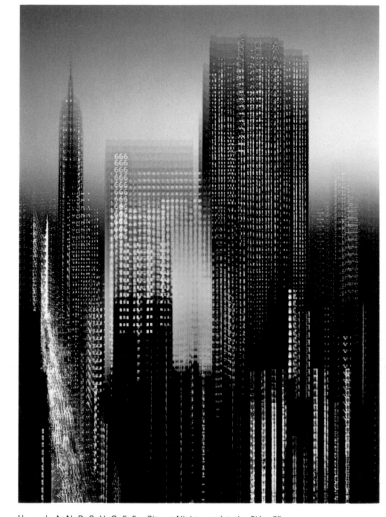

A N D R E A S F E I N I N G E R Intersecting Walls at GM's Technical Center 1955 9½ x 11⅞"

H . L A N D S H O F F City at Night undated 8¼ x 6"

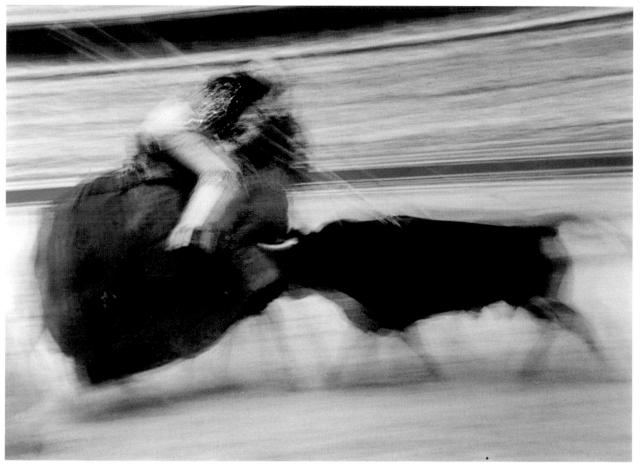

ERNST HAAS Bullfight 1954 13⅞ x 19″

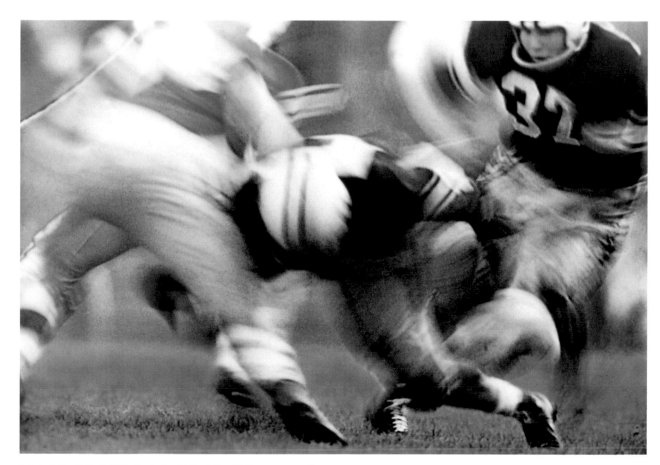

JERRY COOKE Football 1952 13¼ x 19¼″

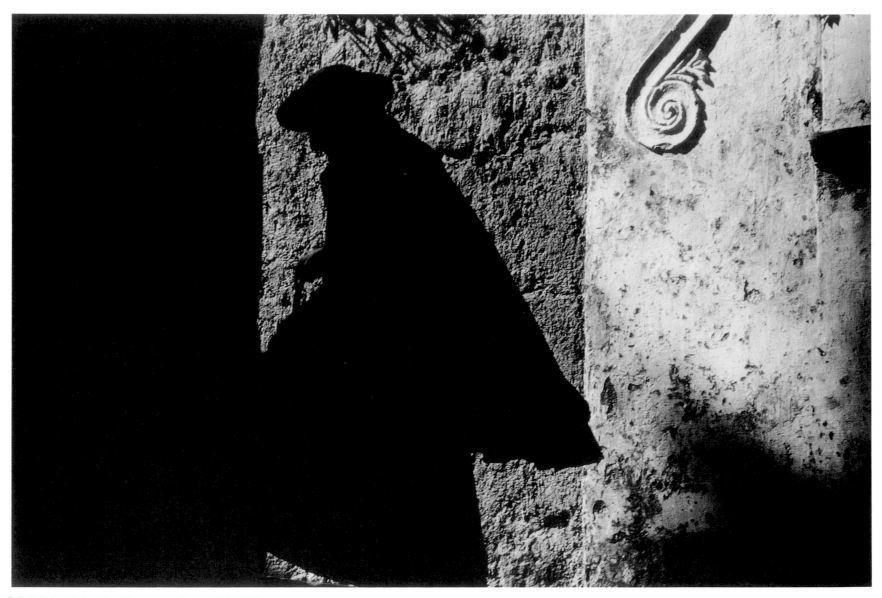

E R N S T H A A S Silhouette undated 10⅞ x 16⅜″

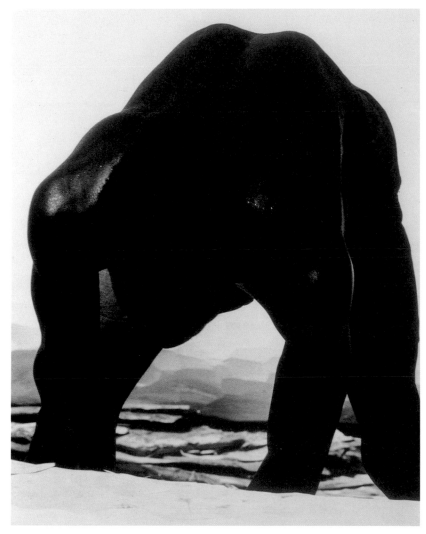

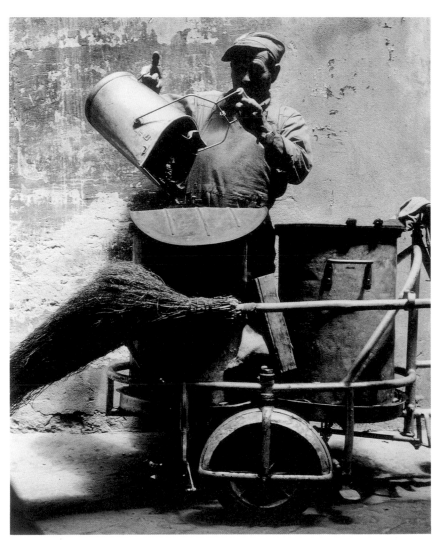

KEN HEYMAN Nigerian Railsplitter 1960 19¾ x 15⅞"

EVELYN HOFER Streetcleaner, Florence 1958 16⅞ x 13⅞"

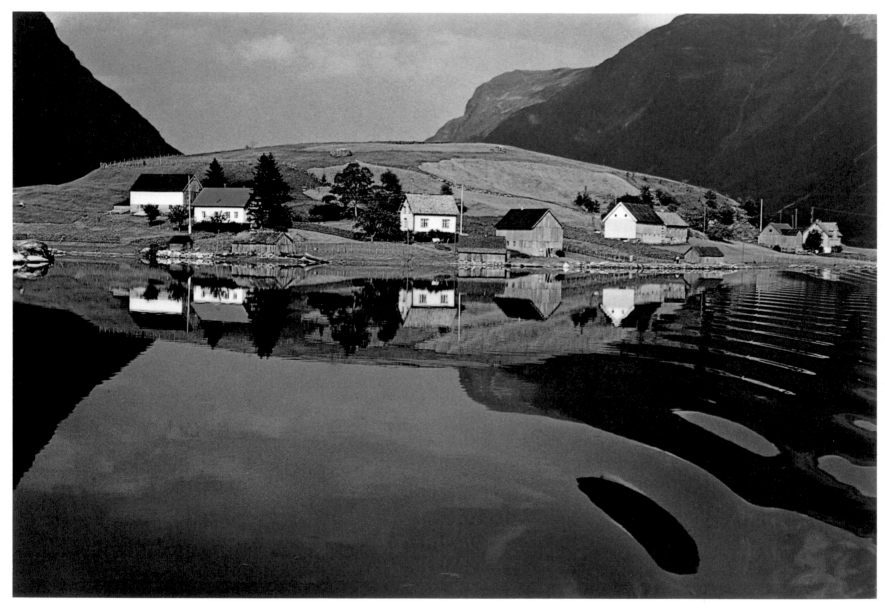

ERNST HAAS Norwegian Fjord 1959 12⅞ x 19″

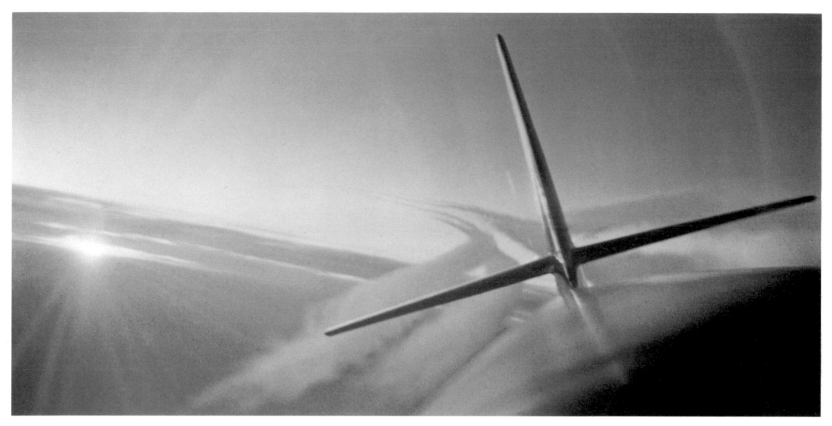

HOWARD SOCHUREK High Altitude Flight 1956 9¾ x 19⅜"

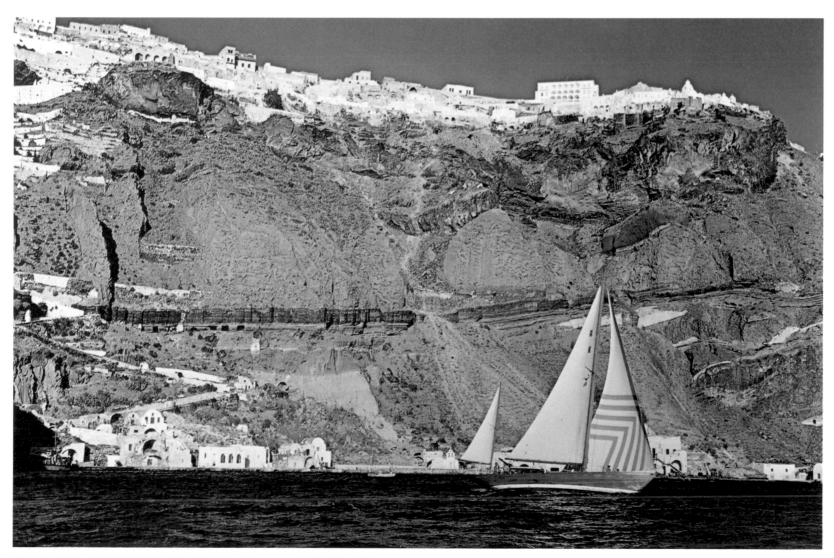

GILBERT GROSVENOR Thira Island, Greece undated 10¼ x 15½"

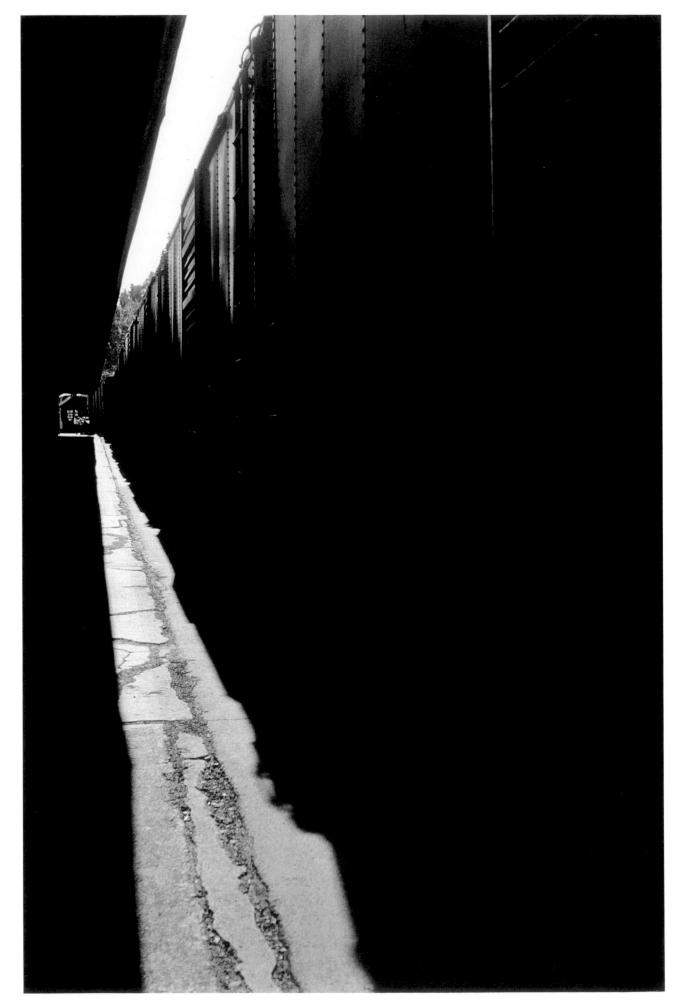

LOUIS STETTNER Freight Cars ca. 1954 12⅛ x 18¼″

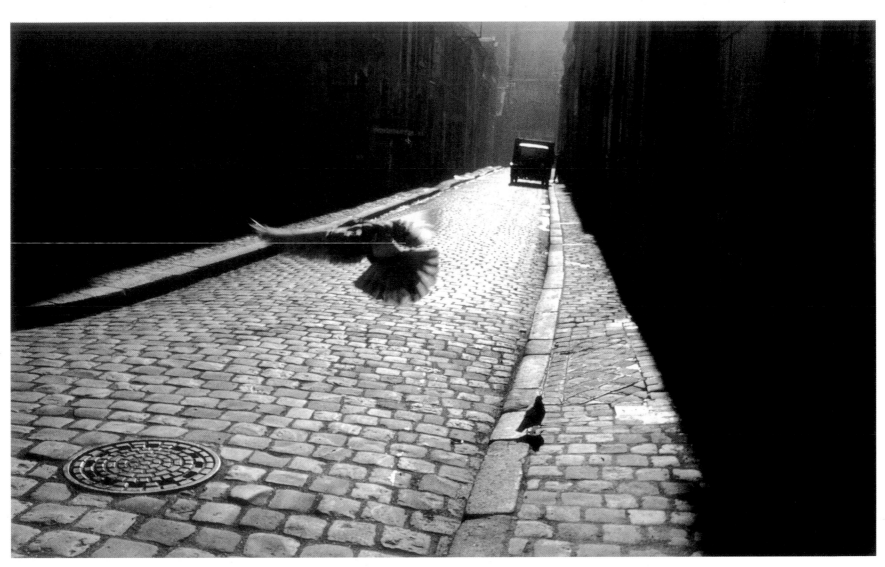

E L L I O T T E R W I T T Street Scene, Orléans, France 1952 11¼ x 18⅛"

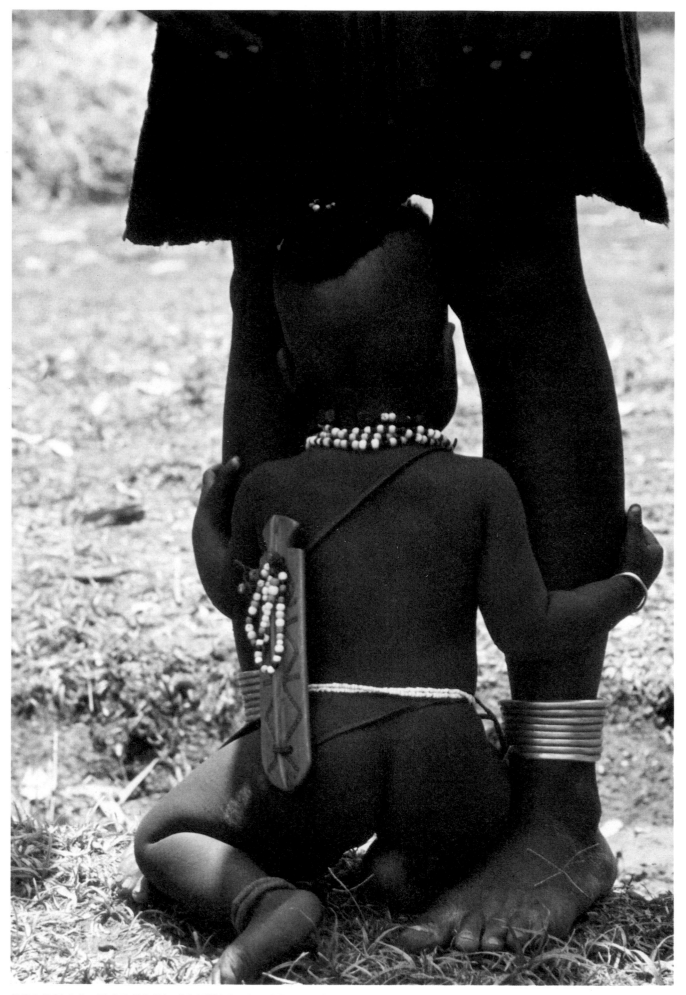

VOLKMAR WENTZEL Kubal Child, Angola 1960 14 x 9⅝"

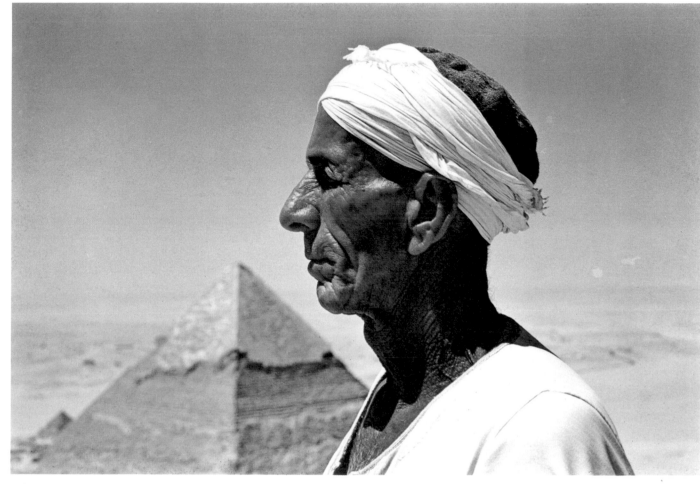

JOSEPH VEACH NOBLE The Egyptian 1960 9½ x 14"

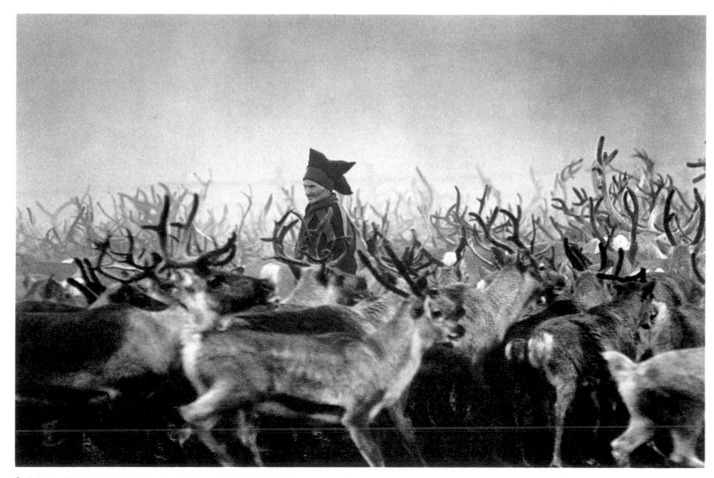

PAUL FUSCO Reindeer, Finland ca. 1961 12⅞ x 19½"

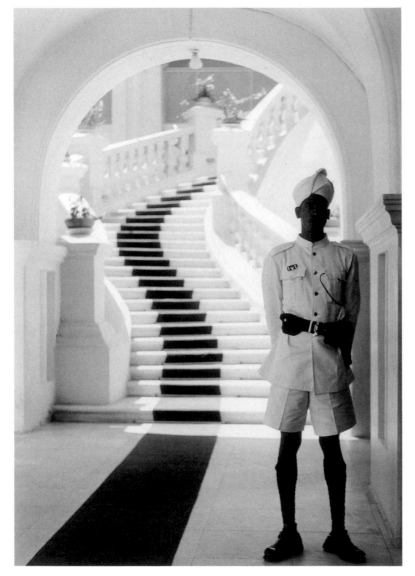

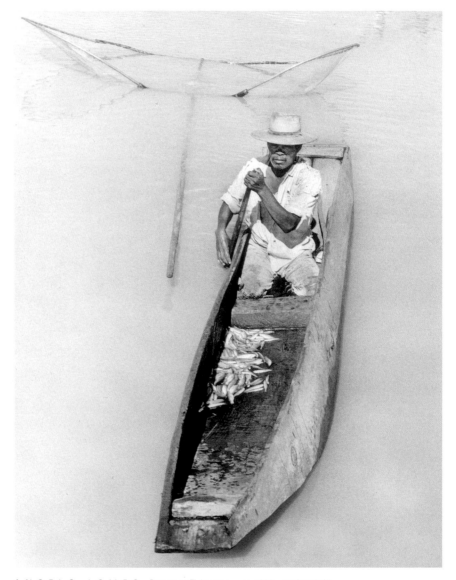

MONETA SLEET A Staircase in Khartoum 1957 13½ x 9½″

ANGELO LOMEO Patzcuaro Fisherman ca. 1958 13½ x 10⅝″

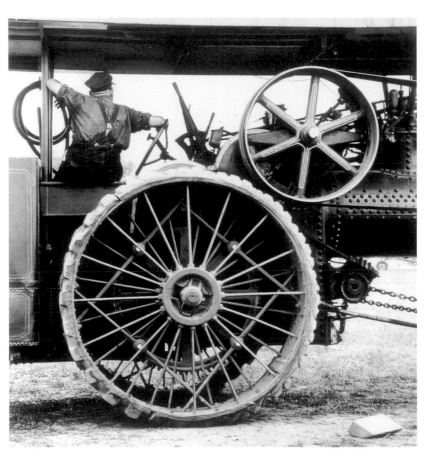

DAVID PLOWDEN Steam Traction Engine 1960 11 x 10½"

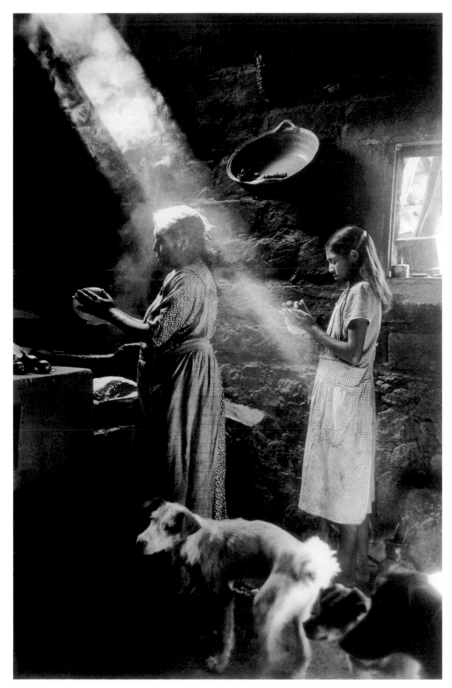

LEONARD McCOMBE Farm Kitchen, Mexico 1949 13⅝ x 8⅞"

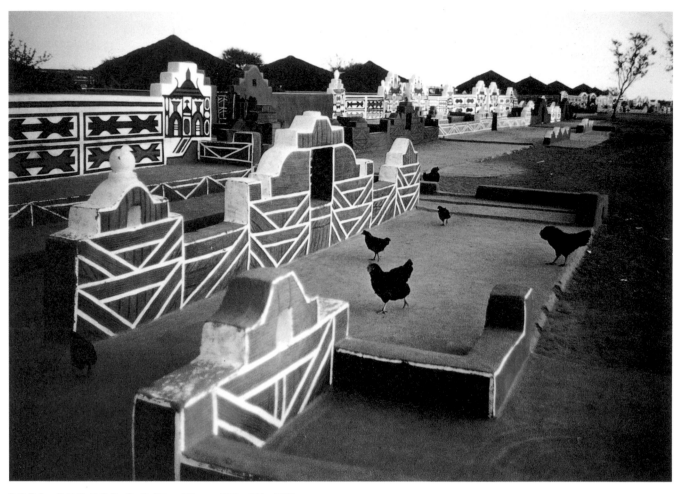

PETE TURNER South African Village 1959 13½ x 19⅛"

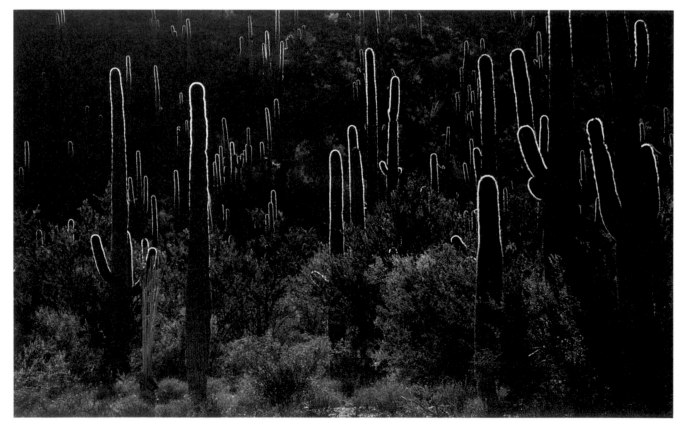

ROBERT F. SISSON Giant Saguaro Cacti undated 7¾ x 12¾"

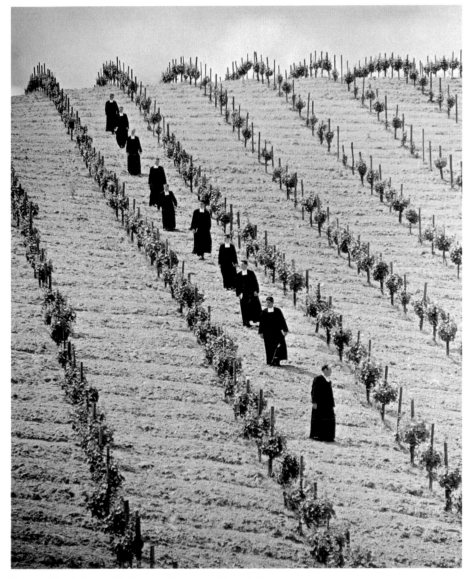

RALPH CRANE Terraced Vineyard 1962 14 x 11¼"

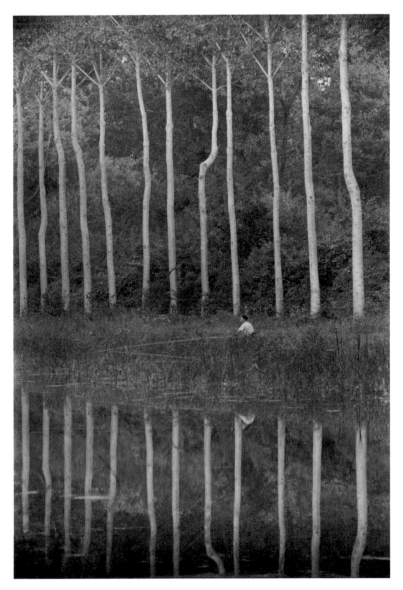

IRVING PENN Fisherman with Poplars, France 1951 19½ x 13⅛"

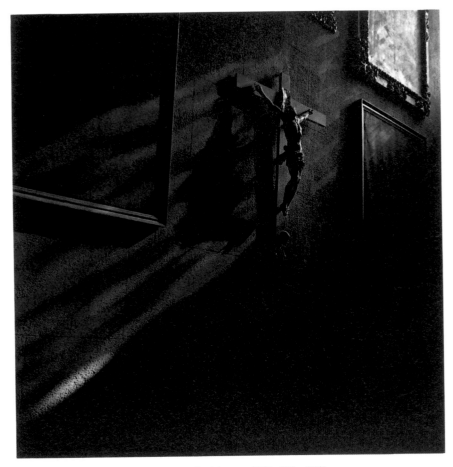

DMITRI KESSEL Crucifix in Cordoba ca. 1952 16¼ x 15¾"

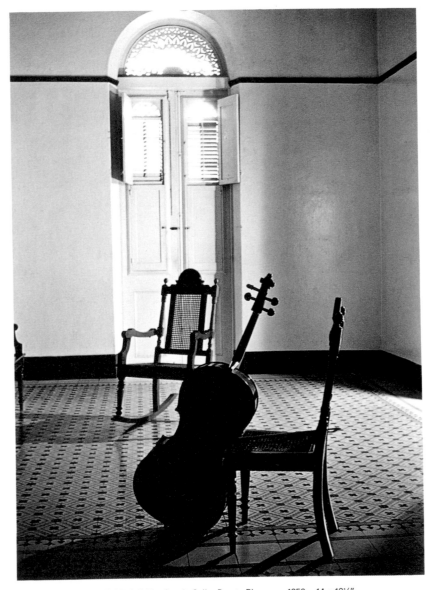

ELLIOTT ERWITT Casals Cello, Puerto Rico ca. 1956 14 x 10⅛"

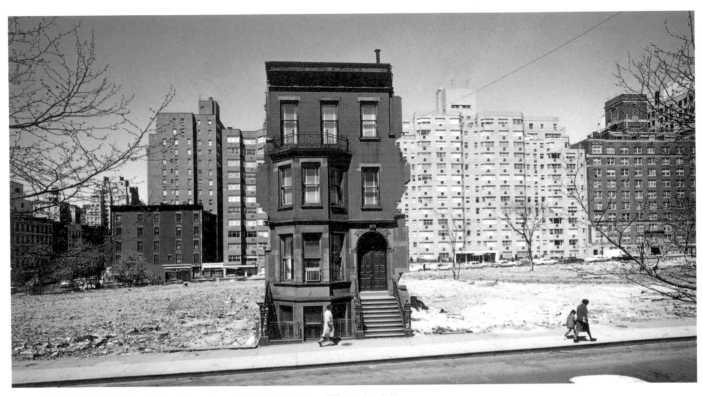

D M I T R I K E S S E L The Lone Brownstone, East 60's, New York 1958 10¾ x 19¾"

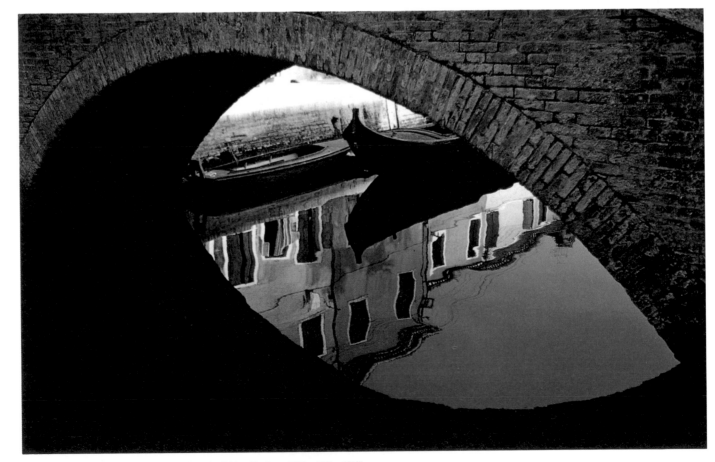

S O N J A B U L L A T Y Gondola under Bridge, Venice 1962 12⅜ x 19¼"

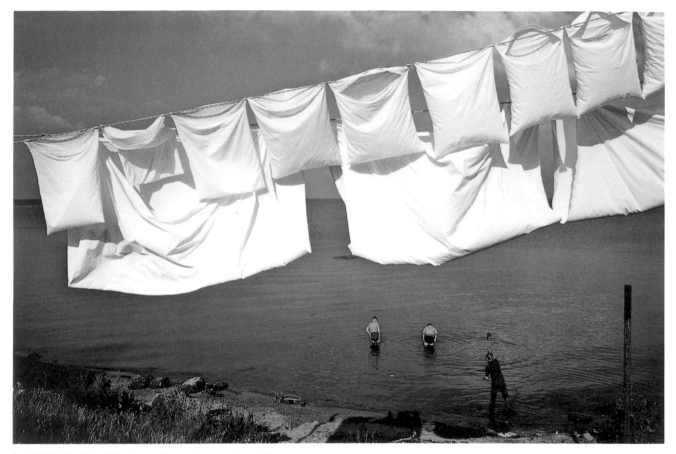

ALFRED BOCH Clothesline undated 11½ x 17⅛″

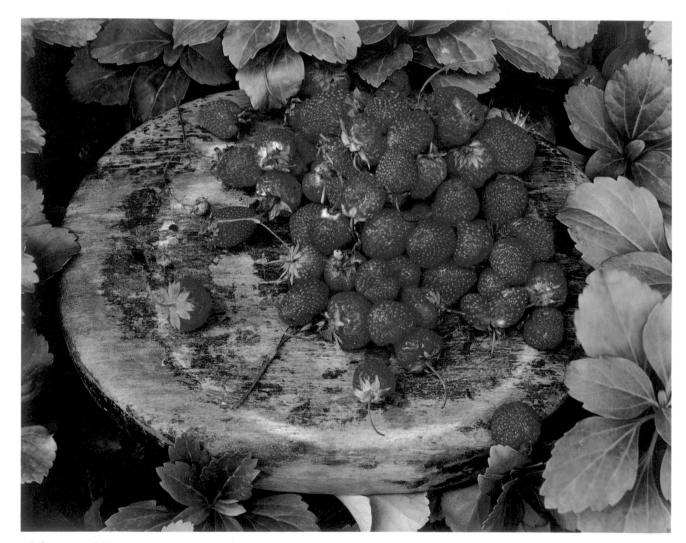

LEON KUZMANOFF Strawberries 1962 15⅜ x 19½″

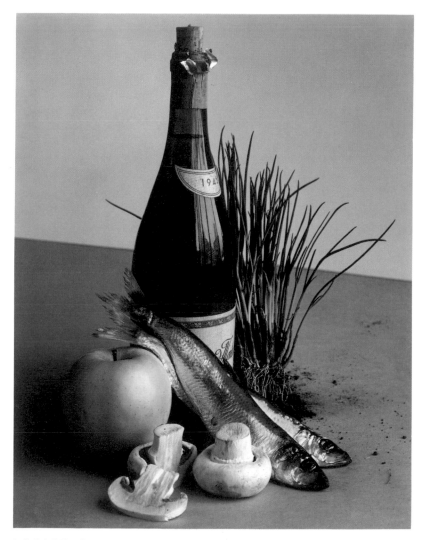

L E S L I E G I L L Fish and Bottle 1952 19½ x 15½"

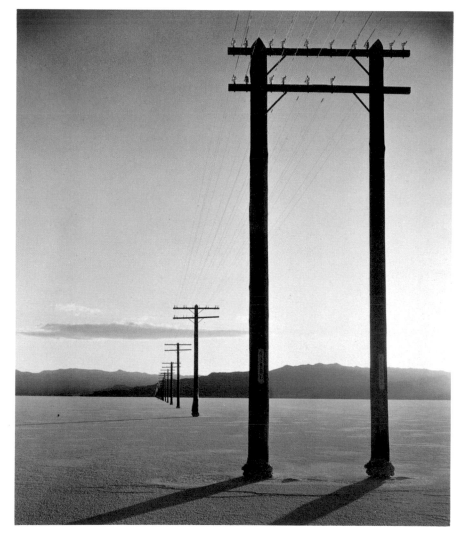

F R I T Z G O R O The Great Salt Desert 1948 11⅝ x 9⅞"

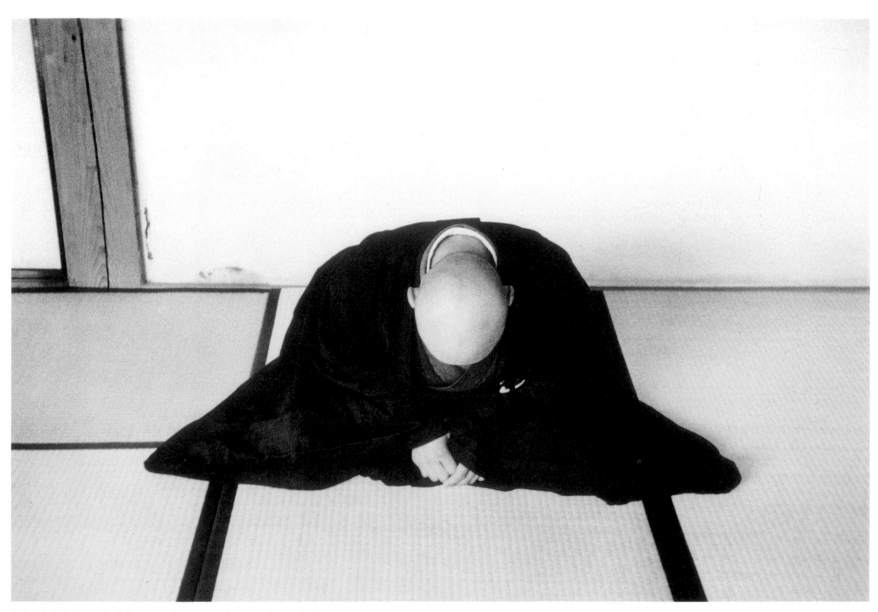

SHELDON BRODY Zen Buddhist Monk undated 9 x 13¼"

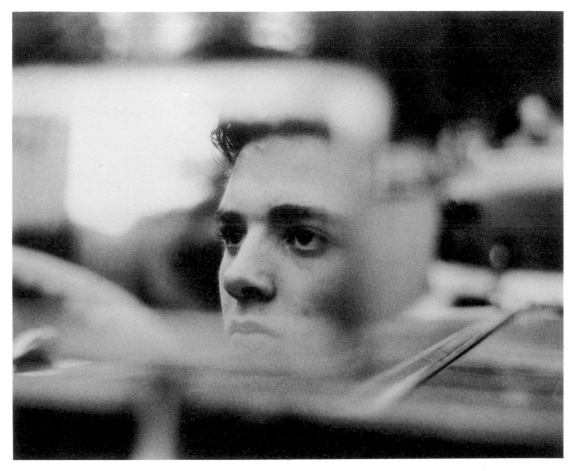

CHARLOTTE BROOKS Teen-Age Driver 1958 13½ x 16½″

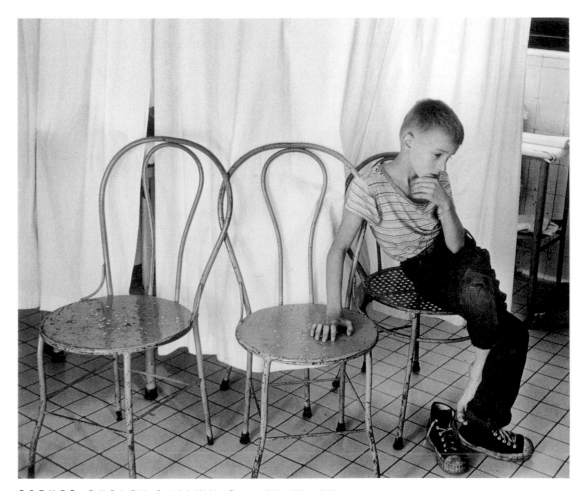

ESTHER BUBLEY St. Luke's Waiting Room 1951 16⅜ x 19¾″

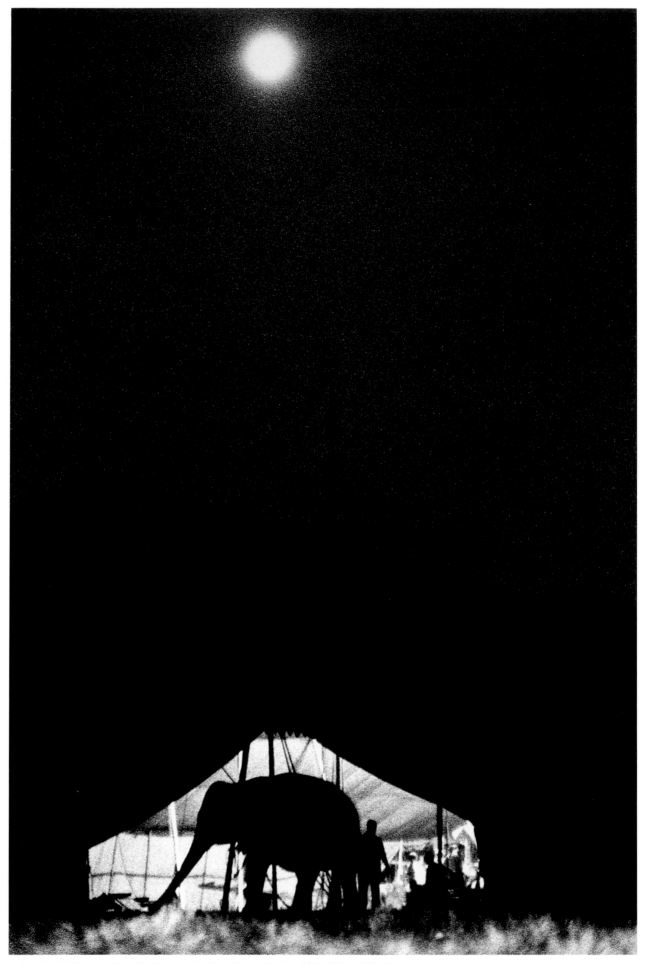

CHARLES HARBUTT Christiani Bros. Circus, Hoboken, N.J. 1957 13½ x 9"

EMIL SCHULTHESS Antarctica 1958 13¼ x 19¾"

FRITZ HENLE König-See and St. Bartolome, Bavarian Alps 1960 12⅜ x 19⅛"

GEORGE LEMOINE Snowstorm in the Park 1961 10½ x 16¼"

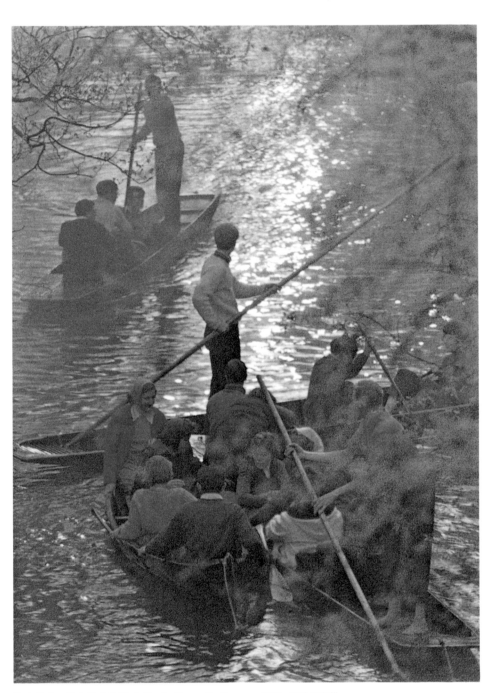

M O R T O N B E E B E Chilean Alps undated 17⅞ x 9⅝"

M A R K K A U F F M A N Punting on the Thames 1958 14¾ x 10⅝"

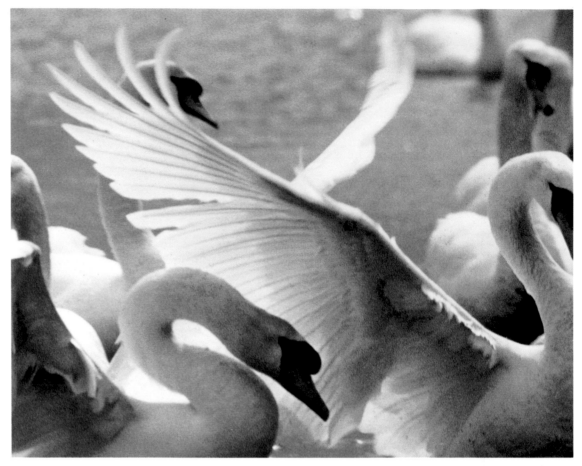

S N O W D O N Mute Swans undated 15½ x 19½"

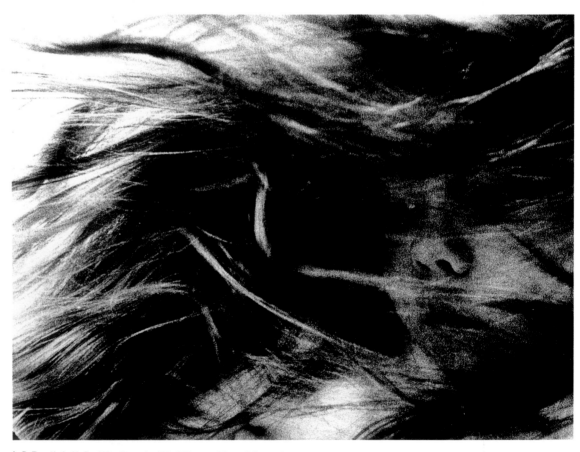

A R T K A N E Why Does the Wind Blow 1961 13⅛ x 17¼"

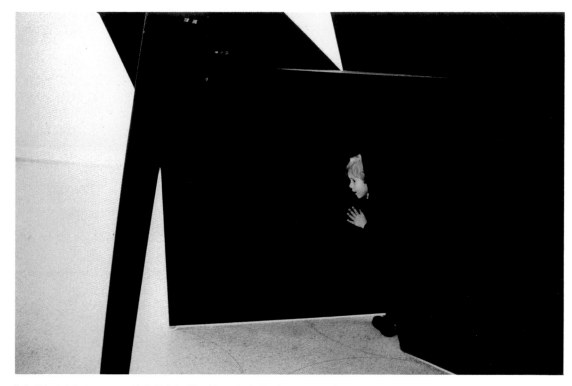

ADELAIDE de MENIL The Alexander Calder Exhibit at the Guggenheim Museum, New York City 1965 9 x 13½"

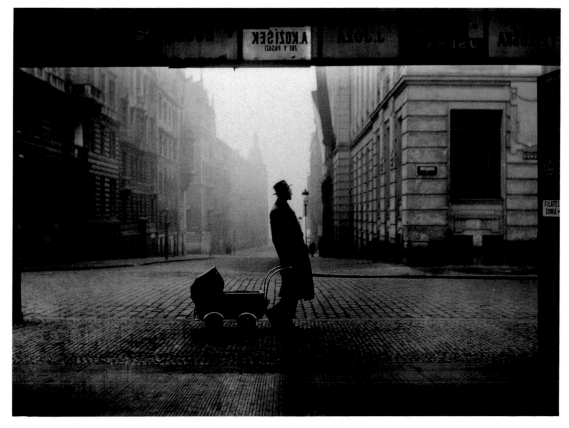

MILADA EINHORNOVA A Father in Prague undated 11⅝ x 15½"

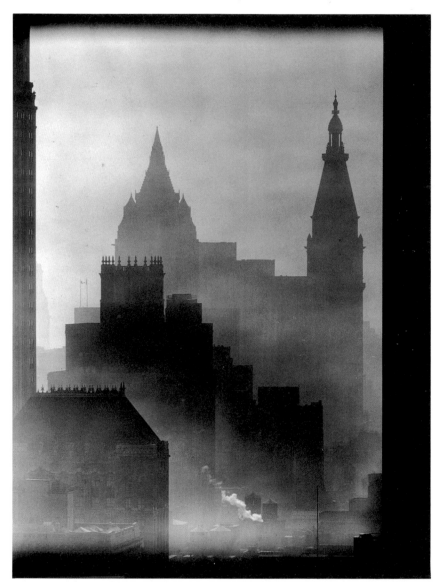

YALE JOEL Fog, New York ca. 1952 19¼ x 14⅛"

EMIL SCHULTHESS Golden Gate Bridge 1953 15 x 15½"

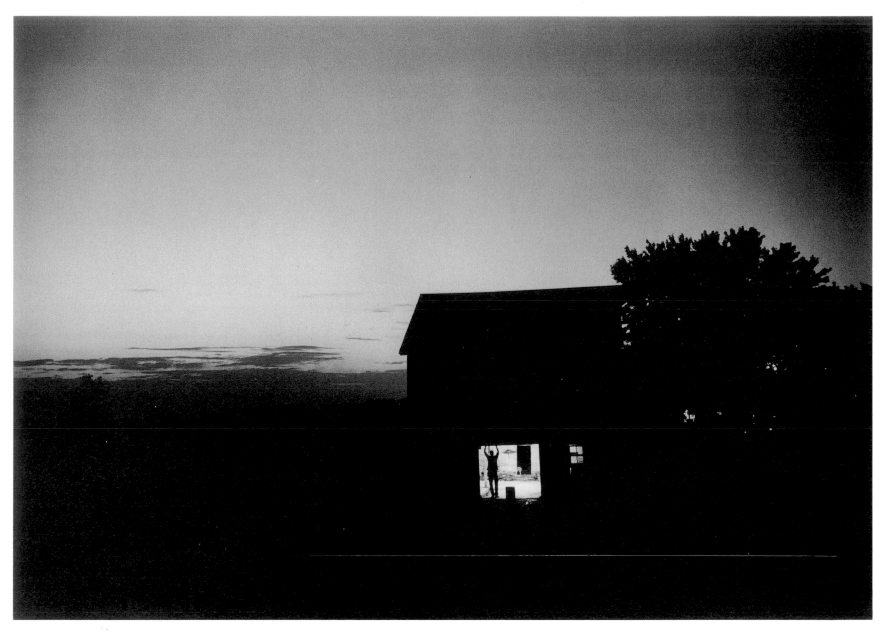

ARCHIE LIEBERMAN Farm Silhouette 19 September 1959 12⅛ x 17⅛″

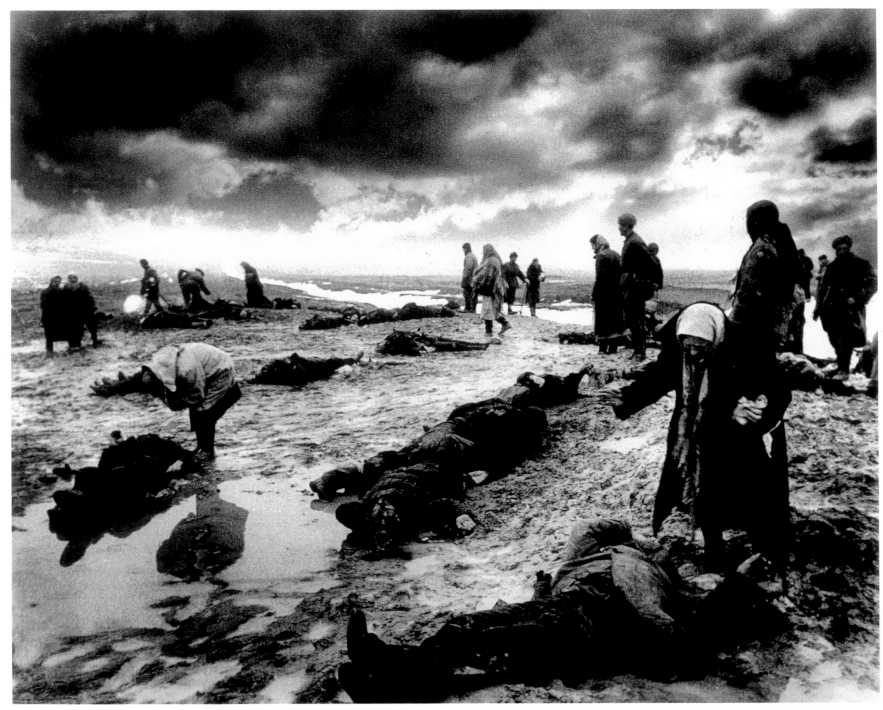

DMITRI BALTERMANTS Grief, Ditch of Kerch, Crimea 1942 13¼ x 16⅜"

The documentary photographs in the PFA exhibitions originated as records, whether of the momentous or the mundane, and were first shown in reproduction in mass magazines. These pictures initially claimed attention as eyewitness reports of events conceived to be of broad popular interest, and their clear presentation of action and ideas and their skill at swiftly arousing emotion were felt to be retained even after they were isolated in PFA exhibitions from their sequences in magazine photo-essays. None documented breaking news by the time they appeared in PFA. The distance of time and decontextualization decreased their narrative specificity while heightening their esthetic and expressive force, allowing the liberal, humanistic values of their photographers to come to the fore. Thus, combat photographs during World War II and Korea were already icons of the horror and heroism of war when PFA circulated them, and certain photojournalists were recognized far beyond the stories that had brought them celebrity. Documentary and illustrative photographs were the best represented genres in PFA, thanks to Dmitri's associations with *The Saturday Evening Post*, the *Saturday Review*, and other magazines, and with numerous photo agencies and societies.

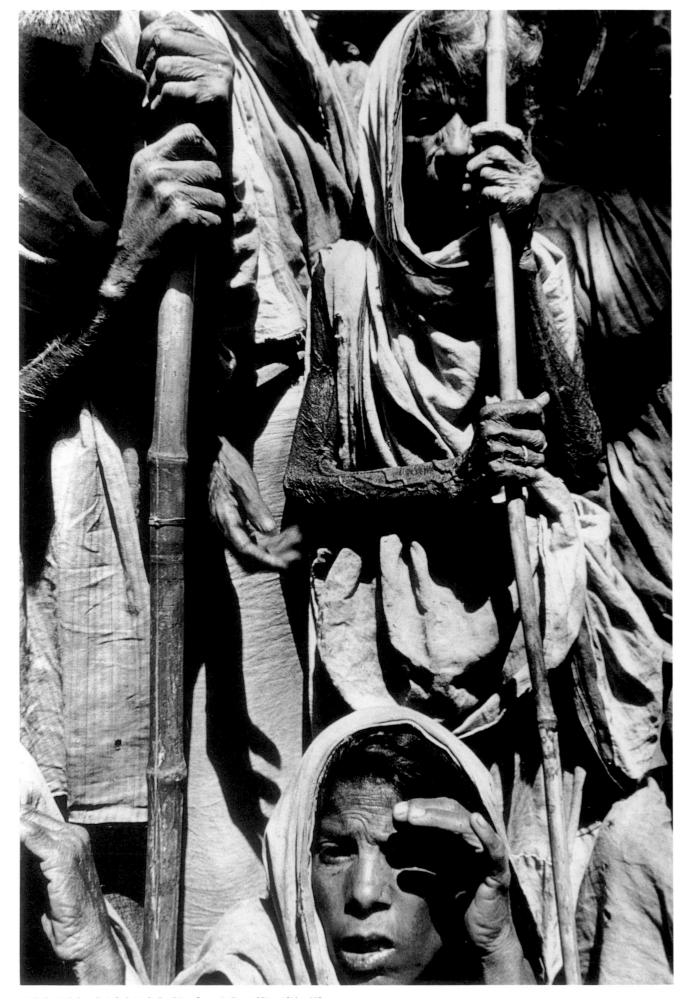

WERNER BISCHOF Bihar State, India 1951 16½ x 11″

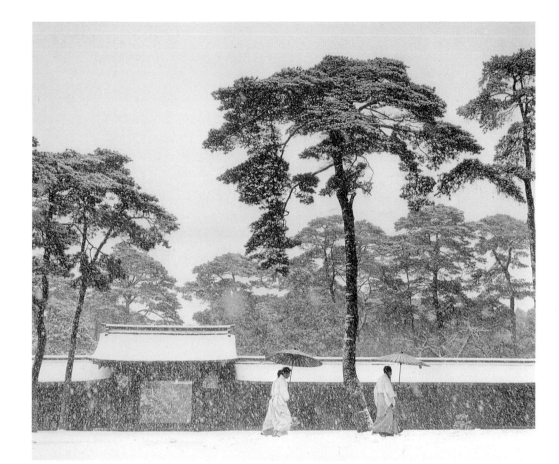

W E R N E R B I S C H O F Shinto Priests in the Garden of Meiji Temple, Tokyo 1951 14⅝ x 16½"

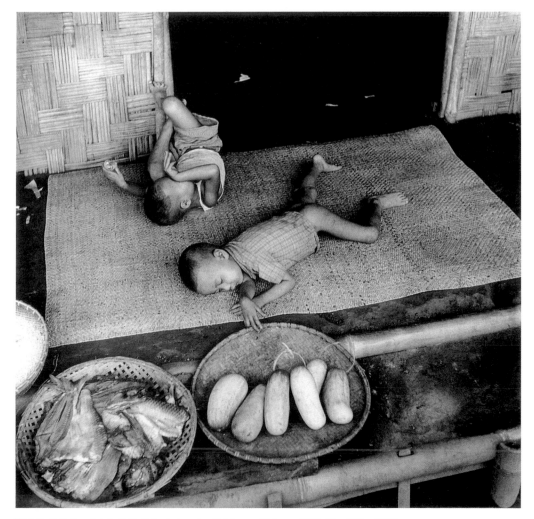

W E R N E R B I S C H O F Indonesian Children on Mat ca. 1951–52 15½ x 15½"

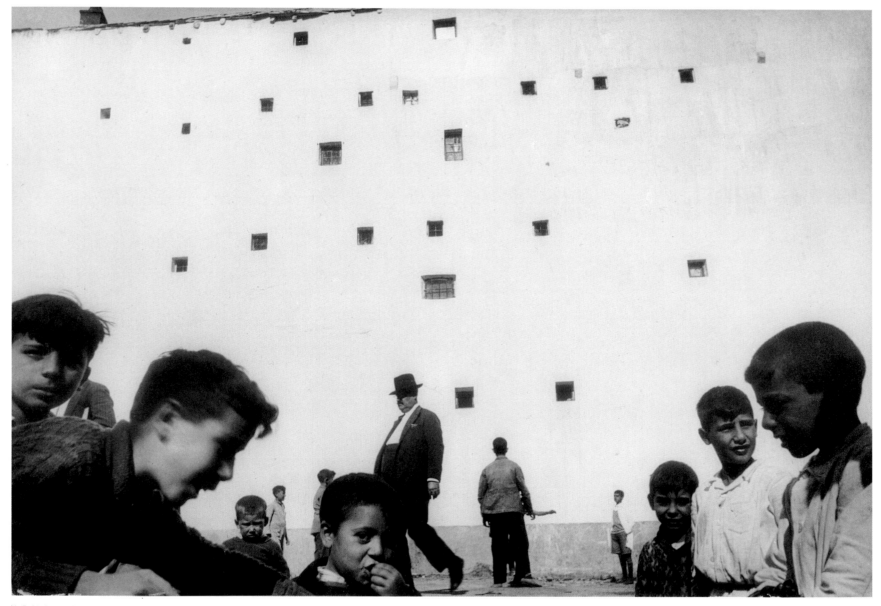

HENRI CARTIER-BRESSON Madrid 1933 19⅜ x 28⅛″

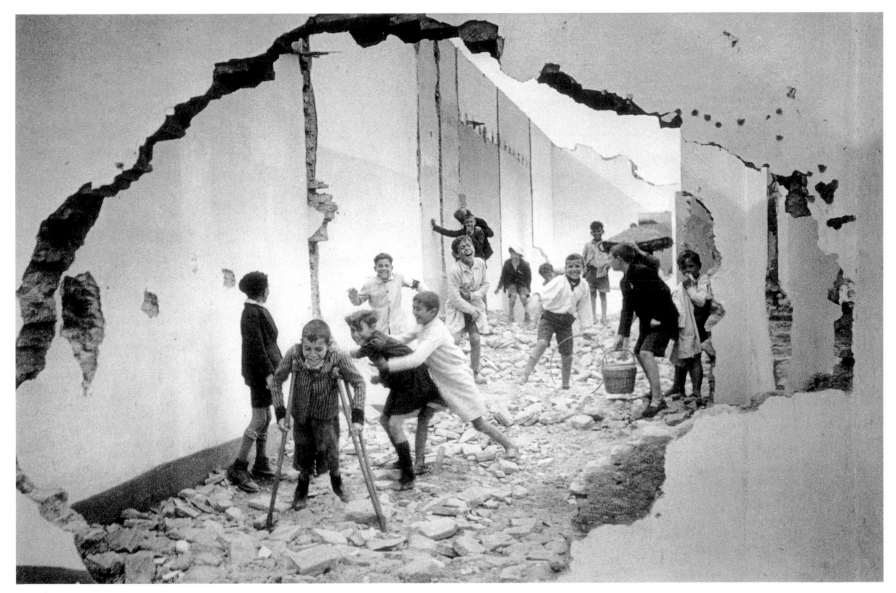

HENRI CARTIER-BRESSON Seville, Spain 1933 18⅞ x 26⅝"

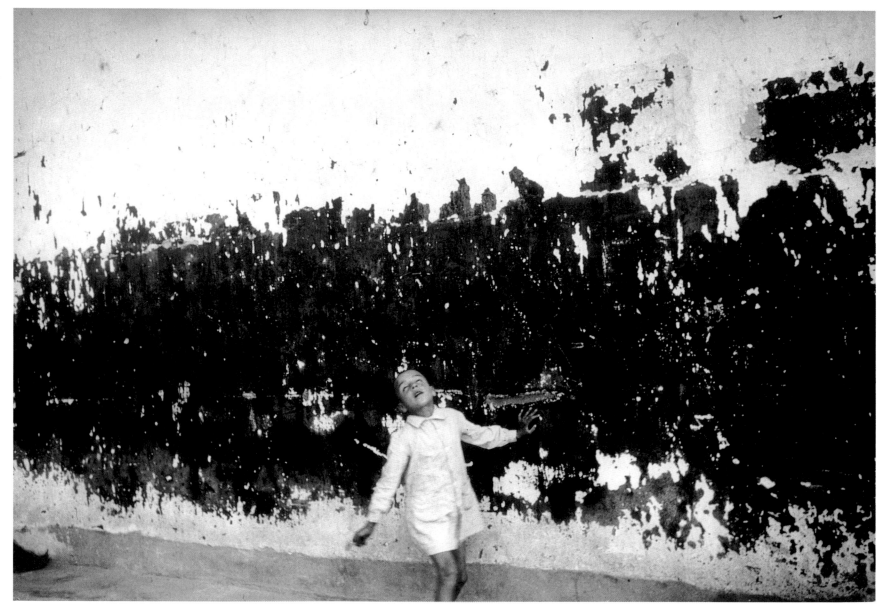

HENRI CARTIER-BRESSON Valencia, Spain 1933 19⅛ x 28"

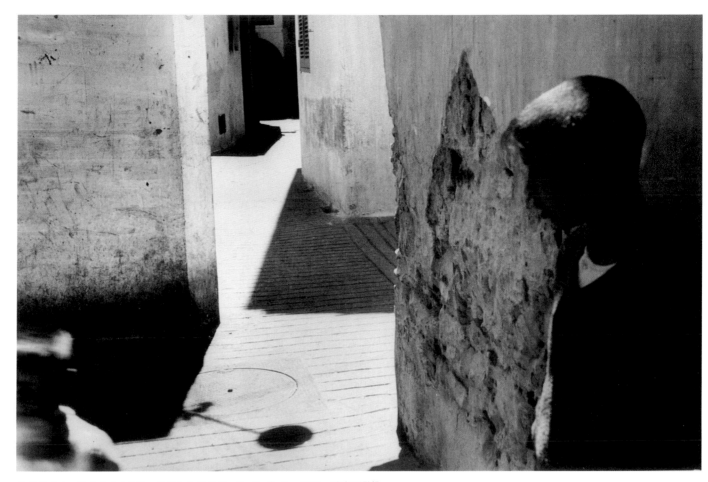

HENRI CARTIER-BRESSON Seville, Spain 1932 10¼ x 15⅜"

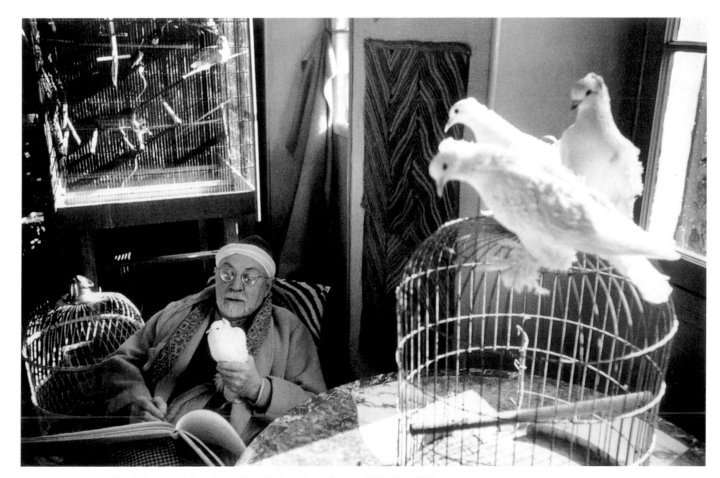

HENRI CARTIER-BRESSON Henri Matisse, Vence, France 1944 13 x 19⅛"

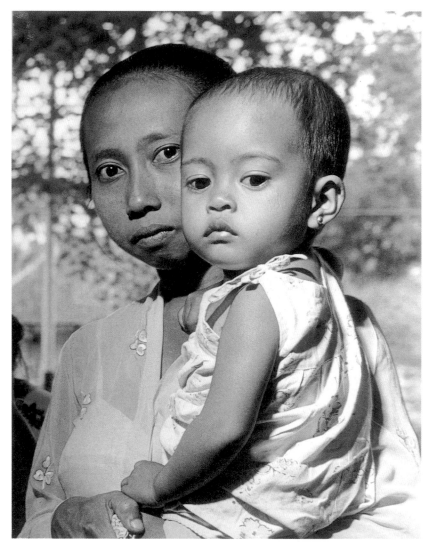

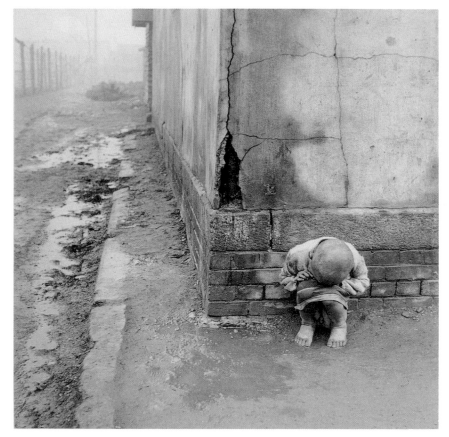

JOSEF BREITENBACH War Orphan, Korea 1953 10½ x 10¾"

JOSEF BREITENBACH Bali Mother and Child 1960 14 x 11"

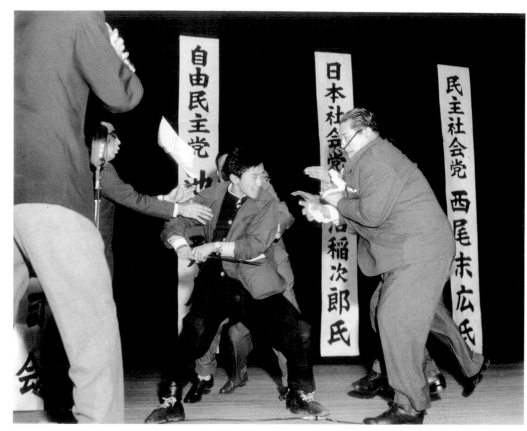

YASUSHI NAGAO Assassination of Asanuma October 12, 1960 8½ x 10½"

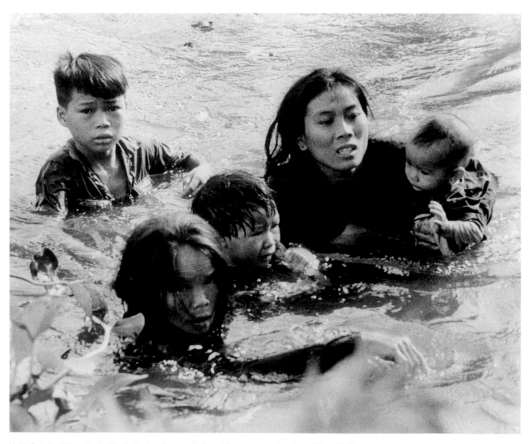

KYOICHI SAWADA Flee to Safety, Vietnam undated 13½ x 16¼"

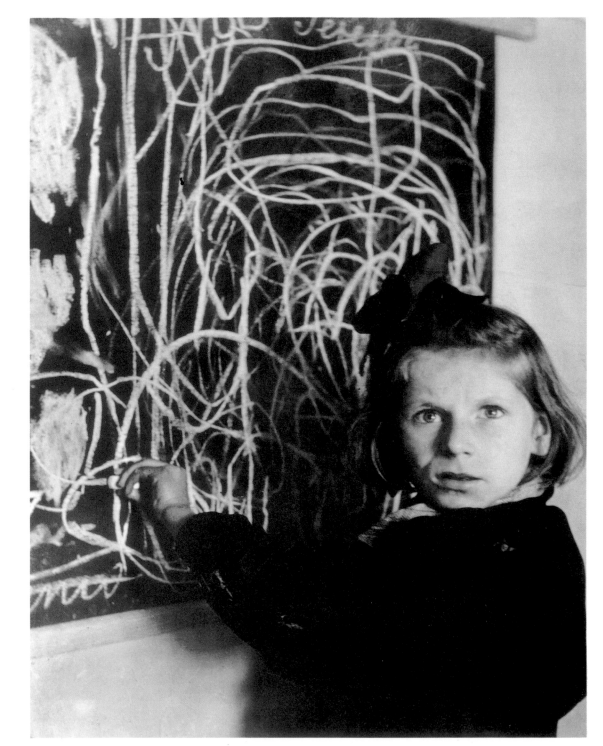

DAVID SEYMOUR "CHIM" Tereska, a disturbed child in an orphanage, Poland 1948 19 x 14¾"

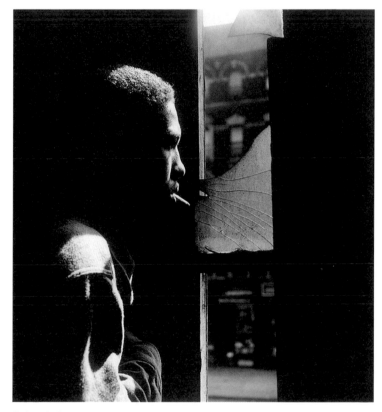

GORDON PARKS Harlem Gang Leader Red Jackson 1948 11⅛ x 10½"

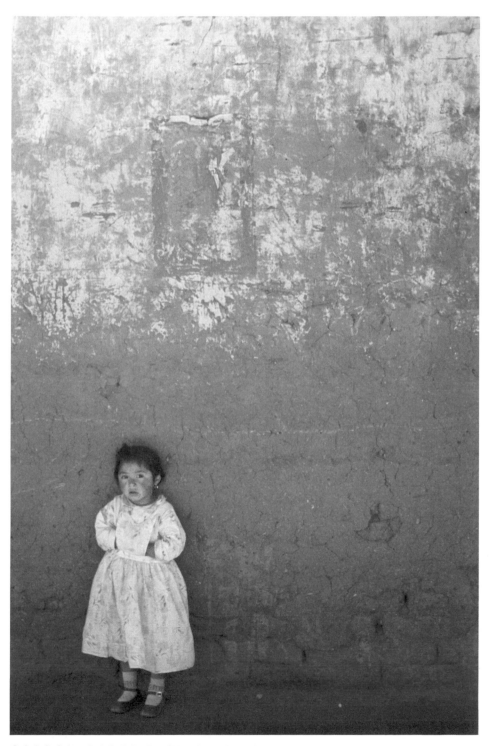

GORDON PARKS Blue Girl 1961 19 x 12½"

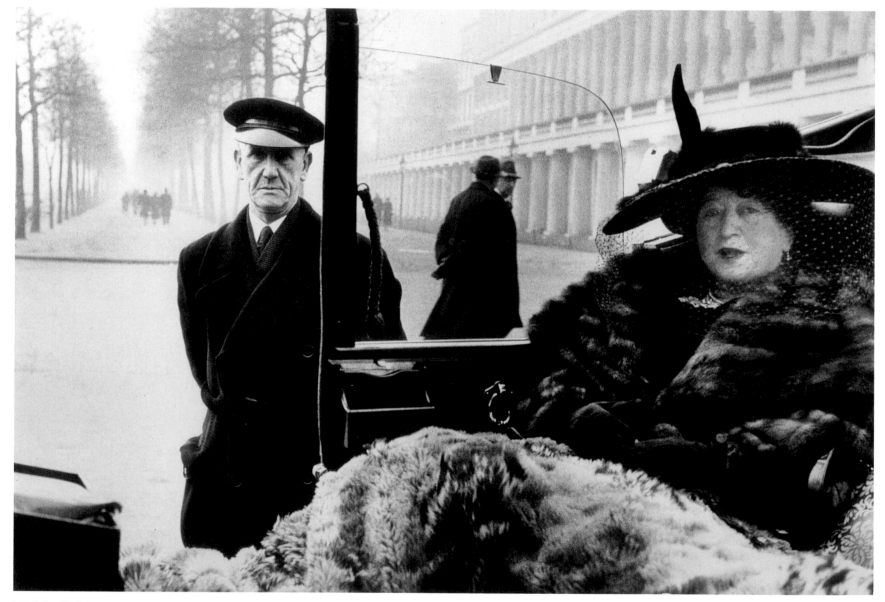

INGE MORATH Mrs. Nash, London 1953 13¼ x 19½"

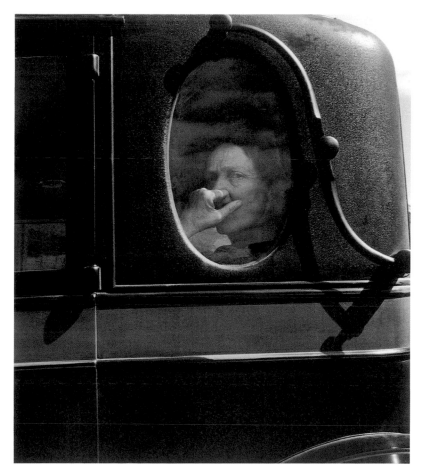

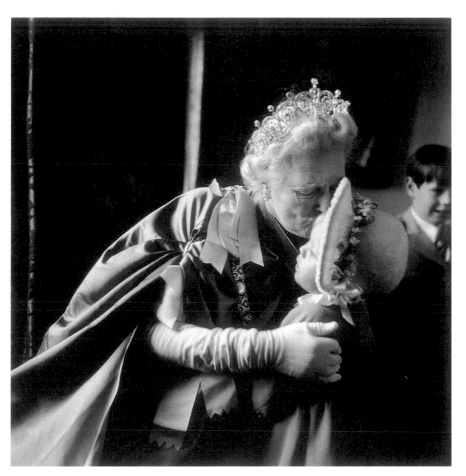

DOROTHEA LANGE Funeral Cortege, End of an Era in a Small Valley Town,
California 1938 10¾ x 9½"

TONI FRISSELL Lady Churchill and Her Granddaughter 1953 14⅛ x 13⅞"

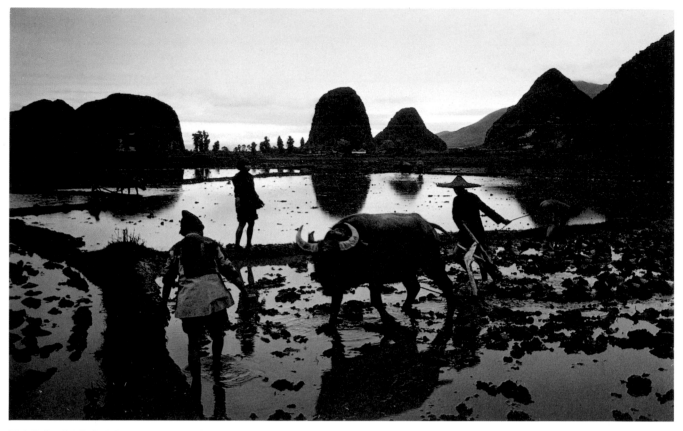

MARC RIBOUD Weird Hills, Lush Rice Paddies and Bitter Labor 1965 12 x 19⅛"

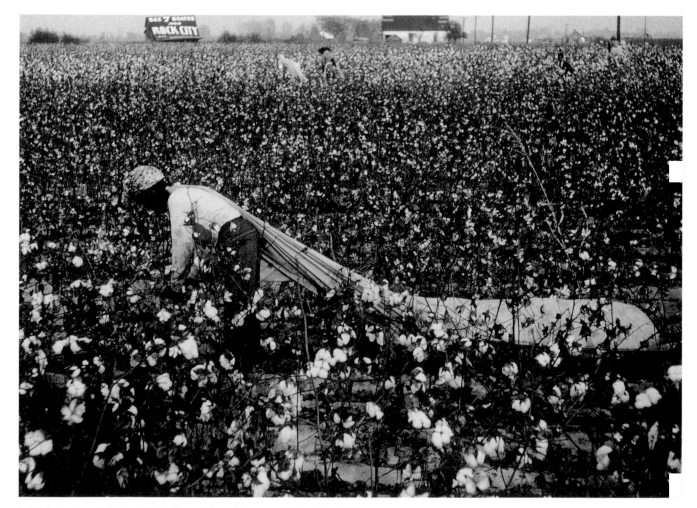

ERICH HARTMANN Cotton Pickers, Arkansas 1953 14⅛ x 19½"

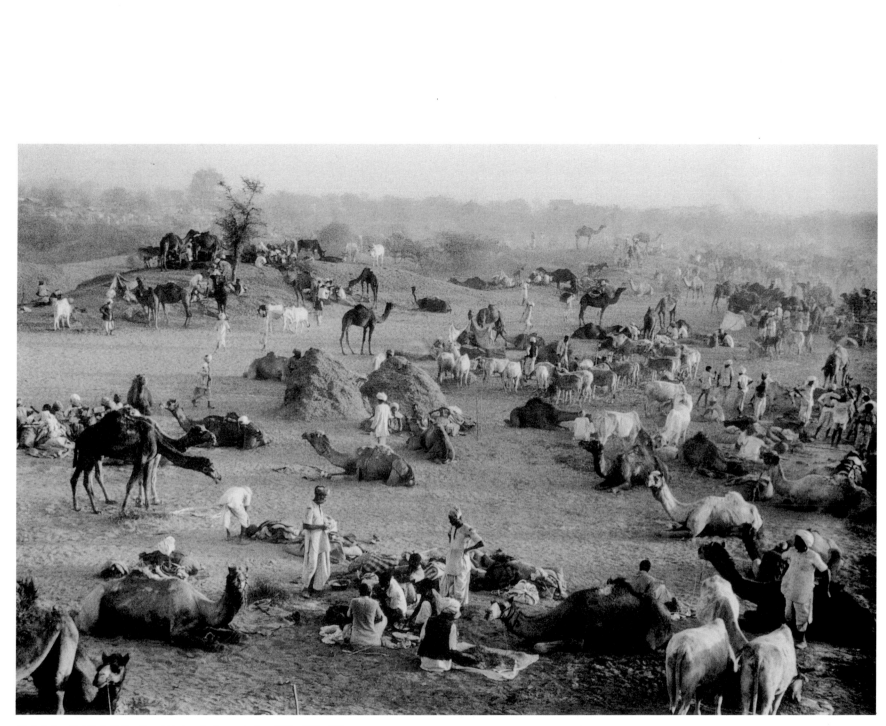

MARC RIBOUD Camel Market, Radjastan, India 1956 18⅜ x 28"

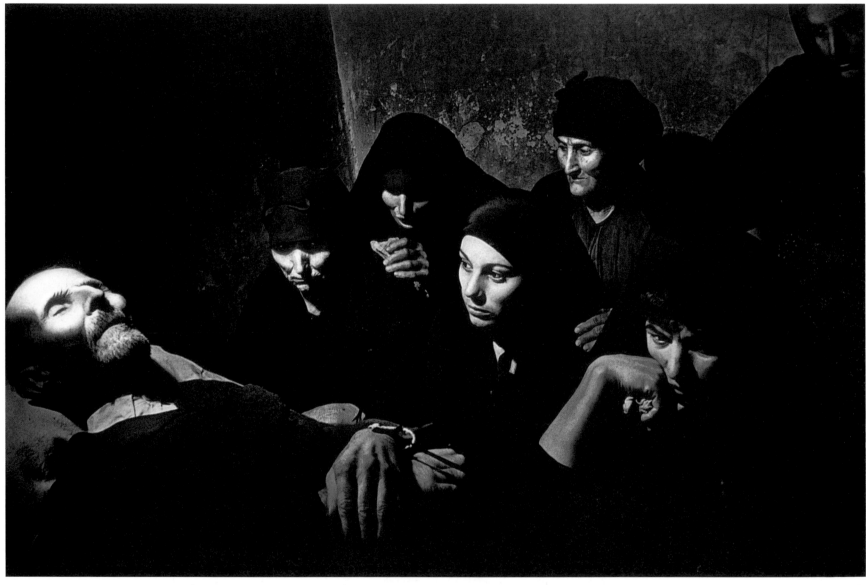

W . E U G E N E S M I T H Wake from the "Spanish Village" essay, LIFE, April 9, 1951 1950 11 x 16½"

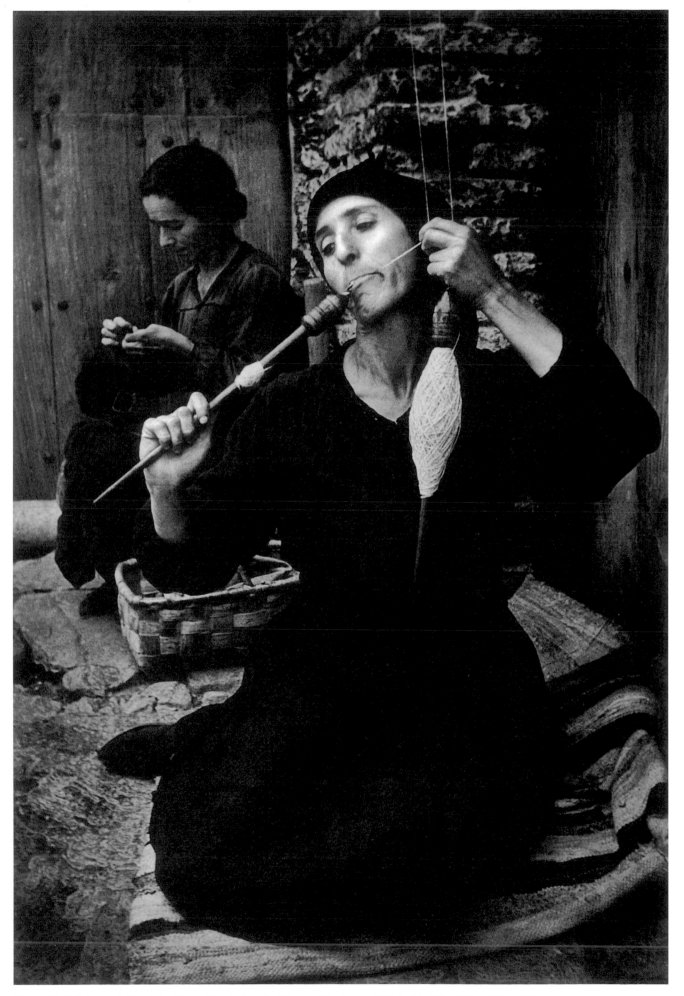

W . E U G E N E S M I T H Woman Weaving from the "Spanish Village" essay, LIFE, April 9, 1951 1950 16½ x 11¼"

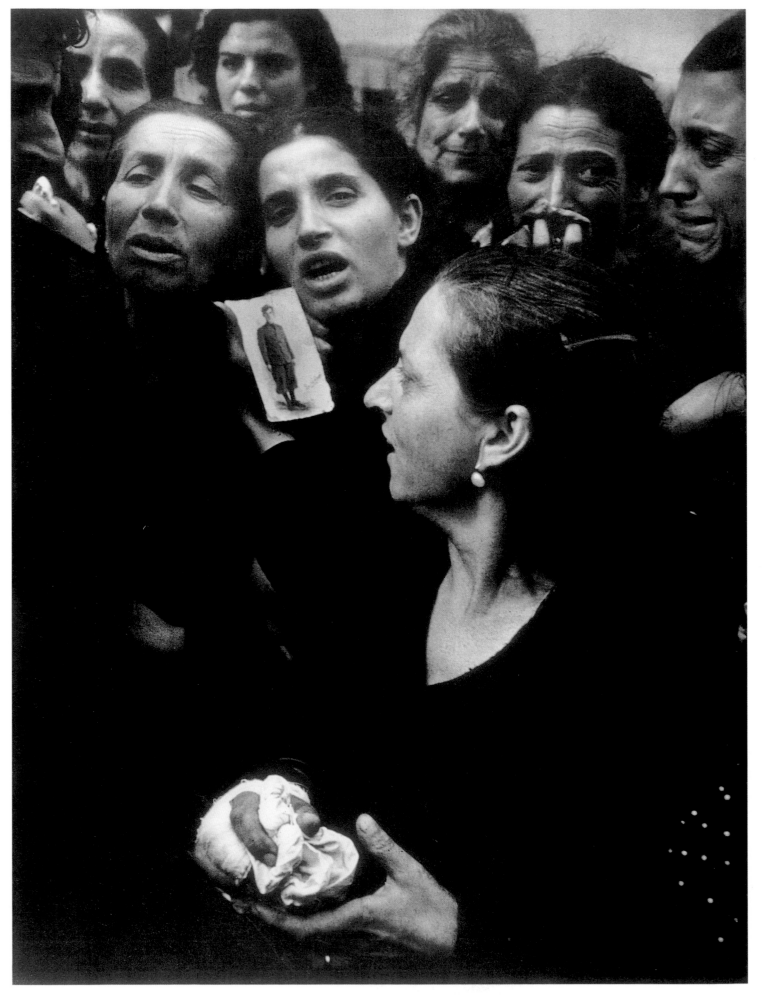

R O B E R T C A P A Italian Mothers Mourn Sons, Naples 1943 17⅞ x 13⅝"

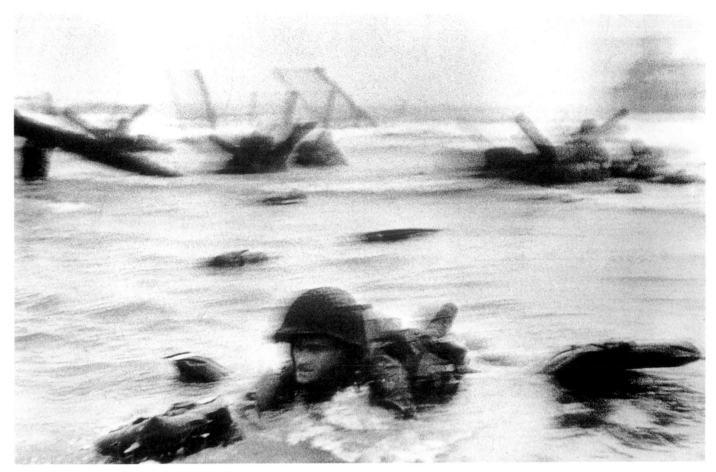

ROBERT CAPA D-Day, Omaha Beach, Normandy June 6, 1944 13 x 19½"

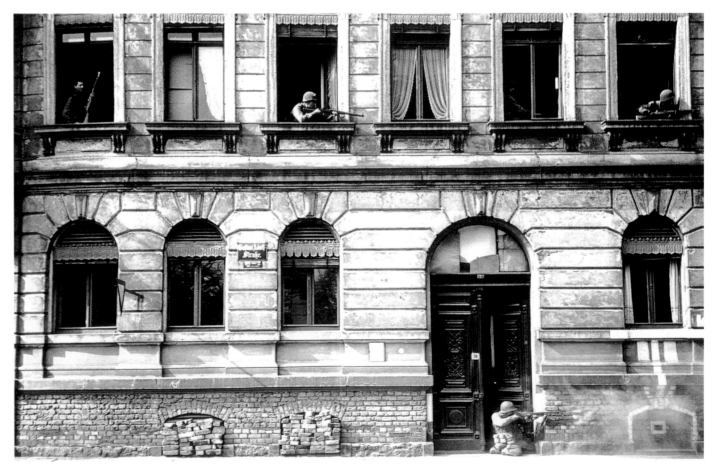

ROBERT CAPA Leipzig, Germany April 18, 1945 12⅞ x 19⅞"

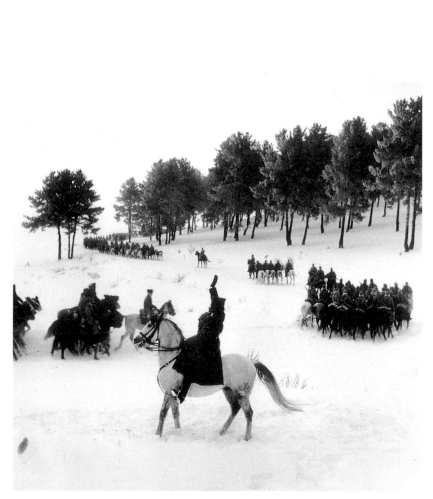

DAVID DOUGLAS DUNCAN Maneuvers of Turkish Cavalry, Russo-Turkish
frontier 1948 15½ x 15½"

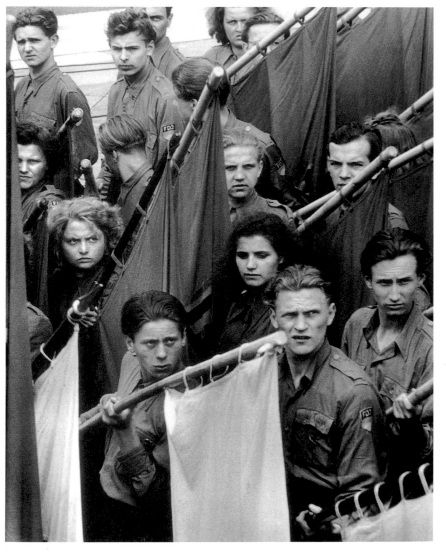

N. R. FARBMAN Communist Marchers, East Germany 1950 19¼ x 15½"

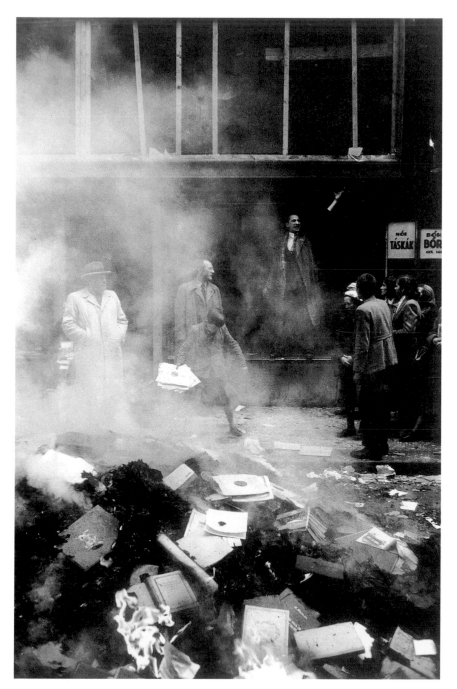

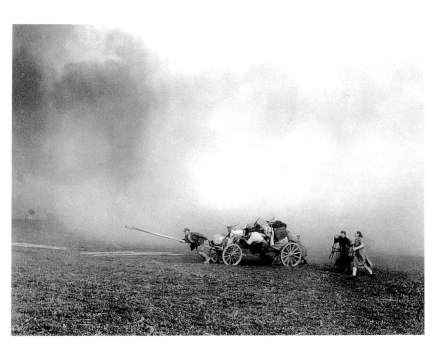

JOHN VACHON Poland 1946 10 x 13"

ERICH LESSING Hungarian Uprising 1956 19¾ x 13"

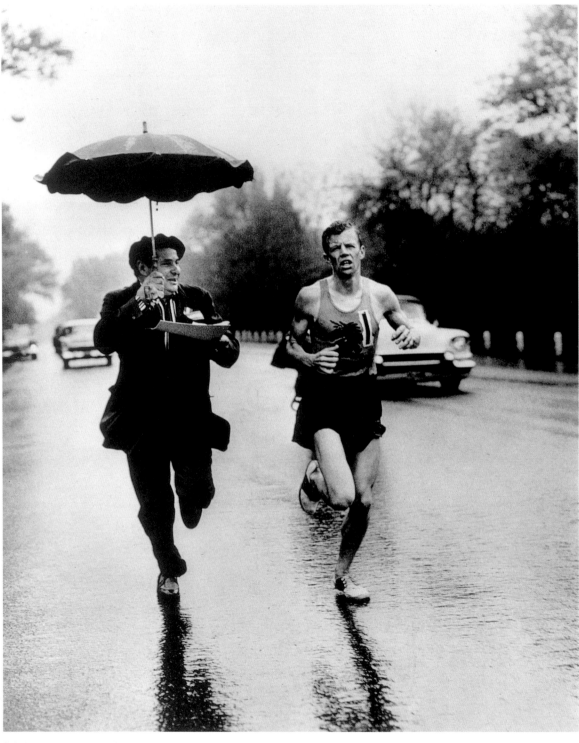

E R N E S T S I S T O Race in the Rain undated 13¾ x 11″

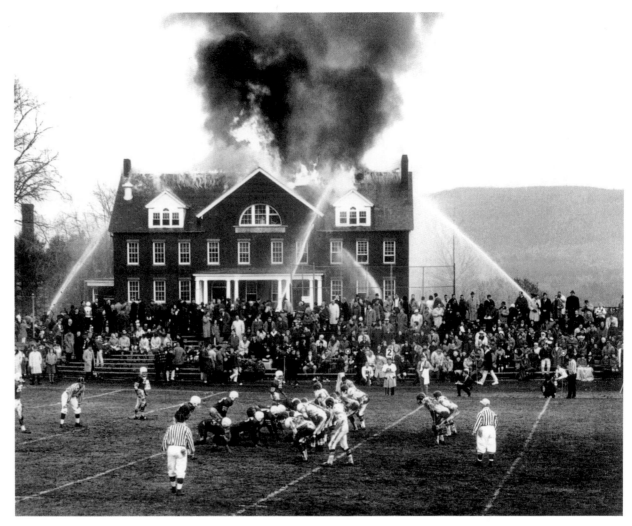

ROBERT VAN FLEET The School's on Fire undated 13⅜ x 16⅛"

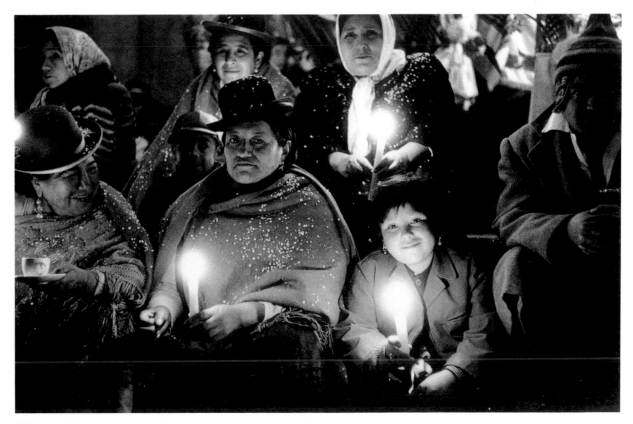

EMIL SCHULTHESS Candlelight Meeting in Peru 1961 9½ x 14¼"

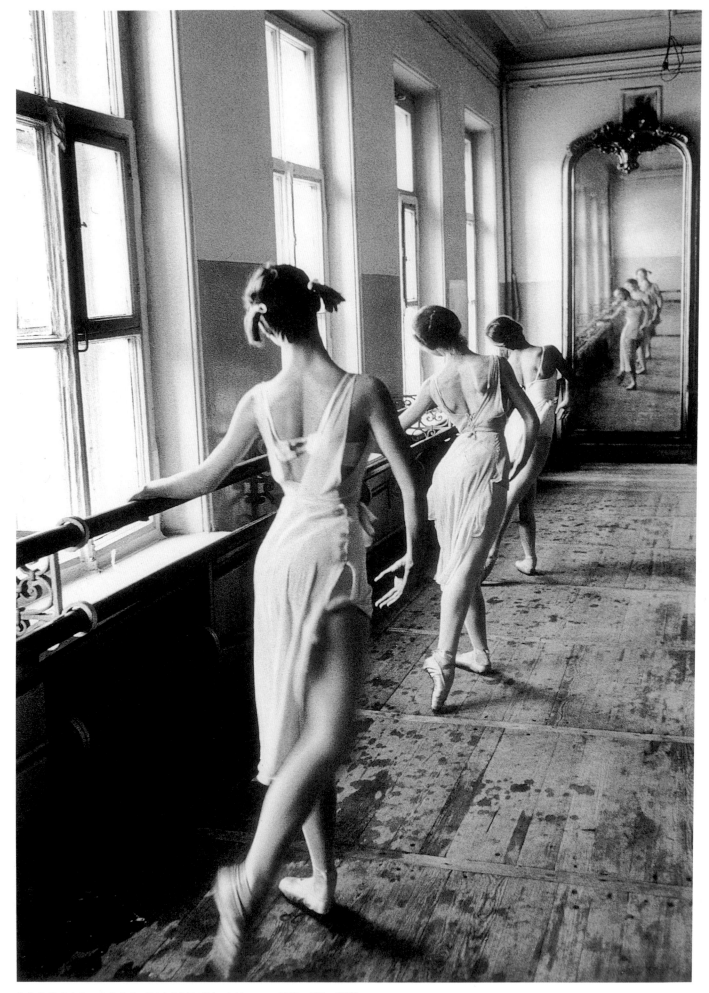

C O R N E L L C A P A Bolshoi Ballet School, Moscow 1958 16½ x 11⅝"

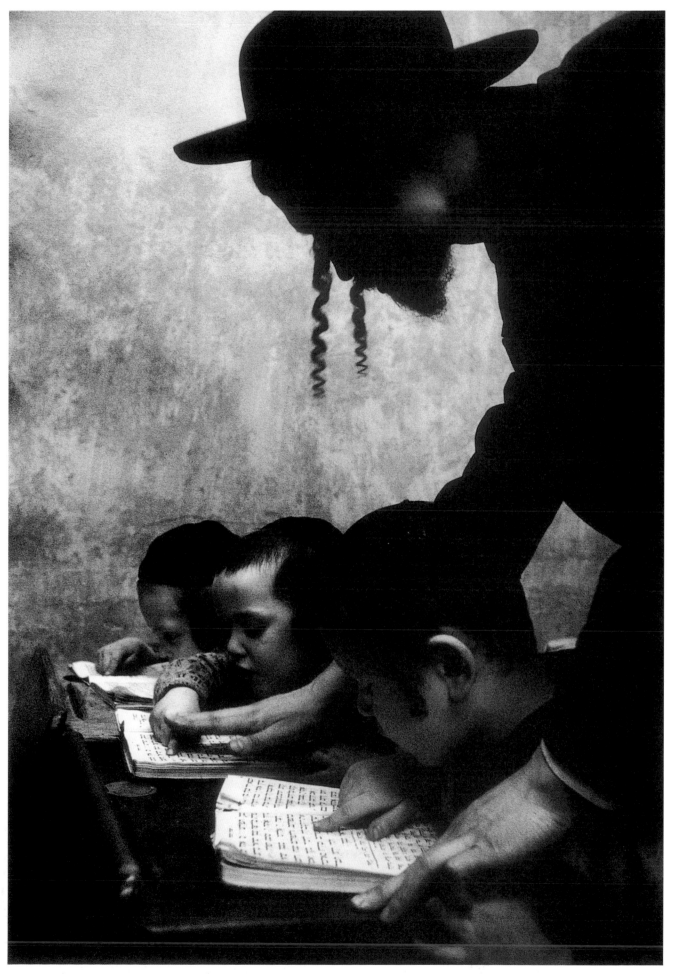

CORNELL CAPA Talmudic Scholars, New York 1956 18⅞ x 12⅞"

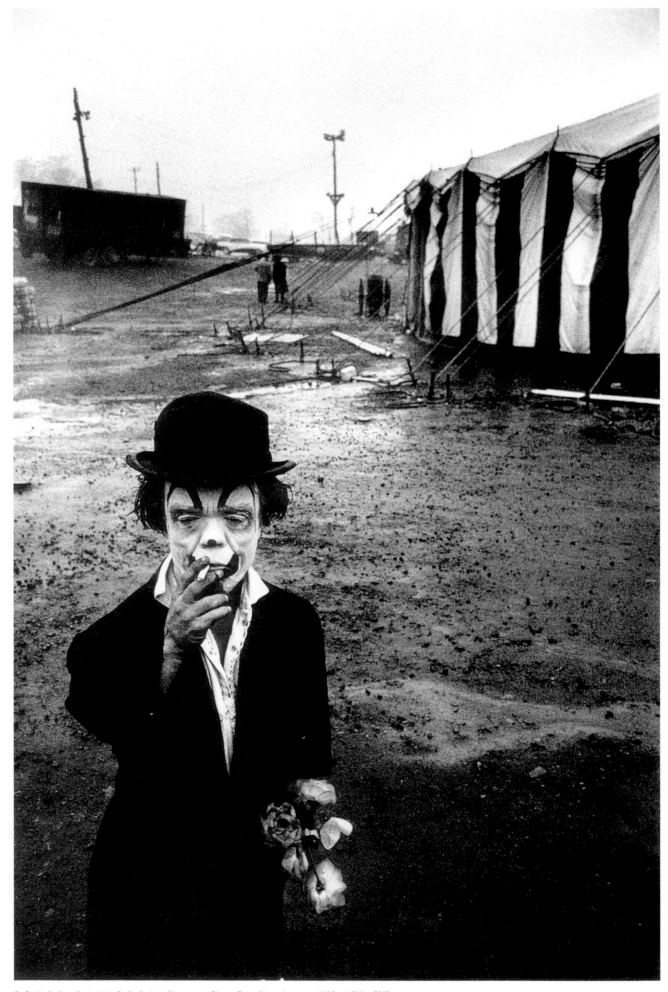

B R U C E D A V I D S O N Clown and Circus Tent, New Jersey 1958 13⅜ x 8⅞"

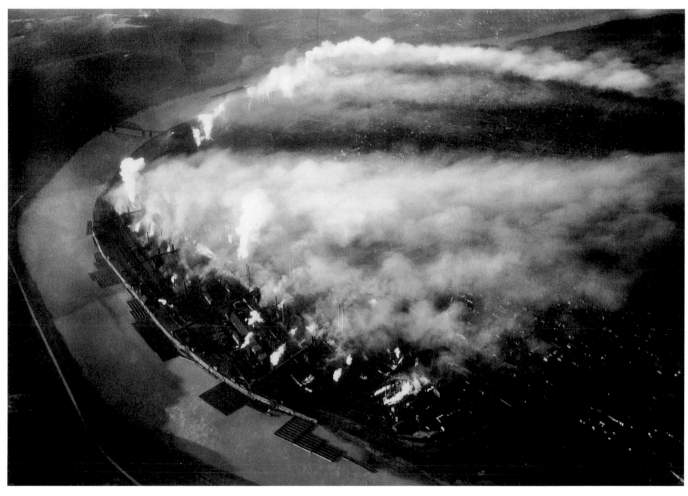

MARGARET BOURKE-WHITE Pittsburgh 1955 11⅝ x 16¾"

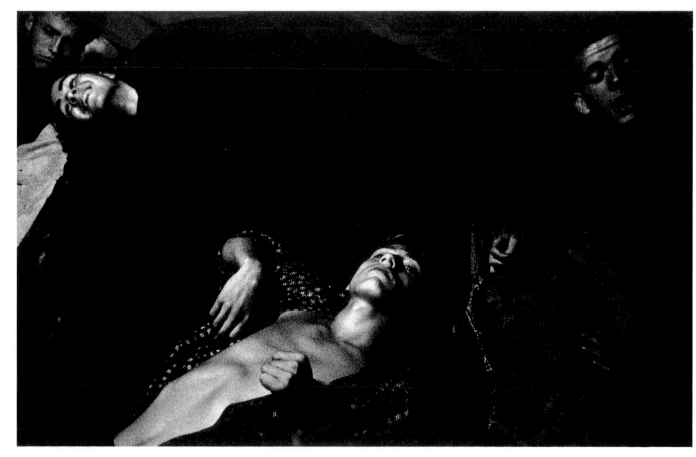

BRUCE DAVIDSON Under the Coney Island Boardwalk 1959 10¾ x 16⅝"

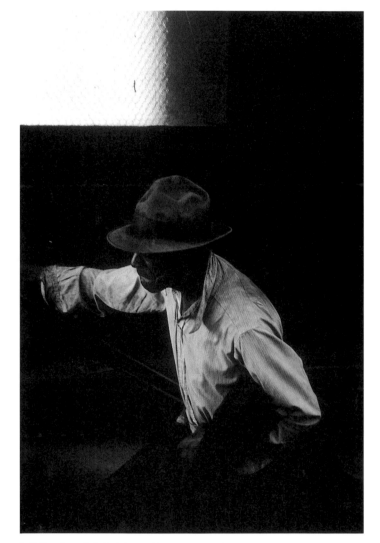

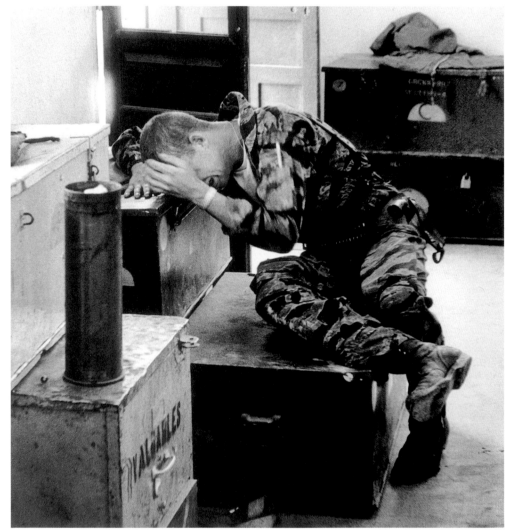

R O Y D e C A R A V A Man on Subway Stairs 1952 19½ x 13″ L A R R Y B U R R O W S Even Marines Break Down Sometimes (Yankee Papa) 1965 14½ x 13⅞″

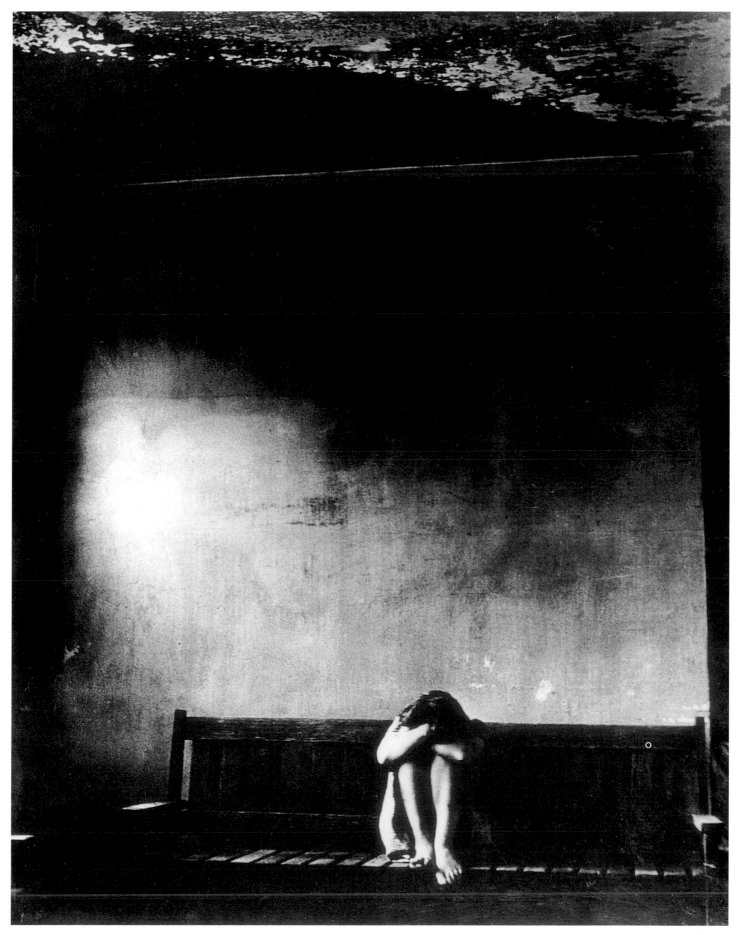

JERRY COOKE Ohio Insane Asylum 1946 19⅜ x 15¼"

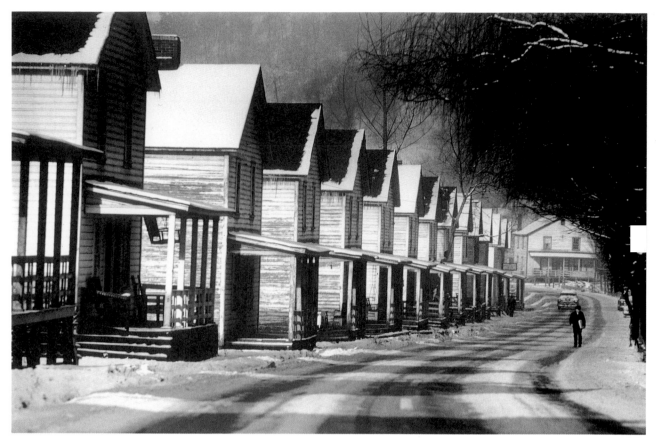

PAUL SCHUTZER Unemployment in the Coalmine Industry 1959 11¼ x 16¾"

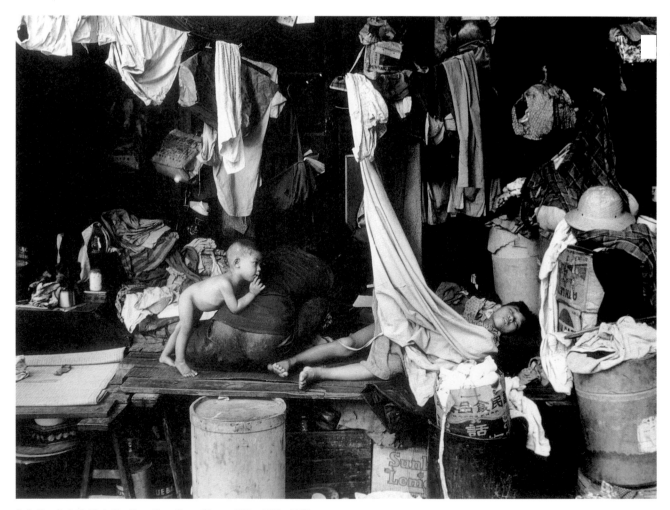

KEN HEYMAN Hong Kong Street Slum 1960 14¾ x 19¾"

ARTHUR ROTHSTEIN Oklahoma Dust Storm 1936 19¼ x 19½"

ARTHUR ROTHSTEIN Alabama Sharecropper's Daughter 1937 12½ x 17⅛"

PETER BEARD Elephant Herd, Uaso Niro, Kenya 1960 12¾ x 19"

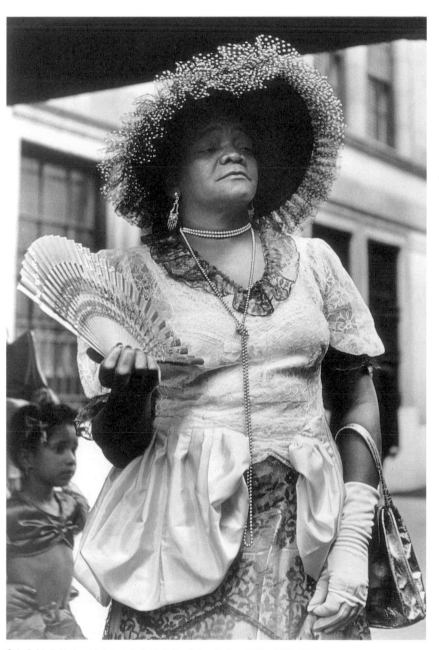

GEORGE RODGER Wrestlers of Korongo Nuba Tribe of Kordofan, Sudan 1949 13 x 8¾" CLEMENS KALISCHER Cuban Lady 1948 13⅞ x 9⅛"

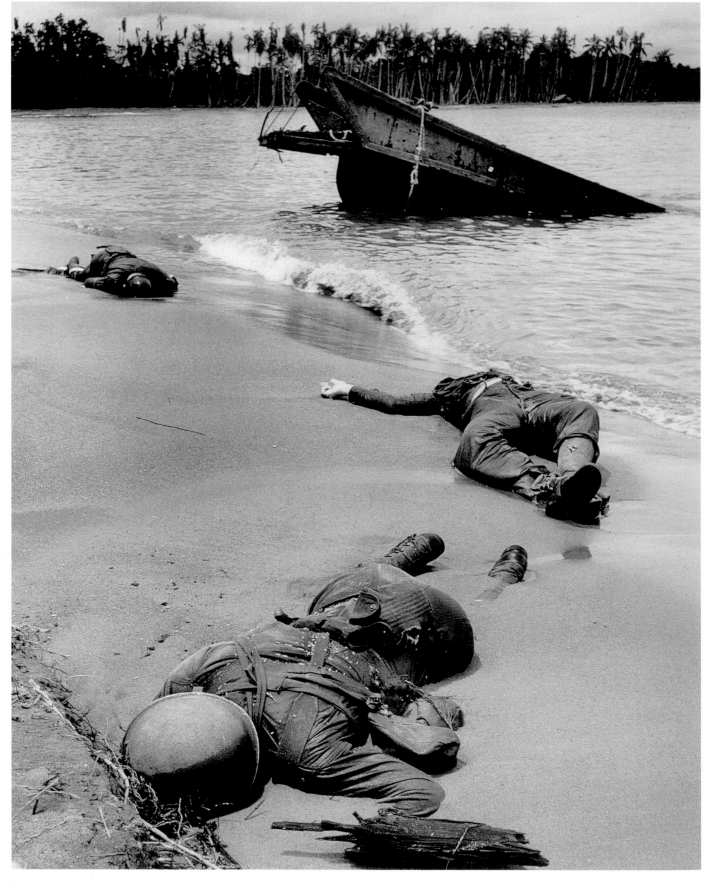

G E O R G E S T R O C K American Casualties, New Guinea 1943 19½ x 15½"

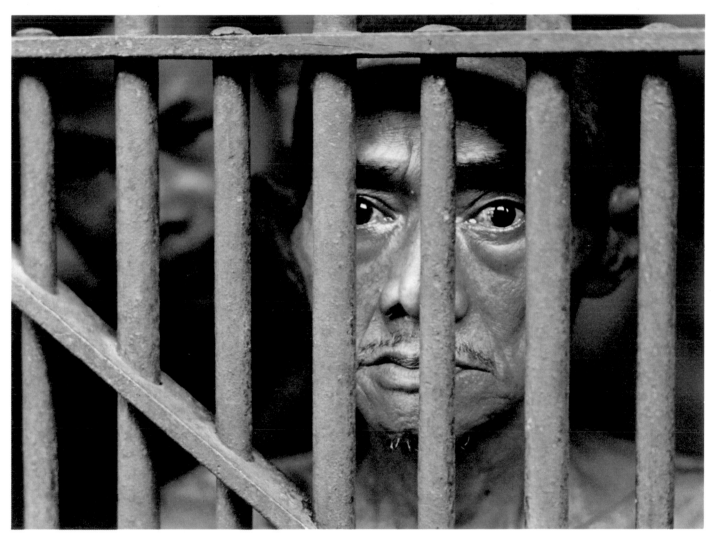

CO RENTMEESTER Indonesian Prisoner 1965 13½ x 18⅛"

ARTHUR SIEGEL The Red Door ca. 1959 9⅛ x 15⅜"

Self-assigned rather than commissioned, intended as self-expression and aimed at an elite audience, "expressive" photography as seen in the PFA exhibitions reflects at least three currents in camera art of the late fifties and early sixties. The strongest current flowed from Stieglitz to the f64 group and their descendants and inspired the radiant landscapes made on the West Coast and the metaphoric details of nature isolated by Minor White and his adherents. These photographers aspired to present equivalents for their emotions and beliefs while upholding in photography the formalist credo of "truth to materials." Pushing reality toward abstraction, these symbolic images appear most often in crystalline black-and-white prints from large-format negatives.

A second tendency in PFA's art photography originated in Moholy-Nagy's amalgam of Constructivist form and Bauhaus practice at the New Bauhaus in Chicago. Using the same pedagogy, Harry Callahan, Arthur Siegel, and Aaron Siskind were transforming this camera art from the experimental to the more subjectively expressive. Finally, a lyrical, personal version of street photography indicates the migration to the United States of that 35mm style first encouraged by French and German magazines between the Wars.

Meant for individual connoisseurs and museum collections, many of the expressive photographs shown in PFA were initially exhibited in pioneering if transient photography galleries as early as the fifties, as well as in the photography workshops and school departments that began to burgeon during the sixties, in part due to the expansion in fine arts education in general. But this kind of photography is least represented in PFA exhibitions, because of PFA's methods of solicitation for its juries and the jury system itself. Similar objections to juried group exhibitions have typified the history of photography, and the result has often been—as it was with PFA—that "survey" exhibitions have surveyed only part of the field.

A N S E L A D A M S St. Francis Church, Rancho de Taos, New Mexico ca. 1956–58 8 x 11"

A N S E L A D A M S Thunderstorm Over the Great Plains, Near Cimarron, New Mexico ca. 1961 15 x 19¼"

W Y N N B U L L O C K Woman and Thistle 1953 7½ x 9½"

W Y N N B U L L O C K The Stark Tree 1956 7½ x 9½"

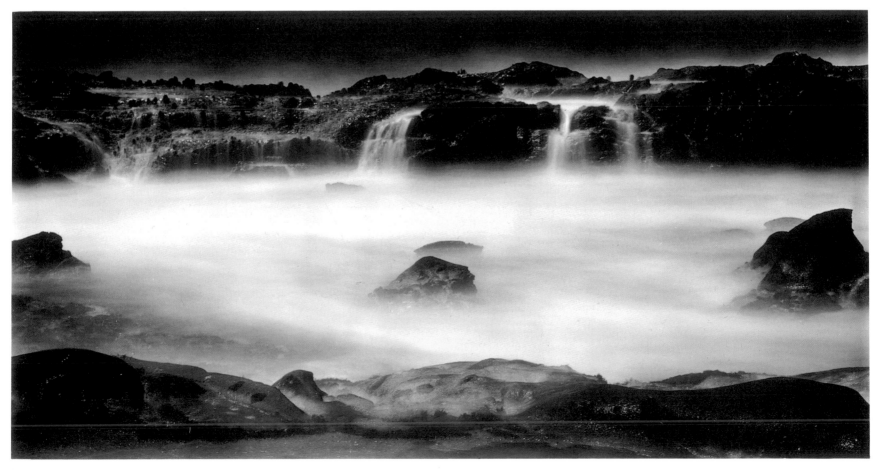

W Y N N B U L L O C K Rocks, Sea and Time 1967 7 x 13"

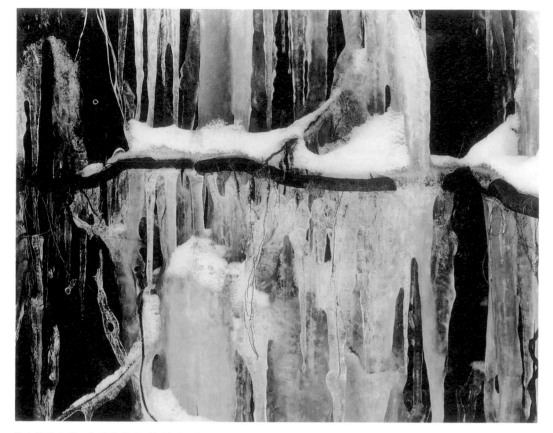

N A T H A N L Y O N S Untitled 1962 7⅝ x 9⅝"

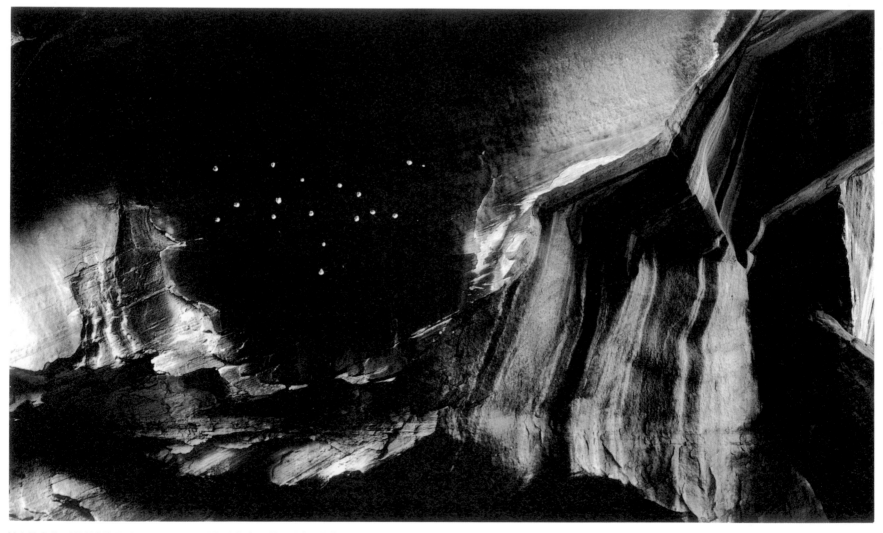

M I N O R W H I T E Bullet Holes, Capitol Reef, Utah 1961 7⅞ x 13⅛"

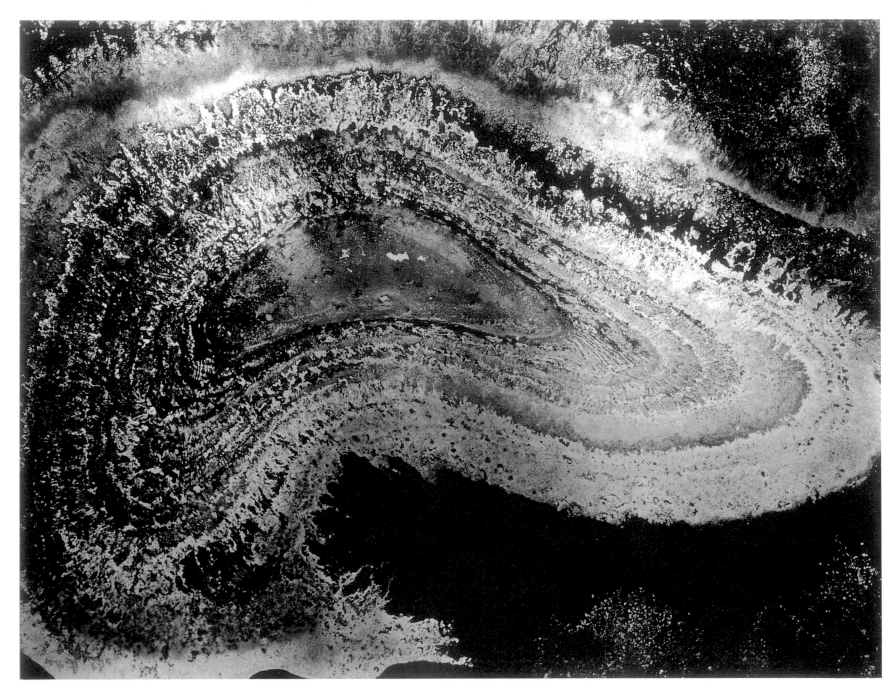

CARL CHIARENZA Great Nature 1962 10¼ x 13⅜"

E L I O T P O R T E R Maple Leaves and Pine Needles, Tamworth, N.H. 1956 10¾ x 8½"

E L I O T P O R T E R Fox-Tail Grass, Lake City, Colorado 1957 8⅛ x 10½″

MARIE COSINDAS Richard Merkin 1967 14 x 11"

M A R I E C O S I N D A S Roses, Mexico 1966 11 x 14″

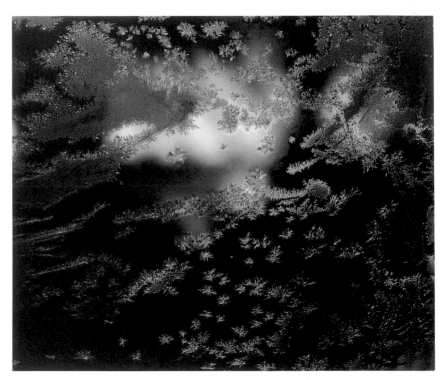

PAUL CAPONIGRO Revere, Massachusetts 1957 7⅝ x 9⅛"

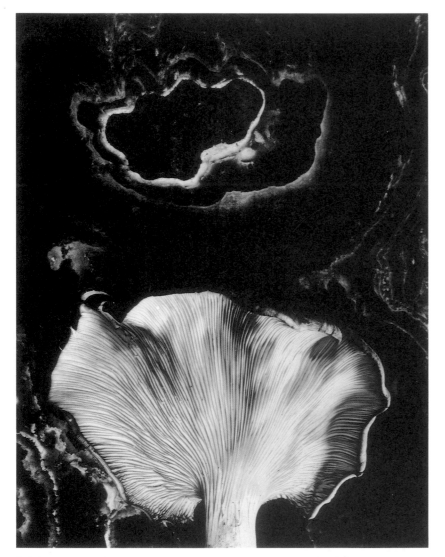

PAUL CAPONIGRO Ipswich, Massachusetts 1962 16¾ x 13⅛"

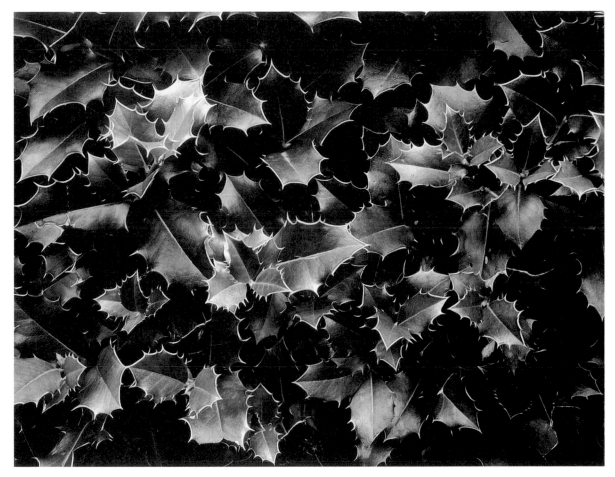

MICHAEL DiBIASE Holly 1965 10½ x 13½"

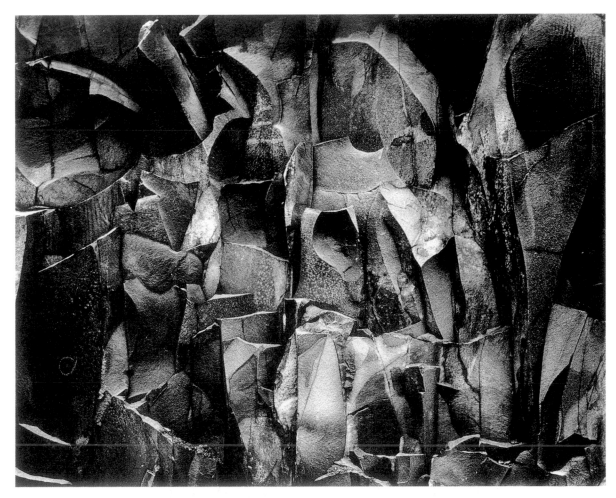

PAUL CAPONIGRO Rock Wall 1959 10⅜ x 13"

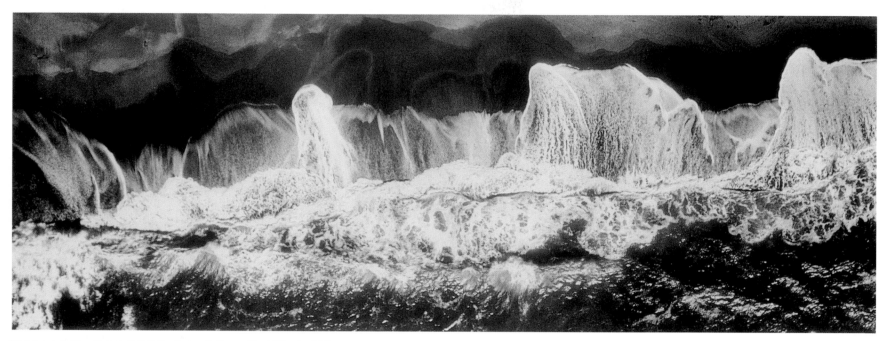

W I L L I A M G A R N E T T Surf at Pt. Reyes #1 1960 5 x 13½″

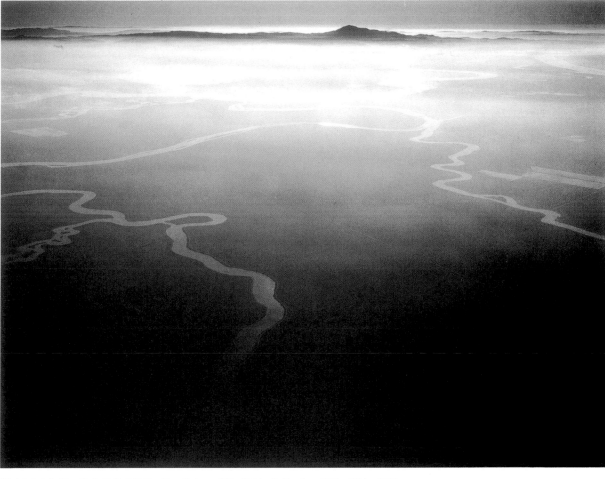

WILLIAM GARNETT River Delta and Mt. Diablo, California 1961 10½ x 13½"

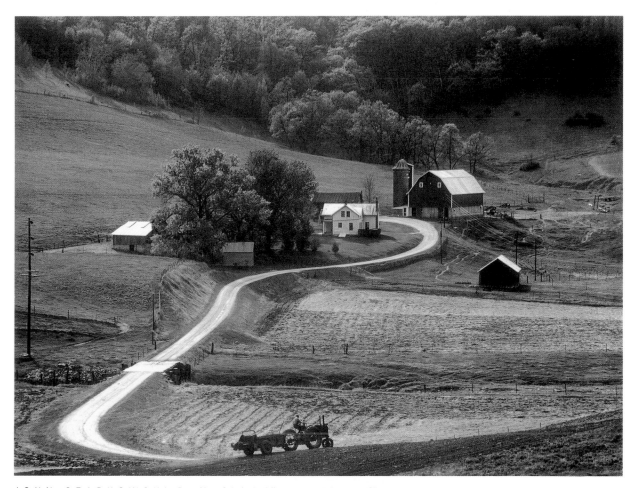

JOHN SZARKOWSKI Farm Near Caledonia, Minnesota 1956 10 x 13"

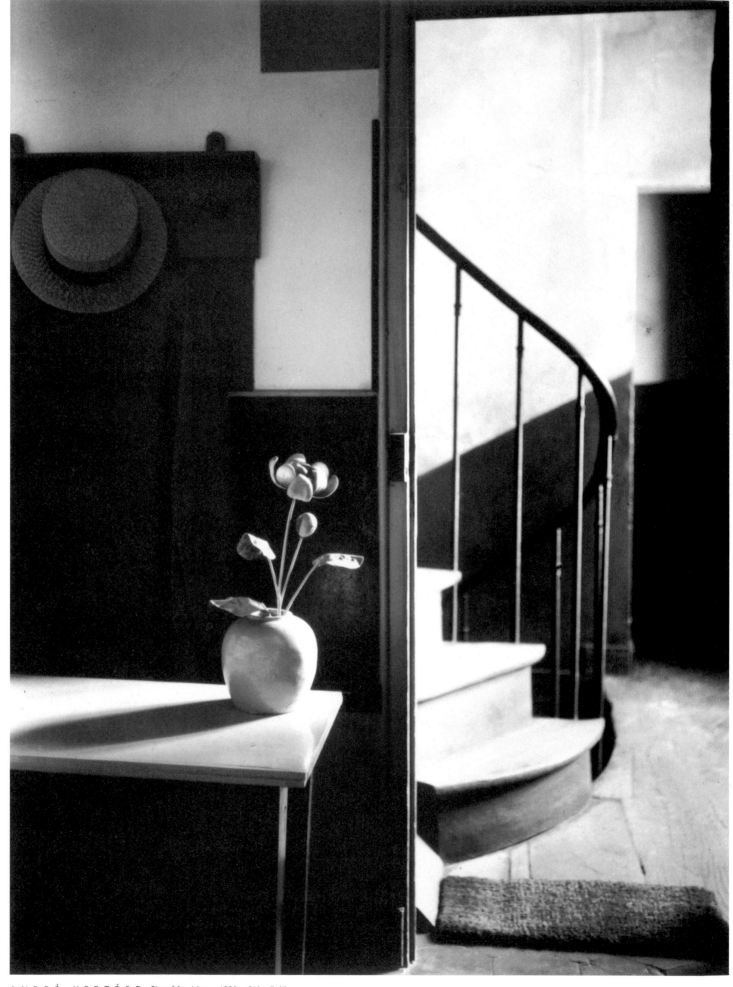

ANDRÉ KERTÉSZ Chez Mondrian 1926 9½ x 7¼"

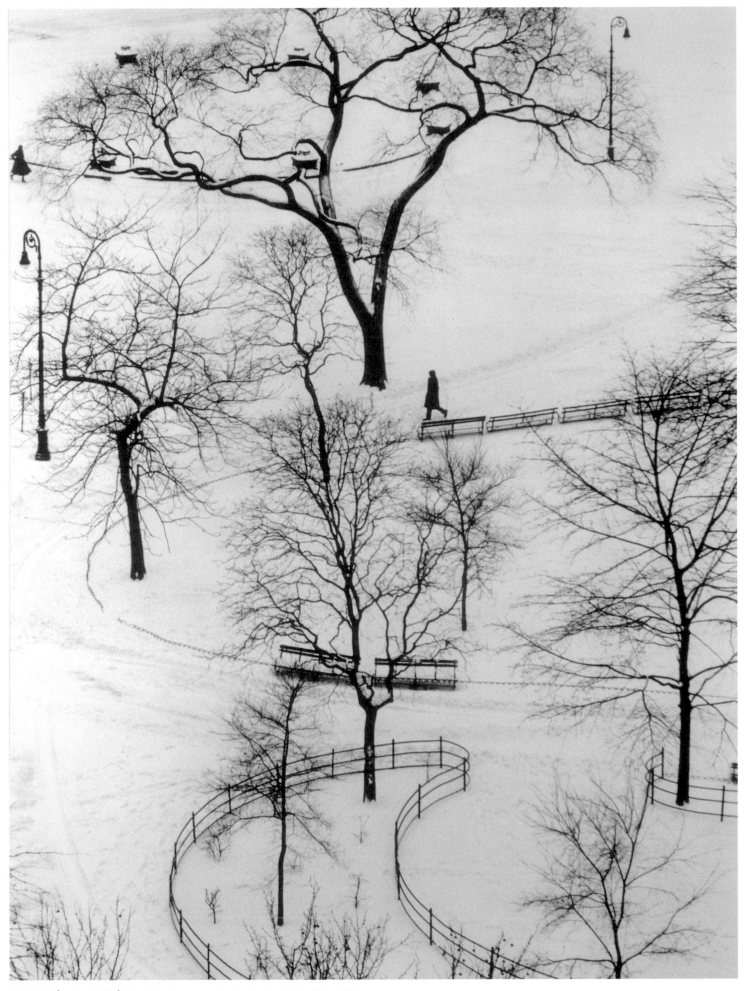

ANDRÉ KERTÉSZ Washington Square, New York 1954 18¾ x 14⅛"

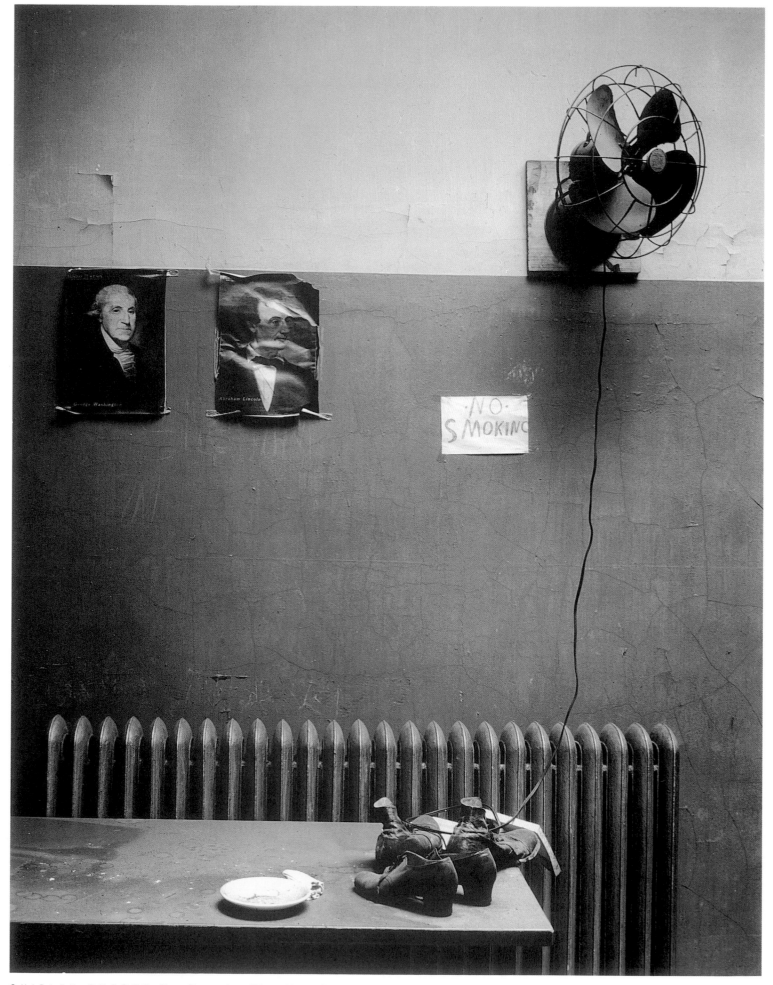

SHIRLEY BURDEN Shoes, Photographs and Fan 1931 13½ x 10⅜"

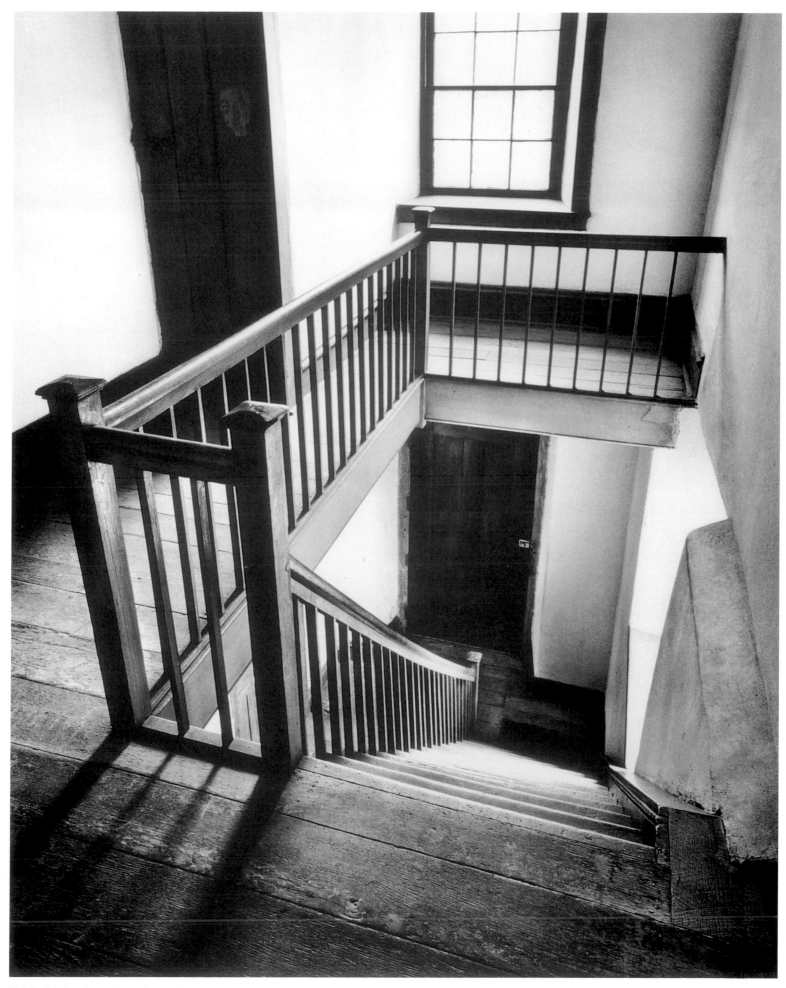

HAROLD ALLEN Old Jail, Carthage, Illinois undated 13¼ x 10⅝″

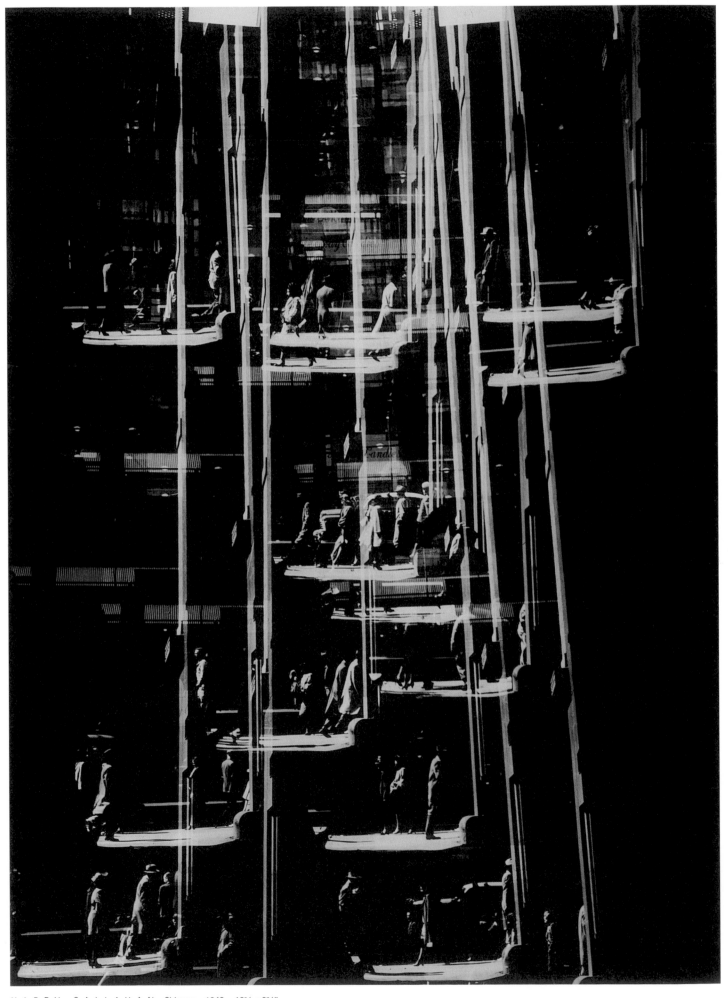

HARRY CALLAHAN Chicago 1948 13⅝ x 9⅞"

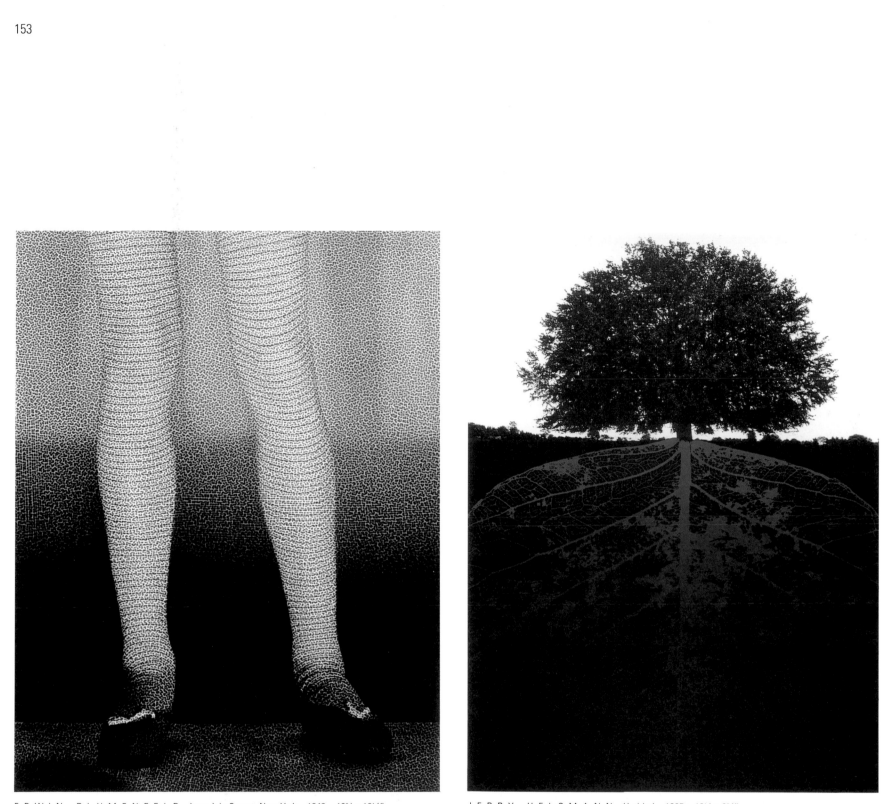

E R W I N B L U M E N F E L D Legs à la Seurat, New York 1942 13⅜ x 10¼"

J E R R Y U E L S M A N N Untitled 1965 13½ x 9⅞"

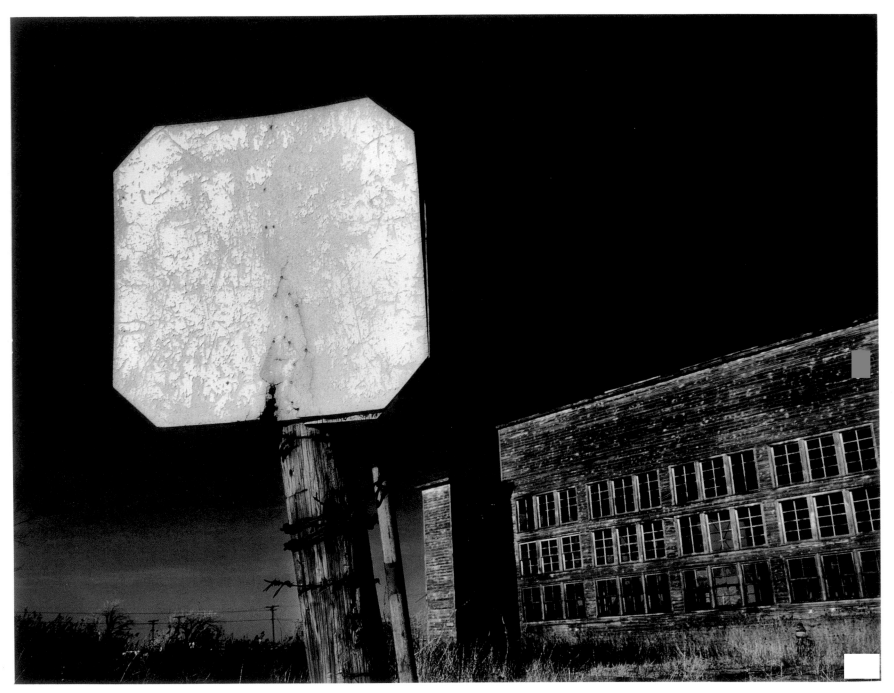

OSCAR BAILEY Sign, Niagara Falls 1965 8⅝ x 14⅝"

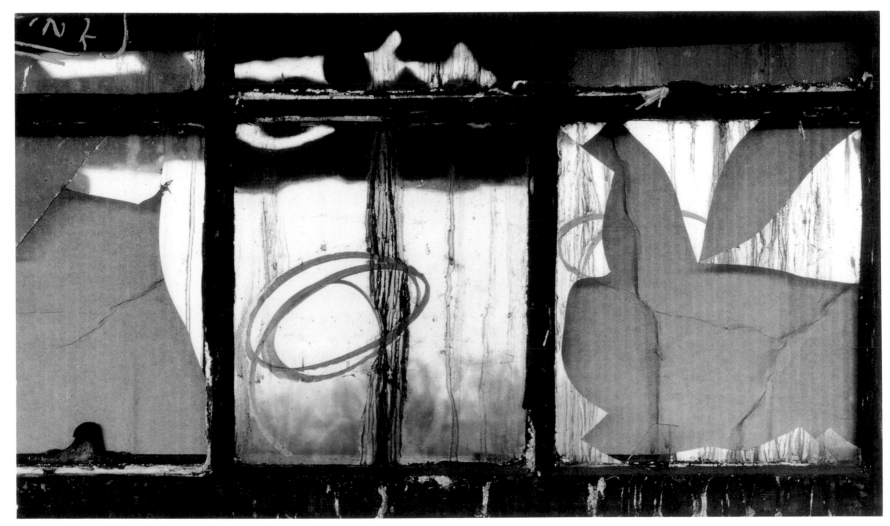

O S C A R B A I L E Y Window and Cardboard, Buffalo 1960 13 x 19¾"

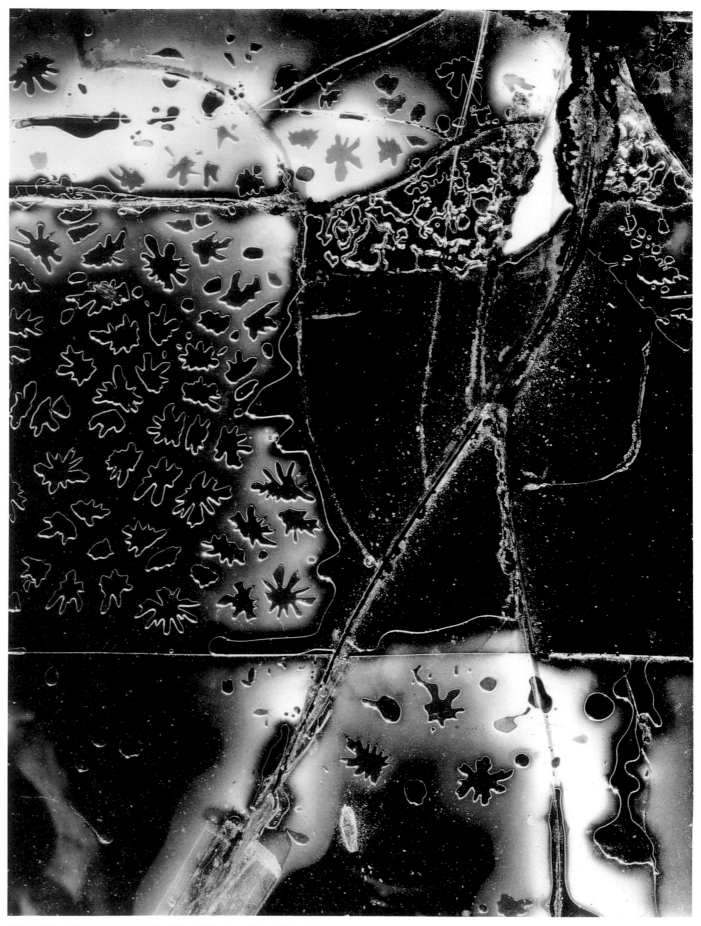

B R E T T W E S T O N Broken Glass, California 1955 13½ x 10¼"

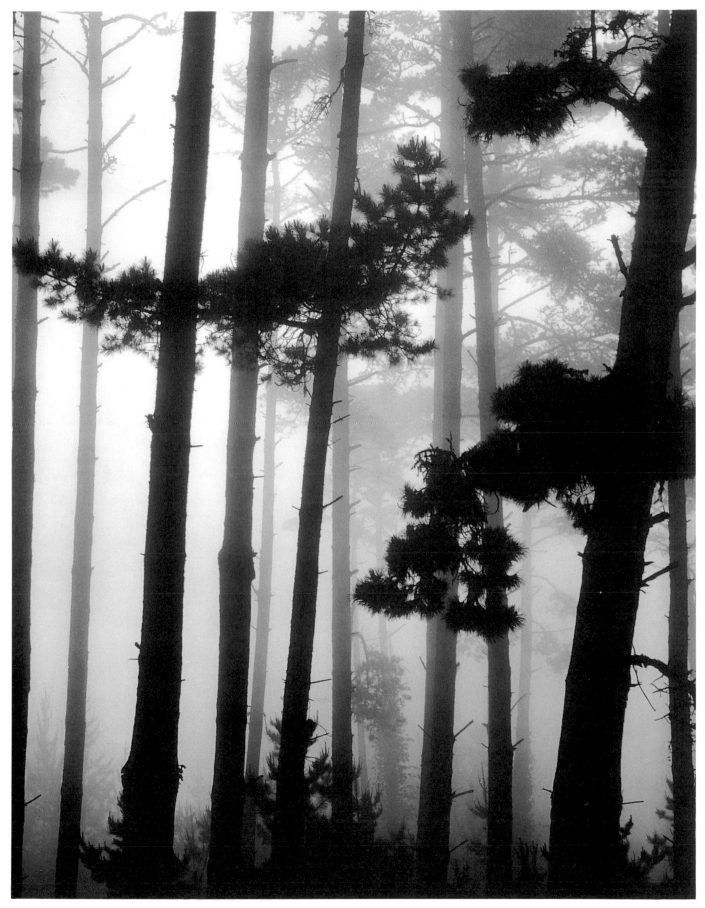

BRETT WESTON Pines in Fog, Monterey, California 1962 13½ x 10⅜"

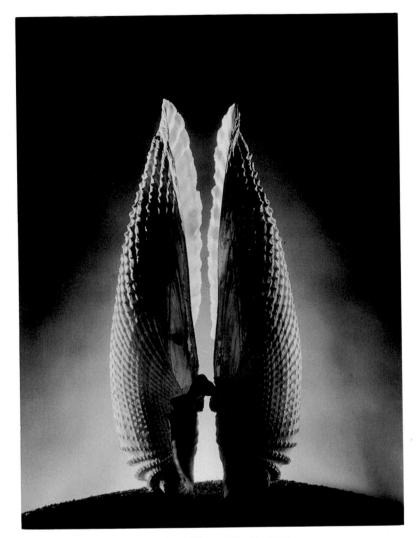

RUTH BERNHARD Angel Wing 1943 14 x 10½"

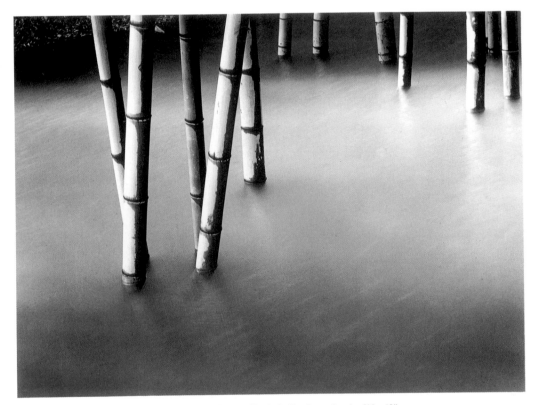

SHINICHIRO KITAMURA Bamboo Trunks in Flood undated 9¾ x 13"

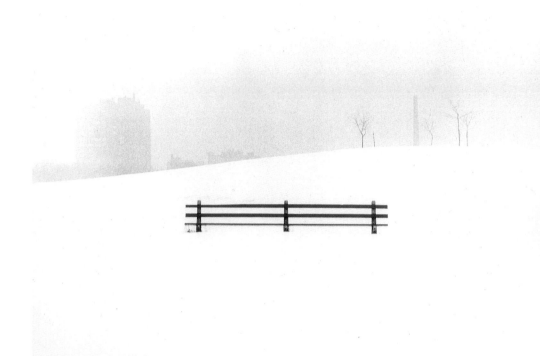

BURK UZZLE Winter Park 1960 10⅞ x 13⅞″

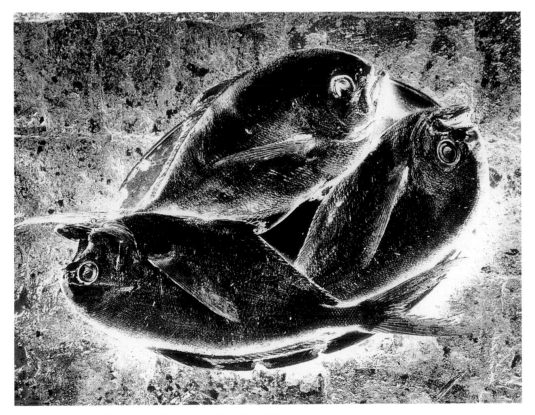

JEAN DIEUZAIDE Vigo's Fish 1963 12 x 15½″

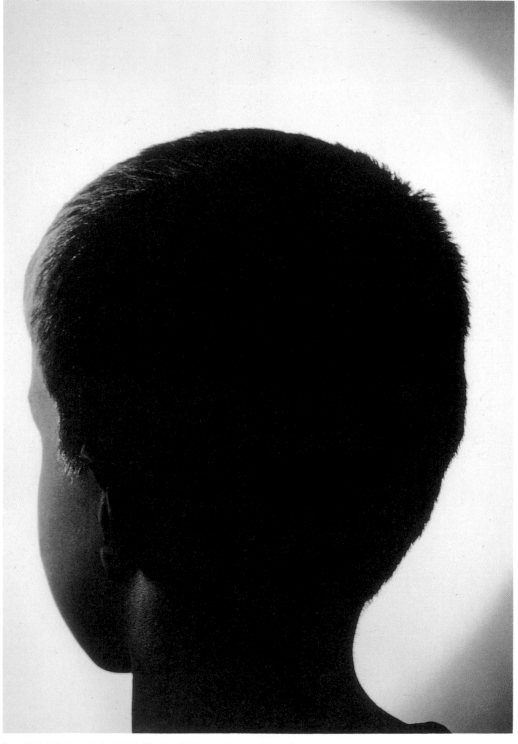

BARBARA MORGAN Lloyd's Head 1944 16½ x 11⅝"

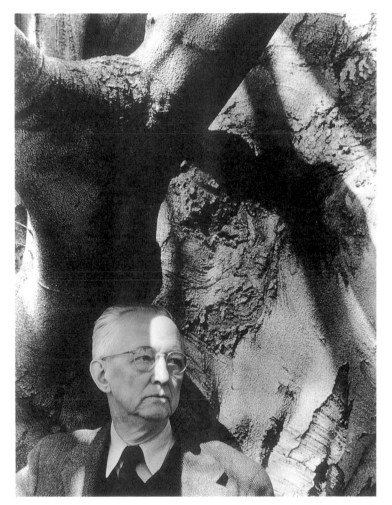

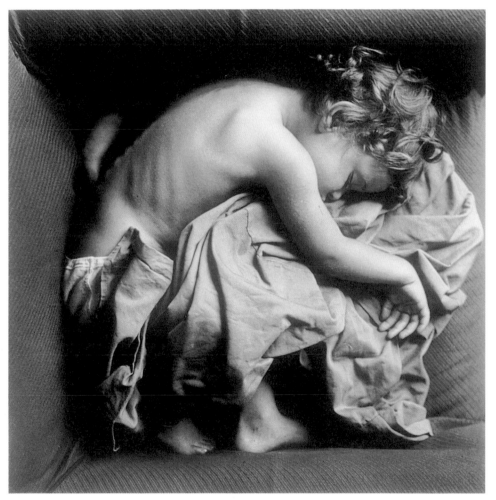

BARBARA MORGAN Charles Sheeler and His Favorite Beech Tree
1945 16⅜ x 12¼"

ARTHUR LEIPZIG Sleeping Child 1950 6½ x 6⅜"

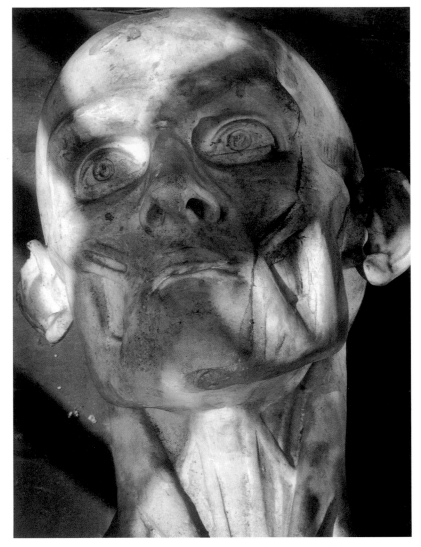

VILEM KRIZ Neighbor (from "Vision of the Times"), Paris 1948 9⅜ x 7"

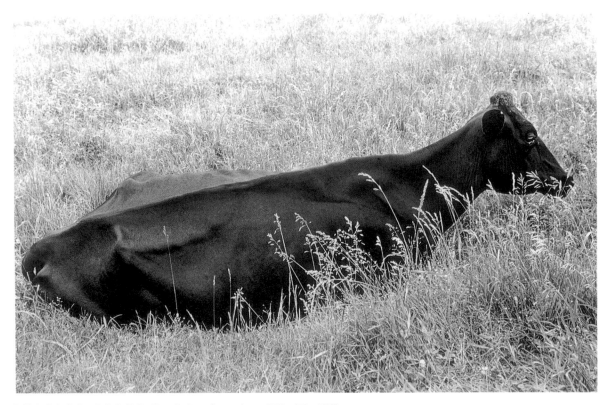

CHARLES PRATT Cow, Roxbury, Connecticut 1964 8¾ x 13⅛"

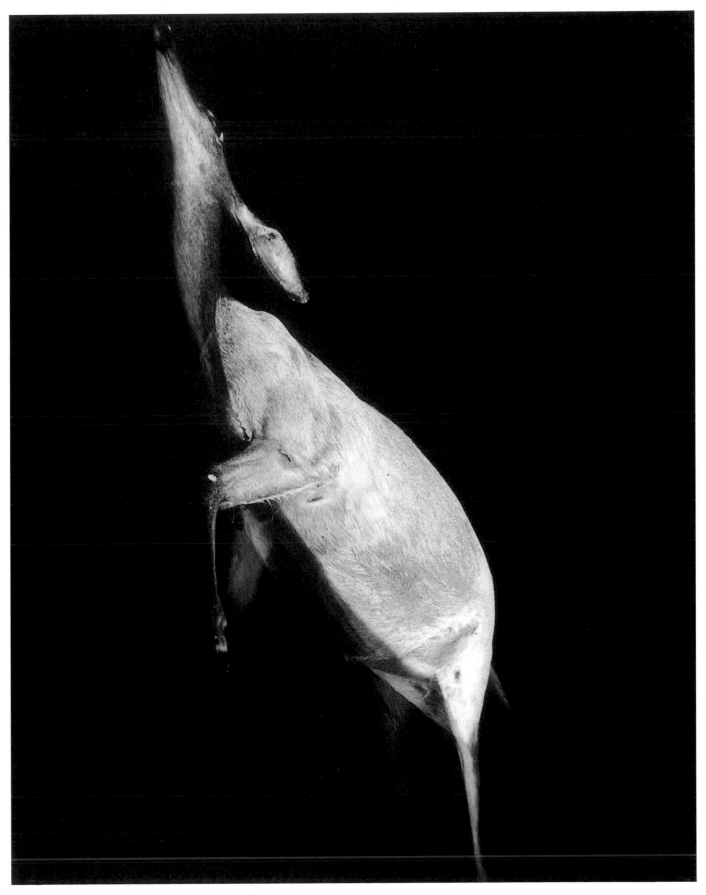

J U D Y D A T E R Dead Deer ca. 1965 9½ x 7½″

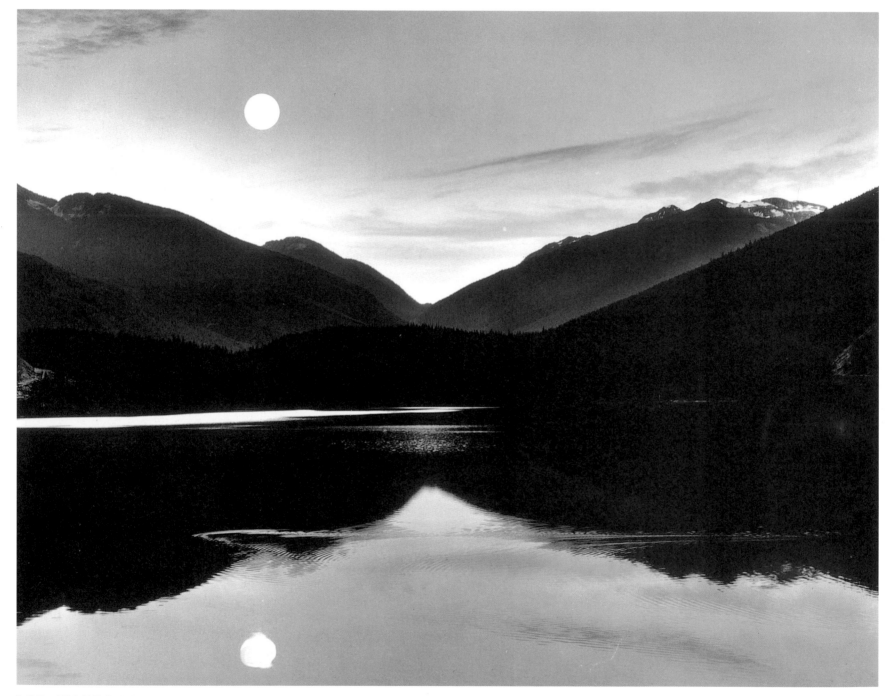

D O N W O R T H Lake and Moon, British Columbia 1961 10½ x 13½"

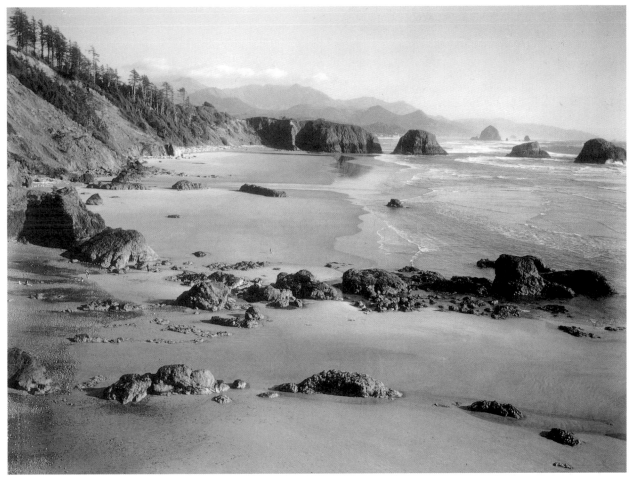

L A W R E N C E H U D E T Z Crescent Beach 1966 7¼ x 9⅝"

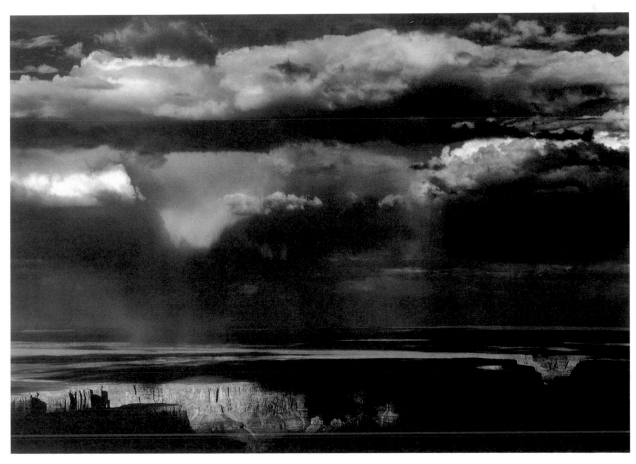

P H I L I P H Y D E Grand Canyon ca. 1963 6⅞ x 9¾"

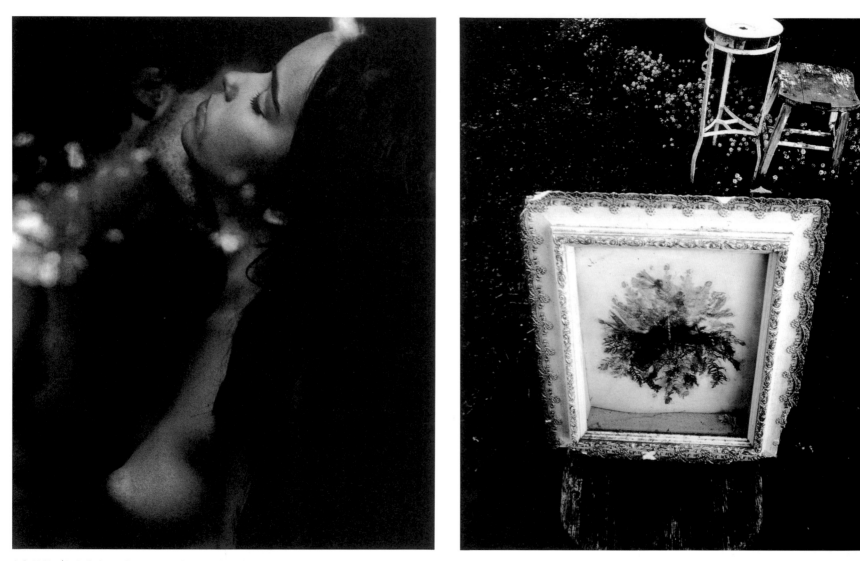

JOHN BROOK The Kiss undated 9½ x 7¾"

JACK WELPOTT The Gift 1964 13¼ x 10½"

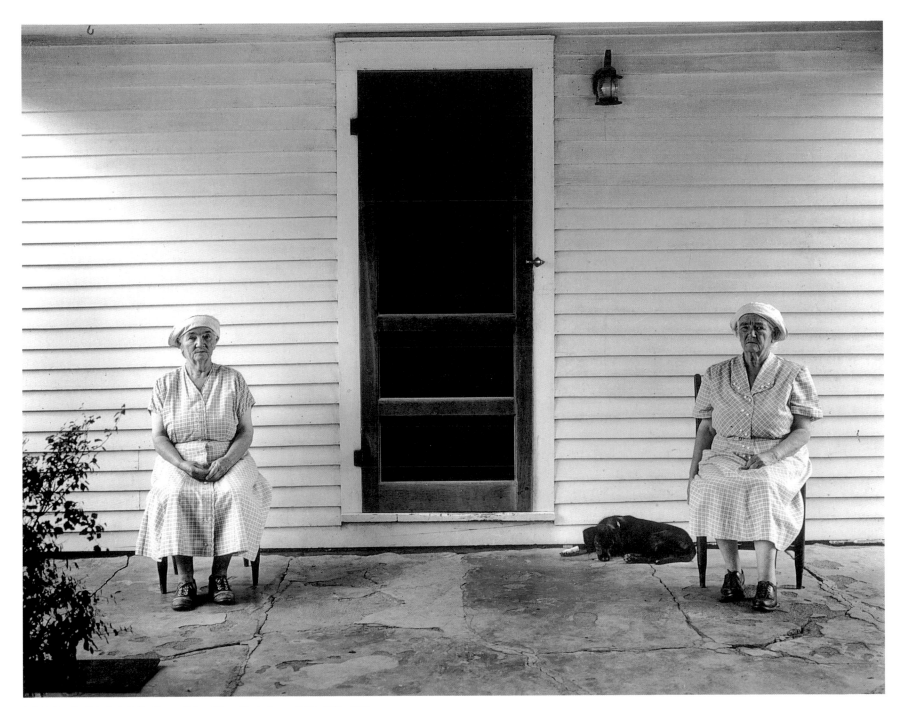

JACK WELPOTT Farmer Twins, Stinesville, Indiana 1958 14⅛ x 18⅝"

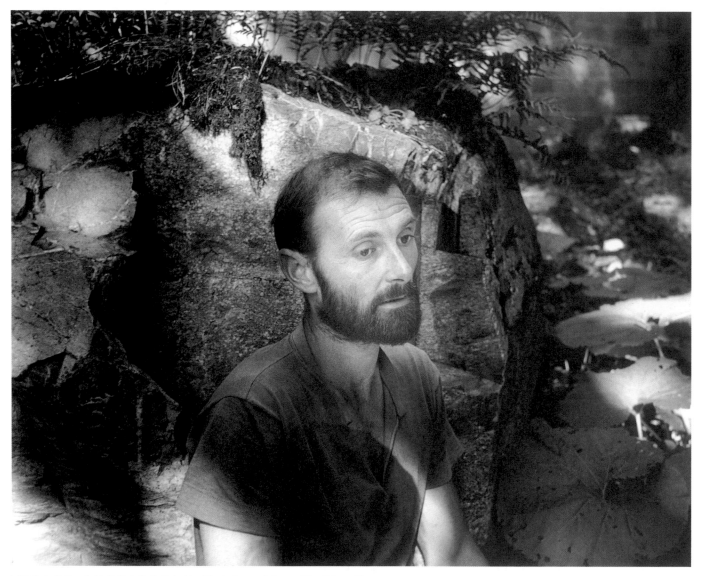

IMOGEN CUNNINGHAM Morris Graves, Painter, 1950 9⅝ x 11⅞″

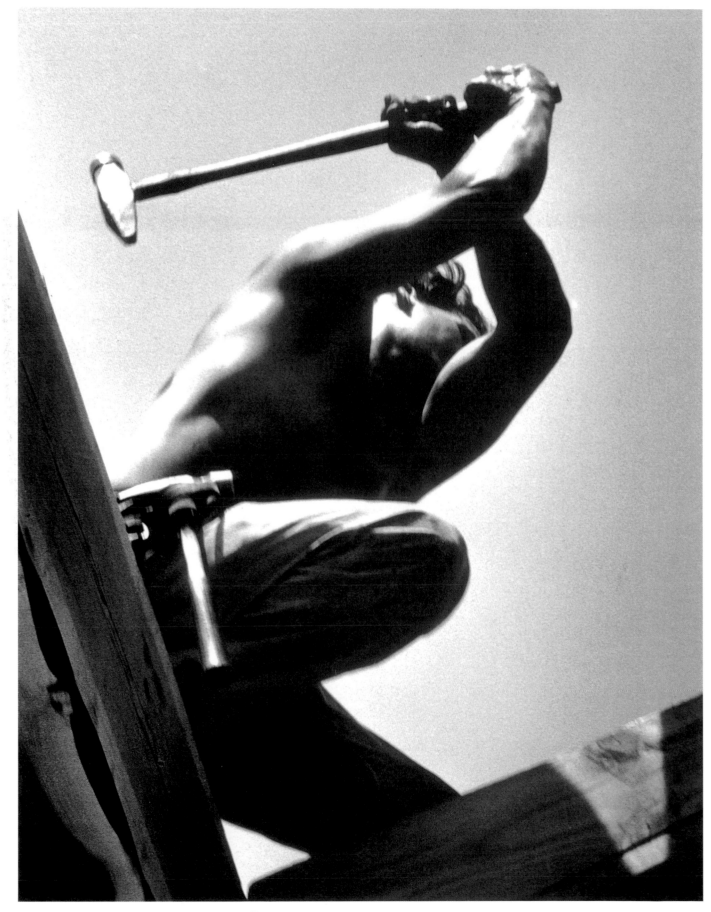

P I R K L E J O N E S Worker 1958 13⅝ x 10⅜"

PFA EXHIBITION I

Opened at The Metropolitan Museum
of Art on May 8, 1959
Closed on September 7, 1959

Chairman
James J. Rorimer
Director,
The Metropolitan Museum of Art

Frank Baker
Senior Art Director, McCann-Erickson

Ivan Dmitri
Director, PFA

Dr. Alfred Frankfurter
Editor, *Art News*

Joyce C. Hall
President, Hallmark Cards

Bartlett H. Hayes, Jr.
Director,
Addison Gallery of American Art

Bryan Holme
Editor, Studio Books, Viking Press

Alexander Liberman
Art Director, *Vogue*

Stanley Marcus
President, Neiman-Marcus

Grace Mayer
Curator, Museum of the City of New York

A. Hyatt Mayor
Curator of Prints,
The Metropolitan Museum of Art

Beaumont Newhall
Director, George Eastman House

Aline B. Saarinen
Associate Art Critic, *The New York Times*

Dorothy Seiberling
Art Editor, *Life*

Edward Steichen
Director, Department of Photography,
Museum of Modern Art

PFA EXHIBITION II

Opened at The Metropolitan Museum
of Art on May 20, 1960
Closed on September 4, 1960

Chairman
James J. Rorimer
Director,
The Metropolitan Museum of Art

Frank Baker
Senior Art Director and member of the
Creative Plans Board, McCann-Erickson

Adelyn Dohme Breeskin
Director, Baltimore Museum of Art

Leslie Cheek, Jr.
Director, Virginia Museum of Fine Arts

Hugh Edwards
Curator, Photography;
Associate Curator, Prints and Drawings,
Art Institute of Chicago

Alexander Eliot
ex-Art Critic, *Time*

Emily Genauer
Art Critic, Columnist,
New York Herald Tribune

Bartlett H. Hayes, Jr.
Director,
Addison Gallery of American Art

Bryan Holme
Director, Studio Books, Viking Press

Sam Hunter
Acting Director,
Minneapolis Institute of Arts

Una E. Johnson
Curator of Prints and Drawings,
The Brooklyn Museum

A. Hyatt Mayor
Curator of Prints,
The Metropolitan Museum of Art

SPECIAL SCREENING JURY

Chairman
Norris Harkness
Hon. PSA; past President,
Photographic Society of America

Mildred Baker
Associate Director, Newark Museum

Eliot Elisofon
Life Magazine Photographer

Adolf Fassbender
Hon. PSA, Dean of Pictorialism

Kathryn E. Gamble
Director, Montclair Museum

Gillett Griffin
Curator of Graphic Arts,
Princeton University Library

Una E. Johnson
Curator of Prints and Drawings,
The Brooklyn Museum

Harris K. Prior
Director, American Federation of Arts

Albert Reese
Kennedy Galleries

Carl J. Weinhardt, Jr.
Associate Curator of Prints,
The Metropolitan Museum of Art

PFA EXHIBITION III

Opened at the Minneapolis Institute
of Arts on June 14, 1961
Closed on September 3, 1961

Chairman
James J. Rorimer
Director,
The Metropolitan Museum of Art

E. A. Adams
Founder and Director,
Art Center School, Los Angeles

Adelyn Dohme Breeskin
Director, Baltimore Museum of Art

Anton Bruehl
Photographer

Leslie Cheek, Jr.
Director, Virginia Museum of Fine Arts

Bartlett H. Hayes, Jr.
Director, Addison Gallery of American Art

Bryan Holme
Director, Studio Books, Viking Press

A. Hyatt Mayor
Curator of Prints,
The Metropolitan Museum of Art

Perry T. Rathbone
Director, Museum of Fine Arts, Boston

Carl J. Weinhardt, Jr.
Director, Minneapolis Institute of Arts

SPECIAL PANEL THAT
QUALIFIED ENTRIES FROM
THE PHOTOGRAPHIC SOCIETY
OF AMERICA

Chairman
Norris Harkness
Hon. PSA, past President,
Photographic Society of America

Mildred Baker
Associate Director,
Newark Museum Association

Joseph Costa
Board Chairman, National Press
Photographers Association

Adolf Fassbender
Teacher of Photography

Gillett Griffin
Curator of Graphic Arts,
Princeton University Library

Una E. Johnson
Curator of Prints and Drawings,
The Brooklyn Museum

Harris K. Prior
Director, American Federation of Arts

Albert Reese
Kennedy Galleries, Inc.

JURY FOR THE UPPER MIDWEST
REGIONAL CONTEST

Wilhelmus B. Bryan
Director, Minneapolis School of Art

Clark Dean
Photographer

Martin Friedman
Director, Walker Art Center

Orazio Fumagalli
Director, Tweed Gallery, Duluth

Malcolm Lein
Director,
St. Paul Gallery and School of Art

Jerome Liebling
Associate Professor of Art,
University of Minnesota

William Saltzman
Director, Rochester Art Center

Carl J. Weinhardt, Jr.
Director, Minneapolis Institute of Arts

PFA EXHIBITION IV

Opened at The Metropolitan Museum
of Art on May 16, 1963
Closed on September 30, 1959

Chairman
James J. Rorimer
Director,
The Metropolitan Museum of Art

Leslie Cheek, Jr.
Director, Virginia Museum of Fine Arts

Gustave Von Groschwitz
Director, Department of Fine Arts,
Carnegie Institute

Bartlett H. Hayes, Jr.
Director, Addison Gallery of American Art

Bryan Holme
Director, Studio Books, Viking Press

A. Hyatt Mayor
Curator of Prints,
The Metropolitan Museum of Art

Beaumont Newhall
Director, George Eastman House

Perry T. Rathbone
Director, Museum of Fine Arts, Boston

Carl J. Weinhardt, Jr.
Director, The Minneapolis Institute of Arts

COMMITTEE OF INVITATION

Chairman
Beaumont Newhall
Director, George Eastman House

Ansel Adams
Photographer

Ralph Steiner
Photographer

JURY FOR THE PHOTOGRAPHIC SOCIETY OF AMERICA

Chairman
Norris Harkness
Hon. PSA

Mildred Baker
Associate Director,
Newark Museum Association

Joseph Costa
Chairman of the Board, National Press
Photographers Association

Alexander Eliot
Art Critic

Adolf Fassbender
Teacher of Photography

Kathryn E. Gamble
Director, Montclair Art Museum

Gillett Griffin
Curator of Graphic Arts,
Princeton University Library

John McKendry
Assistant Curator of Prints,
The Metropolitan Museum of Art

Harris K. Prior
Director, Memorial Art Gallery
of the University of Rochester

Arthur Rothstein
Technical Director of Photography, *Look*

MUSEUM DIRECTORS' SELECTIONS FOR THE 1965 NEW YORK WORLD'S FAIR EXHIBITION

Opened at the Kodak Pavilion at the
World's Fair on May 20, 1965
Closed on June 16, 1965

Chairman
James J. Rorimer
Director, The Metropolitan Museum of Art

Thomas S. Buechner
Director, The Brooklyn Museum

Leslie Cheek, Jr.
Director, Virginia Museum of Fine Arts

Dr. Richard E. Fuller
Director, Seattle Art Museum

Bartlett H. Hayes, Jr.
Director, Addison Gallery of American Art

Dr. Sherman E. Lee
Director, The Cleveland Museum of Art

Perry T. Rathbone
Director, Museum of Fine Arts, Boston

Dr. Evan Hopkins Turner
Director, Philadelphia Museum of Art

John Walker
Director, National Gallery of Art

Carl J. Weinhardt, Jr.
Director, Gallery of Modern Art, New York

Otto Wittmann
Director, The Toledo Museum of Art

PFA EXHIBITION V

Opened at The Metropolitan Museum
of Art on March 14, 1967
Closed on June 11, 1967

Jean Sutherland Boggs
Director, The National Gallery of Canada,
Ottawa

Leslie Cheek, Jr.
Director, Virginia Museum of Fine Arts

Bartlett H. Hayes, Jr.
Director, Addison Gallery of American Art

John McKendry
Associate Curator of Prints, The Metropolitan
Museum of Art

A. Hyatt Mayor
former Curator of Prints, The Metropolitan
Museum of Art

Joseph V. Noble
Vice-Director for Administration, The
Metropolitan Museum of Art

Perry T. Rathbone
Director, Museum of Fine Arts, Boston

Alan Shestack
Assistant Curator, National Gallery of Art

Laurence Sickman
Director, William Rockhill Nelson Gallery of Art,
Kansas City

Evan H. Turner
Director, Philadelphia Museum of Art

Otto Wittmann
Director, The Toledo Museum of Art

PFA EXHIBITION I

Ansel Adams
Michael Anguti
Richard Avedon
Werner Bischof
Shirley C. Burden
Harry Callahan
Cornell Capa
Robert Capa
Henri Cartier-Bresson
Lucien Clergue*
Jerry Cooke
Bruce Davidson
Roy De Carava
David Douglas Duncan
Alfred Eisenstaedt
Eliot Elisofon
Elliott Erwitt
N. R. Farbman
Andreas Feininger
Robert Frank*
Ernst Haas
Phillip Harrington
Takeichi Hotta*
Yale Joel
Yousuf Karsh
Mark Kauffman
Dmitri Kessel
H. Landshoff
Dorothea Lange
Bob Lerner
Leo Lionni
Leonard McCombe
Ray K. Metzker*
Gjon Mili
Mount Wilson and Palomar Observatories
Takahiro Ono*
Gordon Parks
Irving Penn
Arthur Rothstein
Bob Sandberg
Gustav Schenk*
Emil Schulthess
David Seymour
Ben Shahn*
George Silk
W. Eugene Smith
Howard Sochurek
Frederick Sommer*
Leo Stashin
George Strock
Maurice Terrell
Steven Trefonides
Rev. Kenneth W. Tyler
John Vachon
John R. Wells

PFA EXHIBITION II

Harold Allen
Jack Andersson
Michael Anguti
George Aptecker*
Eve Arnold
David Attie
Richard Avedon
J. D. Barnell
Werner Bischof
Jeremy Blodgett
Alfred Boch
Robert Boram
Margaret Bourke-White
Brian Brake
Josef Breitenbach
Charlotte Brooks
Esther Bubley
Wynn Bullock
Cornell Capa
Robert Capa
Henri Cartier-Bresson
Taber Chadwick
Jerry Y. Chong
Bernard Cole
Jerry Cooke
George M. Cunningham
Walter A. Curtin
Jerry Dantzic
Arthur d'Arazien
Bruce Davidson
José Ortiz Echague
Dorothy Meigs Eidlitz
Elliott Erwitt
Sam Falk
Andreas Feininger
David J. Forbert
William Froelich
Paul Fusco
Jim Gagnon*
Richard N. Gardner
A. John Geraci
Leslie Gill
Phil Glickman
Burt Glinn
Carola Gregor
Ernst Haas
Theodore Seymour Hall
Althea W. Hallock
Philippe Halsman
Charles Harbutt
Phillip Harrington
Kay Harris
Erich Hartmann
Margaret Hawley
Ken Heyman
Evelyn Hofer
Horst P. Horst
Carolyn Mason Jones
Carter Jones
Clemens Kalischer
Yousuf Karsh
Mark Kauffman
André Kertész
Dmitri Kessel

Jeannette Klute
Hans Knopf
H. Landshoff
Dorothea Lange
David G. Leach
Arthur Leipzig
Leo Lerch
Erich Lessing
Alexander Liberman
Archie Lieberman
Leo Lionni
W. J. Lippincott
Angelo Lomeo
Walter Lowitz
Sheldon M. Machlin
Charles H. Martens
Ivan Massar
Herbert Matter
Rollie McKenna
Frances McLaughlin-Gill
E. Ulrich Meisel
Wayne Miller
Neil Montanus and Richard Boden
Inge Morath
Barbara Morgan
Arnold Newman
Joseph V. Noble
Irving Penn
Eliot F. Porter
John Rawlings
Bruno C. Reinicke
Marc Riboud
George Rodger
Leonard Ross
Arthur Rothstein
Kosti Ruohomaa
Dr. Henry Sarason
Emil Schulthess
Paul Schutzer
David Seymour
Susan Sherman
Bill Shrout
Lawrence N. Shustak
Ernest Sisto
Moneta Sleet, Jr.
David M. Stanley
Joseph Stanley
Louis Stettner
Roy Stevens
John Stewart
Jed Sylbert
John Szarkowski
Kryn Taconis
Rev. W. George Thornton
Michael A. Vaccaro
John Vachon
Kenneth Van Sickle
W. W. Vasillov
Ruth Velissaratos
James C. Vincent
Carl B. Wahlund
Rick Warner
John R. Wells
Werner Wolff
José Lorenzo Zakany

PFA EXHIBITION III

Jack S. Andersson
Richard Avedon
F. Berko
Cal Bernstein
Alfred Boch
A. Aubrey Bodine
Robert Boram
John W. Bower
Robert E. Boyse
Brian Brake
Josef Breitenbach
Sheldon A. Brody
John Brook
Mary Eleanor Browning
Wynn Bullock
Shirley Burden
Paul Caponigro
Taber Chadwick
Jerry Cooke
Arthur d'Arazien
Jean Dieuzaide
Allen Downs
A. Wilson Embrey, III
Elliott Erwitt
Peter Fink
David J. Forbert
William G. Froelich
Kazuichi Fujita
Margaret L. Gilliam
Robert B. Goodman
Irwin Gooen
Keiichiro Goto
Crawford H. Greenewalt
Gilbert M. Grosvenor
A. G. W. Grotefend
W. J. Hagedorn
Ernst Halberstadt
Philippe Halsman
Kay Harris
Gerard Healy
Esther Henderson
Thomas Henion
Fritz Henle
Richard Hewett
Ken Heyman
Hiro
Lee Howick
George Hoxie
Edward J. Jacobs
Carter Jones
Douglas Jones
Pirkle Jones
Fritz Juras
Art Kane
Richard Kantor
Yousuf Karsh
James N. Keen
Peter Keetman
Wallace Kellam
André Kertész
William Klein
Ewing Krainin
E. W. Kurtz
H. Landshoff

John Launois
Nina Leen
Arthur Leipzig
Alexander Liberman
Otto Litzel
Angelo Lomeo
Walter Lowitz
Sheldon M. Machlin
William Mallas
Fred J. Maroon
James Marshall
Leonard McCombe
Frances McLaughlin-Gill
Lew Merrim
Gerri Mindell
Betty Moore
Virginia Moore
Fred Morgan
Yasushi Nagao
Hans Namuth
Tom Nebbia
Joseph V. Noble
Ruth Orkin
Irving Penn
Eliot Porter
Richard Quataert
Bruno C. Reinicke
Martha McMillan Roberts
Spencer Ross
Theodore Rozumalski
William Samenko, Jr.
Emil Schulthess
Carrol Seghers, II
Sybil Shelton
Lawrence E. Shustak
George Silk
Tadd Stam
James R. Stanford
Joseph Stanley
B. Anthony Stewart
Fred H. Stocking
Bill Strode
Harlan Thompson
Marvin Tjornhom
Pete Turner
Alvin B. Unruh
Michael A. Vaccaro
John Vachon
W. Vasillov
Volkmar Wentzel
Elsie B. Westmark
Brett Weston
Eileen Widder
Walter Wissenbach
Ray Witlin
Werner Wolff
Frances R. Wolfson
Barbara Young

PFA EXHIBITION IV

Kathryn Abbe
Ansel Adams
Sylvia Albert
Ollie Atkins
Richard Avedon
Sid Avery
Oscar Bailey
Betty Barford
Morton Beebe
Cal Bernstein
Alfred Boch
A. Aubrey Bodine
John W. Bower
Gertrude C. Bray
Josef Breitenbach
John Brook
Sonja Bullaty
Wynn Bullock
Albert J. Burrows
Lew Bush
Paul Caponigro
Taber Chadwick
Walter Chappell
Carl Chiarenza
Gim H. Chong
Bernard Cole
Marie Cosindas
Ralph Crane
Arthur d'Arazien
Al Deane
Jean Dieuzaide
H. P. Dodge
Franz Dutzler
P. Eckel
Eliot Elisofon
Sam Falk
Daniel Farber
Andreas Feininger
Sidney Fichtelberg
Peter Fink
Albert Freytag
William G. Froelich
Kengo Fujie
Paul Fusco
William A. Garnett
James B. Gitlitz
Fritz Goro
Virna Haffer
Ernst Halberstadt
M. Halberstadt
Philippe Halsman
Arno Hammacher
James Hansen
Suzanne Hausamann
Fritz Henle
Ken Heyman
Louis J. Hoeflinger
George Holton
Don Hunter
Philip Hyde
Takeo Iwamatu
Carter Jones
Pirkle Jones
Clemens Kalischer
Yousuf Karsh

Norman C. Kerr
André Kertész
Dmitri Kessel
Kazuhiko Kondo
Robert J. Kornfeld
Willem Kriz
Leon Kuzmanoff
H. Landshoff
Alma Lavenson
Alexander Liberman
Archie Lieberman
Werner Luthy
Nathans Lyons
Jack Manning
Fred J. Maroon
Ivan Massar
C. G. Maxwell
Sadie E. McGillis
Dick McGraw
Thomas F. Myers, III
Hans Namuth
Peter Nelson
Arnold Newman
Stephen Nichols
Harold M. Null
Ruth Orkin
Brooks Paige
Gordon Parks
Eliot F. Porter
Joseph Baylor Roberts
Bob Roos
Merg Ross
W. Gillies Ross
Bruno Rosso
Arthur Rothstein
Lorette Ryan
Walter Sanders
Martin J. Schmidt
Emil Schulthess
John Scofield
Evelyn I. Seitz
Arthur Siegel
Elsbeth Siegrist
George Silk
Ben Somoroff
Bert Stern
John Stewart
Richard L. Swanson
Kryn Taconis
Masae Tamura
Joseph G. Taylor
Harlan Thompson
Pete Turner
John Upton
Burk Uzzle
Ronconi Vittorio
Zdenek Vozenilek
Lynn C. Wall
Jack W. Welpott
Brett Weston
Minor White
Don Worth
Akisuke Yamaguchi
José Lorenzo Zakany

MUSEUM

DIRECTORS'

SELECTIONS FOR

THE 1965 NEW YORK

WORLD'S FAIR

EXHIBITION

PFA EXHIBITION V

Ansel Adams	Arnold Newman	William Albert Allard	William A. Garnett	Richard Quataert
Jack S. Andersson	Joseph V. Noble	Jack S. Andersson	Mario Giacomelli	David D. Read
Richard Avedon	Harold M. Null	Herbert Angeli	Marcel Giro	Peter Remington
Oscar Bailey	Ruth Orkin	Sven Asberg	Robert B. Goodman	Co Rentmeester
Morton Beebe	Brooks Paige	Richard Avedon	Morris Gordon	Marc Riboud
Werner Bischof	Irving Penn	Oscar Bailey	Richard F. Gordon	Arthur Rothstein
Alfred Boch	Eliot F. Porter	Dmitri Baltermants	Phillip Harrington	William Samenko, Jr.
John W. Bower	Bruno C. Reinicke	Peter Beard	Suzanne Hausammann	Kyoichi Sawada
Josef Breitenbach	Marc Riboud	Peter E. Beckett	Fritz Henle	William Schneider
John Brook	Merg Ross	Bill Belknap	John F. Hermle	John Schulze
Mary Eleanor Browning	Bruno Rosso	Ruth Bernhard	Ken Heyman	Arthur Seller
Esther Bubley	Arthur Rothstein	Marc and Evelyne Bernheim	Lawrence Hudetz	Elsie Seltzer
Wynn Bullock	Theodore Rozumalski	Heinz Bertelsmann	Robert Huntzinger	Susan Sherman
Cornell Capa	Kosti Ruohomaa	Erwin Blumenfeld	Philip Hyde	Irene Shwachman
Robert Capa	Martin J. Schmidt	Alfred Boch	Robert Ishi	Robert F. Sisson
Paul Caponigro	Emil Schultess	John W. Bower	Carter Jones	Dorothy May Small
Henri Cartier-Bresson	Evelyn I. Seitz	Josef Breitenbach	Art Kane	Charlotte B. Smith
Taber Chadwich	David Seymour	Sheldon A. Brody	Yousuf Karsh	Gordon Smith
Marie Cosindas	Susan Sherman	Richard W. Bruggemann	Peter Keetman	Snowdon
George M. Cunningham	Arthur Siegel	Wynn Bullock	Richard Kelly	James L. Stanfield
Arthur d'Arazien	Elsbeth Siegrist	George Bunzl	André Kertész	James R. Stanford
P. Eckel	George Silk	Larry Burrows	Shinichiro Kitamura	Bert Stern
Eliot Elisofon	W. Eugene Smith	Taber Chadwick	Bill Noel Kleeman	Tokutaro Tanaka
Elliott Erwitt	Ben Somoroff	Marie Cosindas	Erwin Kneidinger	Gordon Tenney
Sam Falk	James R. Stanford	Adger W. Cowans	Robert J. Kornfeld	Harlan Thompson
Daniel Farber	Bert Stern	Robert Coyle	Sylvia Kramer	Charles L. Trainor
Andreas Feininger	B. Anthony Stewart	Imogen Cunningham	Leon Kuzmanoff	Shiu-Min Tsay
David J. Forbert	John Stewart	David G. Currie	H. Landshoff	Pete Turner
William G. Froelich	John Szarkowski	Judy Dater	John Launois	Jerry N. Uelsmann
Paul Fusco	Masae Tamura	Adelaide de Menil	George A. LeMoine	John Vachon
Phil Glickman	W. George Thornton	Dena	Norman Lerner	William Vandivert
Burt Glinn	Michael A. Vaccaro	John de Visser	J. S. Lewinski	Robert Van Fleet
Keiichiro Goto	Zdenek Vozenilek	Michael Di Biase	Ehud Locker	Zdenek Vozenilek
Ernst Haas	Lynn C. Wall	Jean Dieuzaide	Lee Lockwood	Fred Ward
Ernst Halberstadt	Rick Warner	Stephanie Dinkins	Angelo Lomeo	Bradford Washburn
M. Halberstadt	John R. Wells	John Dominis	Herral Long	Jack W. Welpott
Philippe Halsman	Brett Weston	Jerome Drown	David Ming-Li Lowe	Brett Weston
Fritz Henle	Walter Wissenbach	Margaret Durrance	Herbert Marcus	Eileen Widder
Ken Heyman	Ray Witlin	Peggy Eagan	Fred J. Maroon	Walter Wissenbach
Don Hunter	Don Worth	Gilles Ehrmann	Martin Martincek	Myron Wood
Takeo Iwamatu	Akisuke Yamaguchi	Sigurjon Einarsson	Fred Mayer	Don Worth
Edward J. Jacobs		Milada Einhornova	Nelson Medina	John Yang
Carter Jones		Alfred Eisenstaedt	Richard D. Merritt	
Art Kane		Niki Ekstrom	Manuel Minces	
Yousuf Karsh		Daniel Farber	Paolo Monti	
Wallace Kellam		Andreas Feininger	David Moore	
Norman C. Kerr		Toni Ficalora	Anne Morgan	
Dmitri Kessel		Peter Fink	Barbara Morgan	
William Klein		David J. Forbert	Horst Munzig	
Robert J. Kornfeld		R. Robert Franco	Jon Naar	
H. Landshoff		Lawrence Fried	Hans Namuth	
Dorothea Lange		Toni Frissell	Thomas Nebbia	
John Launois		William G. Froelich	Lucia Nebel	
Alma Lavenson		Kengo Fujie	Arnold Newman	
Alexander Liberman			Harold M. Null	
Archie Lieberman			Ruth Orkin	
Leo Lionni			Wingate H. Paine	
Sheldon M. Machlin			Ann Parker	
Sadie E. McGillis			Gordon Parks	
Frances McLaughlin-Gill			Freeman Patterson	
Inge Morath			Jerrold A. Peil	
Barbara Morgan			Selina Petch	
Fred Morgan			David Plowden	
Yasushi Nagao			Charles Pratt	
Hans Namuth				

*indicates photographers whose work
was not in the collection of the
PFA Foundation.

Listings are chronological. Duplicate names in the same year indicate that museums hosted different PFA exhibitions.

1959

Metropolitan Museum of Art

Minneapolis Institute of Arts

Parrish Art Museum, Southampton, N.Y.

Virginia Museum of Fine Arts, Richmond, Va.

J. B. Speed Art Museum, Louisville, Ky.

1960

Currier Gallery of Art, Manchester, N.H.

Henry Ford Museum, Dearborn, Mich.

Atlanta Art Association

Art Institute, Tampa, Fla.

University of Wisconsin

Metropolitan Museum of Art

Baltimore Museum of Art

Corning Museum of Glass, Corning, N.Y.

National Museum of Modern Art, Tokyo, Japan

Virginia Polytechnic Institute, Blacksburg, Va.

Mary Baldwin College, Staunton, Va.

Washington and Lee University, Lexington, Va.

Sweet Briar College, Sweet Briar, Va.

Chapters of Virginia Museum of Fine Arts, Waynesboro and Winchester

Highlands Art Festival, Abingdon, Va.

Minneapolis Institute of Arts

Henry Ford Museum

Art Gallery, Osaka, Japan

Museum of Fine Arts, Houston, Tex.

City Art Museum, St. Louis, Mo.

Art Center School, Los Angeles, Calif.

Whittier College, Whittier, Calif.

1961

Allen Memorial Art Museum, Oberlin, Ohio

Art Center in La Jolla, La Jolla, Calif.

Emma Willard Art Gallery, Troy, N.Y.

Society of the Four Arts, Palm Beach, Fla.

Columbia Museum of Art, Columbia, S.C.

Carnegie Institute, Pittsburgh, Pa.

Grand Rapids Art Gallery, Grand Rapids, Mich.

University of Kansas, Lawrence

Museum of Fine Arts, Dallas, Tex.

Minneapolis Institute of Arts

Isaac Delgado Museum of Art, New Orleans, La.

Corning Museum of Glass

Atlanta Art Association

Flint Institute of Arts, Flint, Mich.

Centennial Art Museum, Corpus Christi, Tex.

Ball State Teachers College, Muncie, Ind.

Portland Museum of Art, Portland, Me.

Des Moines Art Center, Des Moines, Iowa

Biennale Exposition, Paris, France

Wake Forest College, Winston-Salem, N.C.

Nelson Art Gallery, Kansas City, Mo.

Fine Arts Association, Tucson, Ariz.

Munson-Williams-Proctor Institute, Utica, N.Y.

1962

Arkansas Arts Center, Little Rock, Ark.

Baltimore Museum of Art

Midland Art Association, Midland, Mich.

Joslyn Art Museum, Omaha, Nebr.

Ball State Teachers College, Muncie, Ind.

M. H. De Young Memorial Museum, San Francisco, Calif.

Museum of Fine Arts, Dallas, Tex.

Texas Tech, Amarillo, Tex.

Toledo Museum of Art

Baltimore Museum of Art

University of Wisconsin

Dayton Art Institute, Dayton, Ohio

Ripon College, Ripon, Wis.

Joe and Emily Lowe Art Gallery, Miami, Fla.

Whittier College

Grand Rapids Art Gallery

Museum of Fine Arts, Springfield, Mass.

Museum of Fine Arts, Boston, Mass.

Museum of Art, Birmingham, Ala.

Flint Institute of Arts

Wadsworth Atheneum, Hartford, Conn.

Museum of Art, Santa Barbara, Calif.

Ball State Teachers College

Corning Museum of Glass

City Art Museum, St. Louis, Mo.

Roberson Memorial Center, Binghamton, N.Y.

Sheldon Swope Art Gallery, Terre Haute, Ind.

Institute of Technology, Chicago, Ill.

Mint Museum of Art, Charlotte, N.C.

Atlanta Art Association

Rhode Island School of Design, Providence, R.I.

Museum of Fine Arts, Springfield, Mass.

1963

Wichita Art Museum, Wichita, Kan.

Joslyn Art Museum

Dartmouth College, Hopkins Center, Hanover, N.H.

Cranbrook Academy of Art, Bloomfield Hills, Mich.

Fine Arts Center, Colorado Springs, Colo.

Wustum Museum of Fine Arts, Racine, Wis.

Art League, Parkersburg, W. Va.

Texas Tech

Municipal Art Gallery, Los Angeles, Calif.

Currier Galley of Art, Manchester, N.H.

Rahr Public Museum, Manitowoc, Wis.

Wesleyan University, Wesleyan, Ohio

Wake Forest College

M. H. De Young Memorial Museum

Lauren Rogers Museum of Art, Laurel, Mich.

Northern Illinois University, De Kalb, Ill.

Metropolitan Museum of Art

Brooks Memorial Art Gallery, Memphis, Tenn.

Hallmark Galleries, Kansas City, Mo.

University of Wisconsin

Corning Museum of Glass

Phoenix Art Museum

Seattle Art Museum

Emma Willard Art Gallery

Dartmouth College

Stanford University, Stanford, Calif.

Baltimore Museum of Art

Edward W. Root Art Center, Utica, N.Y.

Museum of Fine Arts, Springfield, Mass.

1964

Richmond Art Association, Richmond, Ind.

Kalamazoo Institute of Arts, Kalamazoo, Mich.

Telfair Academy of Arts and Sciences, Savannah, Ga.

Lake Forest College, Lake Forest, Ill.

Dallas Museum of Fine Arts

State University of New York at Oswego

Dartmouth College

John and Mable Ringling Museum of Art, Sarasota, Fla.

Arnot Art Gallery, Elmira, N.Y.

Carnegie Institute

Museum of New Mexico

Sioux City Art Center, Sioux City, Iowa

Roberson Memorial Center

Atlanta Art Association

Museum of Fine Arts, Boston

Texas Tech

Museum of Art, Birmingham, Ala.

Northern Illinois University

Isaac Delgado Museum of Art

Southern Vermont Art Center

Guild Hall Galleries, Chicago, Ill.

Arkansas Arts Center, Little Rock, Ark.

Minneapolis Institute of Arts

Sheldon Swope Art Gallery

Stanford University

Rose Polytechnic Institute, Terre Haute, Ind.

University of North Carolina

J. B. Speed Art Museum

Corning Museum of Glass

Phoenix Art Museum

Seattle Art Museum

Emma Willard Art Gallery

Dartmouth College

Stanford University, Stanford, Calif.

Baltimore Museum of Art

Edward W. Root Art Center, Utica, N.Y.

Museum of Fine Arts, Springfield, Mass.

Portland Art Museum, Portland, Ore.

Hartwick College, Oneonta, N.Y.

Fine Arts Gallery, San Diego, Calif.

Brooks Memorial Art Gallery, Memphis, Tenn.

1965

St. Edward's University

Philbrook Art Center, Tulsa, Okla.

Ontario College, Toronto, Canada

M. H. De Young Memorial Museum

Contemporary Arts Center, Cincinnati, Ohio

University of Oregon, Eugene, Ore.

Lake Forest College, Lake Forest, Ill.

Heritage Center, State Capitol, Bismarck, N.D.

Denver Art Museum

University of North Dakota, Grand Forks, N.D.

New York World's Fair

North Carolina Museum of Art, Raleigh, N.C.

City Art Museum, St. Louis, Mo.

Guild Hall, East Hampton, N.Y.

Flint Institute of Arts

Monmouth Museum, Red Bank, N.J.

Dartmouth College

College of Wooster, Wooster, Ohio

Toledo Museum of Art

Long Island University, Brooklyn, N.Y.

Museum of Fine Arts, St. Petersburg, Fla.

1966

Texas Tech

Loch Haven Art Center, Orlando, Fl.

Hartwick College, Oneonta, N.Y.

Lake Forest College, Lake Forest, Ill.

Carolina Art Association, Charleston, S.C.

University of Connecticut, Storrs, Conn.

Nassau Community College, Garden City, N.Y.

Phoenix Art Museum

Corning Museum of Glass

Honolulu Academy of Arts

Southern Vermont Art Center,
Manchester, Vt.

Museum of Arts and Sciences,
Norfolk, Va.

Everhart Museum, Scranton, Pa.

Contemporary Arts Center,
Cincinnati, Ohio

Muhlenberg College, Allentown, Pa.

University of Wisconsin

University of Cincinnati

Museum of Fine Arts, Springfield, Mass.

1967

Paine Art Center, Oshkosh, Wis.

Junior College of Broward County,
Ft. Lauderdale, Fla.

Royal Ontario Museum, Toronto, Canada

Hartwick College

Lake Forest College

Illinois Wesleyan University,
Bloomington, Ill.

Metropolitan Museum of Art

St. Edward's University, Austin, Tex.

Parrish Art Museum, Southampton, N.Y.

Southern Vermont Art Center

Flint Institute of Arts

Tennessee Fine Arts Center,
Nashville, Tenn.

Akron Art Institute

Rutgers College, New Brunswick, N.J.

Columbus Gallery of Fine Arts,
Columbus, Ohio

Museum of Fine Arts, Springfield, Mass.

Wake Forest College

Central Connecticut State College,
New Britain, Conn.

M. H. De Young Memorial Museum

Museum of Fine Arts,
St. Petersburg, Fla.

1968

Saint Leo College, Saint Leo, Fla.

Seattle Art Museum

Carolina Art Association,
Charleston, S.C.

University of Georgia

North Carolina Museum of Art,
Raleigh, N.C.

Wichita Art Museum, Wichita, Kans.

State University of New York at Oswego

St. Edward's University

High Museum of Art, Atlanta, Ga.

Long Island University

Virginia Museum of Fine Arts

Arkansas Arts Center

Southern Vermont Art Center

Corning Museum of Glass

Delaware Art Center

Museum of Fine Arts, Montgomery, Ala.

E. B. Crocker Art Museum,
Sacramento, Calif.

Fine Arts Center, Colorado Springs, Colo.

Museum of Fine Arts, Dallas, Tex.

Phoenix Art Museum

1969

Herron Museum of Art,
Indianapolis, Ind.

Museum and Art Center,
Wichita Falls, Tex.

Oklahoma Art Center,
Oklahoma City, Okla.

W. R. Nelson Gallery of Art,
Kansas City, Mo.

Des Moines Art Center,
Des Moines, Iowa

University of Wisconsin Art Gallery

Tucson Art Center

Greenville County Museum of Art,
Greenville, S.C.

Isaac Delgado Museum of Art

Memphis Academy of Arts,
Memphis, Tenn.

1970

Civic Center Museum, Philadelphia, Pa.

Wake Forest University

Saginaw Art, Saginaw, Mich.

Records from the PFA Foundation, as
well as from some participating
institutions, are incomplete; therefore, it
is possible that some of the exhibitions
that PFA circulated might have toured
additional institutions not listed here.